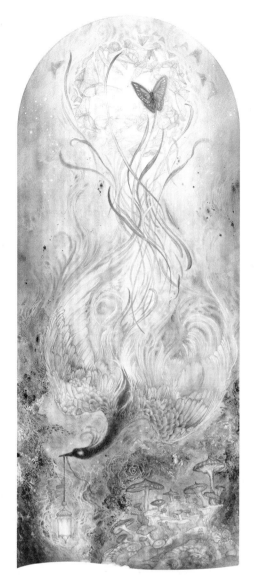

LUPENTE

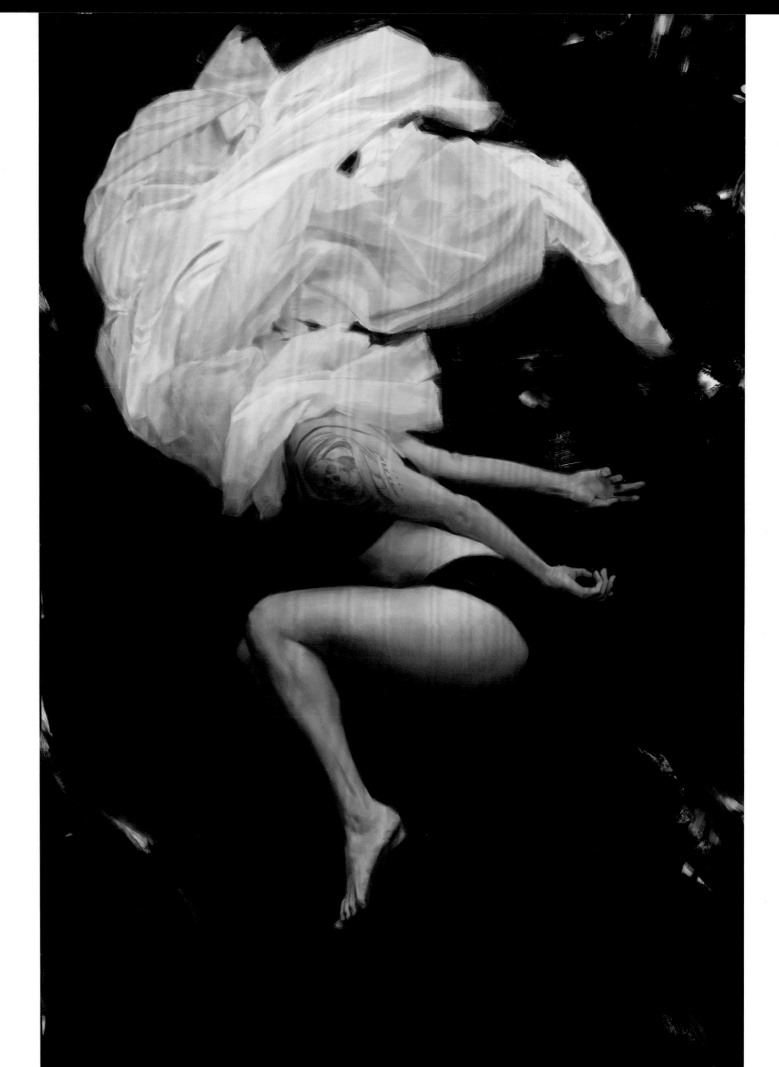

ORTIZ

LUPENTE

FLESK ARTIST SHOWCASE

EDITED BY
JOHN FLESKES

FLESK

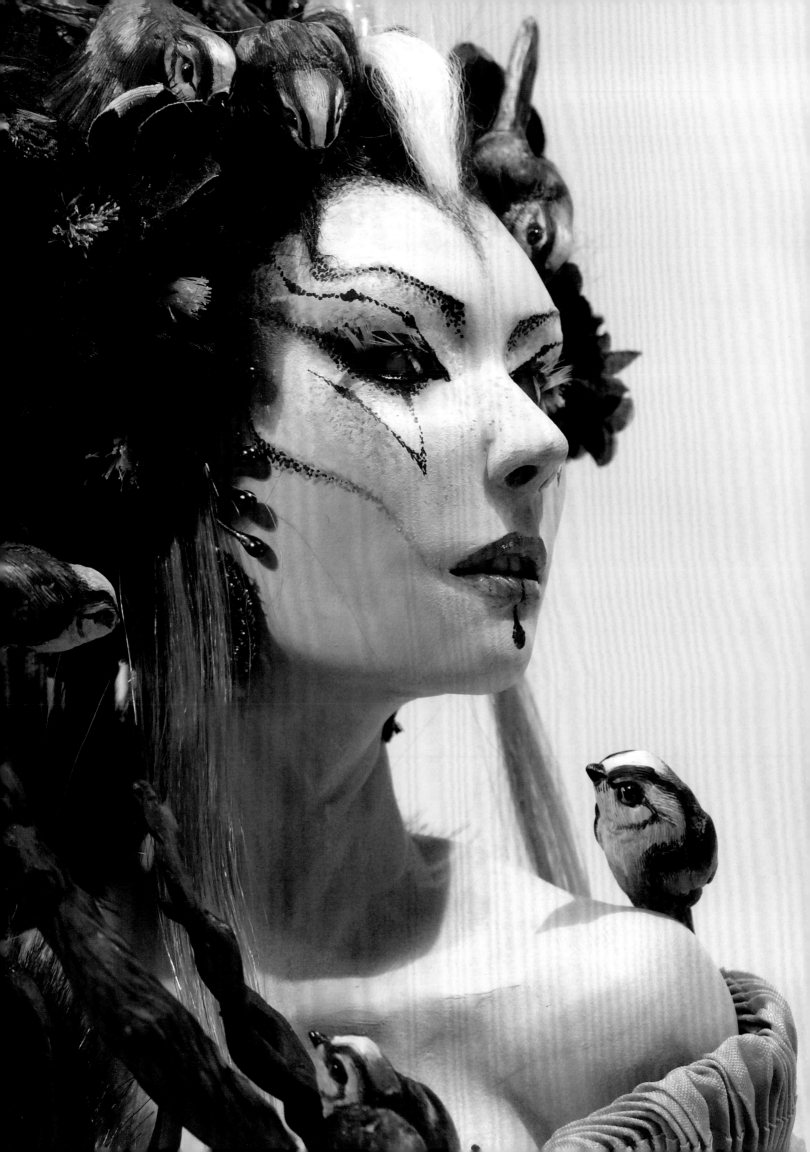

CONTENTS

INTRODUCTION
BY JOHN FLESKES

Since I started publishing in 2002, I have had the good fortune to work within a field that I am enthusiastic about. The opportunity to make art books and to meet and correspond with artists in a variety of fields is something that brings me daily pleasure.

Back in 2011, I published a book titled *Flesk Prime*. It was a collection of pieces by five artists with whom I was then working. They included Craig Elliott, Gary Gianni, Petar Meseldžija, Mark Schultz and William Stout. We went on to have a group trip and book signing in the Netherlands during the Strip Festival in Breda that year. Since then, it had always been in the back of my mind to continue a series of books where I could highlight another collection of five artists in an exquisite format that I could share with others. Now is that time.

"Lupente" (pronounced Lu-pen-té) is a unique word that was created specifically for this book. It actually is a combination of two words and represents the beauty found in nature and the strength of the number five. The word Lupine (otherwise known as Lupinus and Lupin) was suggested by my son, Ocean. The *Lupinus albifrons* (Silver Lupine) is one of our local California natives. These plants have large flower blooms in a variety of colors. About two hundred species can be found in North and South America and other parts of the world, and they represent a wide diversity with a variety of beneficial uses. Five is the most typical structure seen in the flora and fauna all around us. It is also significant in serving as the five elements in nature: earth, water, fire, air and the sky. *Pente* is the Greek word for the number 5. By combining these two words, "Lupente" was born.

Nature and art have always served as my two centers. Most of my time is spent immersing myself in these two areas. By touching upon nature with its title, Lupente serves as a personal format to share my passion for art. This book is the first of an ongoing series that will be released once a year. It serves to spotlight five artists who I feel are doing exceptional work.

The artists found within these pages are five inspiring human beings who I have admired for years—not only for their range and abilities but also for who they are. I am lucky to have met all of them in person and to see what kind people they are. **Julia Blattman** has a gift for capturing light and infusing moods into her paintings, which tell stories and feel alive. **Stephanie Law** pulls from dreams and reality to highlight the boundaries between those two worlds. **Karla Ortiz** is as much a public icon for her motivational talks as she is renowned for her personal works and designs for film. **Virginie Ropars** is one of the most revered dollmakers today and serves as an inspiration to many sculptors around the world. And **Erica Williams**, also known as "HookieDuke," has mastered a unique, highly intricate style of lines and designs that centers on nature as its inspiration. I had the chance to talk with each individual to learn more about them. This allowed me to present their work alongside commentary and essays that offer insight behind their creations. Their art is not a product. It is an extension of who they are. Each of these artists brings beauty into the world, and it is my pleasure to have this opportunity to share them with you.

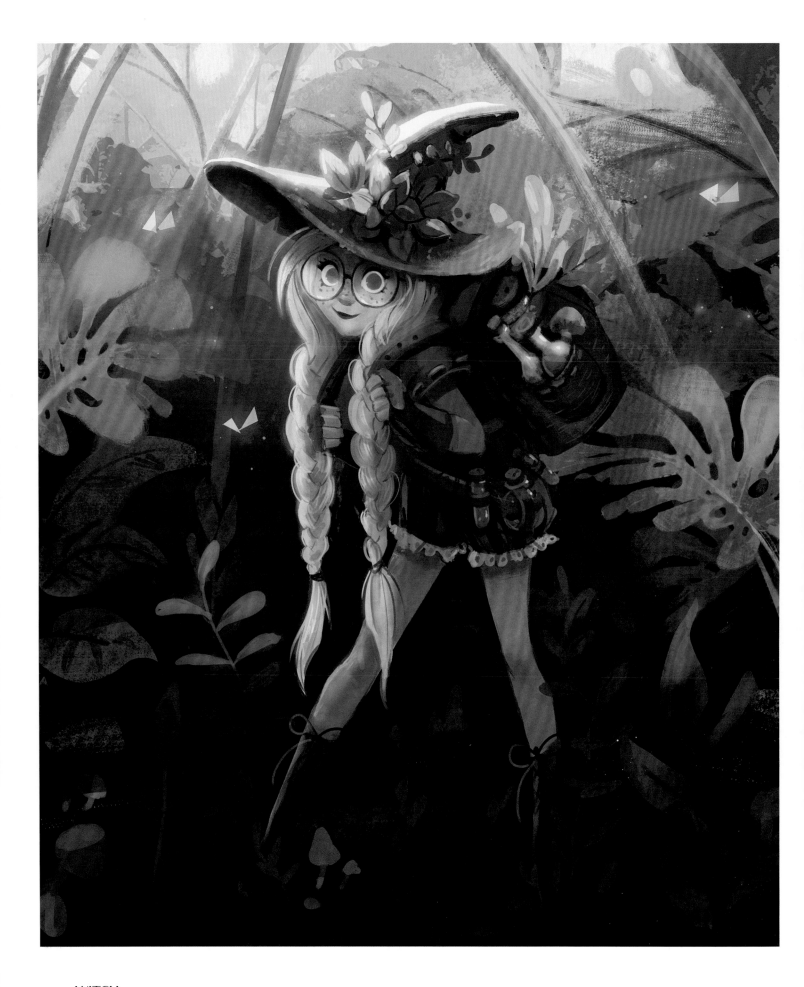

WITCH

This is a painting based on an Inktober sketch. "She's a wandering witch who collects potions and herbs," says Julia. "She's a vagabond and sells her potions."

JULIA BLATTMAN

When Julia Blattman was a child, she was obsessed with the sea. Her bedroom was ocean-themed, and she developed an enthusiasm for mermaids after seeing Disney's *The Little Mermaid*. By the age of five or six, she would put on performances of the film for her parents. "If they left during it, I would throw a fit," she recalls with laughter. Julia's interest in drawing started at the same time. She would stay up late, hiding under the covers with a light and filling her sketchbooks with mermaids using colored pencils. "I remember the adrenaline rush," she adds. "I wanted to draw them forever."

As she got older, Julia came to the realization that people made the animated movies she had grown up watching. She picked up some Disney animation books and saw her first glimpse into how the films were made.

Julia was inspired by the visual-development artists and made it her goal to work in animation. She started by taking a landscape painting course after classes let out in middle school. The teacher was a close friend of Bob Ross (famed for teaching painting on TV), and he helped to immerse Julia in the craft. She fell in love with oil painting and gained an understanding of how brushes worked and how colors interact with one another. She later attended the Academy of Art University in San Francisco as an illustration major.

When she began her college courses, Julia thought that producing "good art" meant being as realistic as possible. She struggled to show her work unless she felt it was perfect. At first, Julia worked primarily from reference photos and spent much of her time indoors. She was using the fundamentals and technical skills

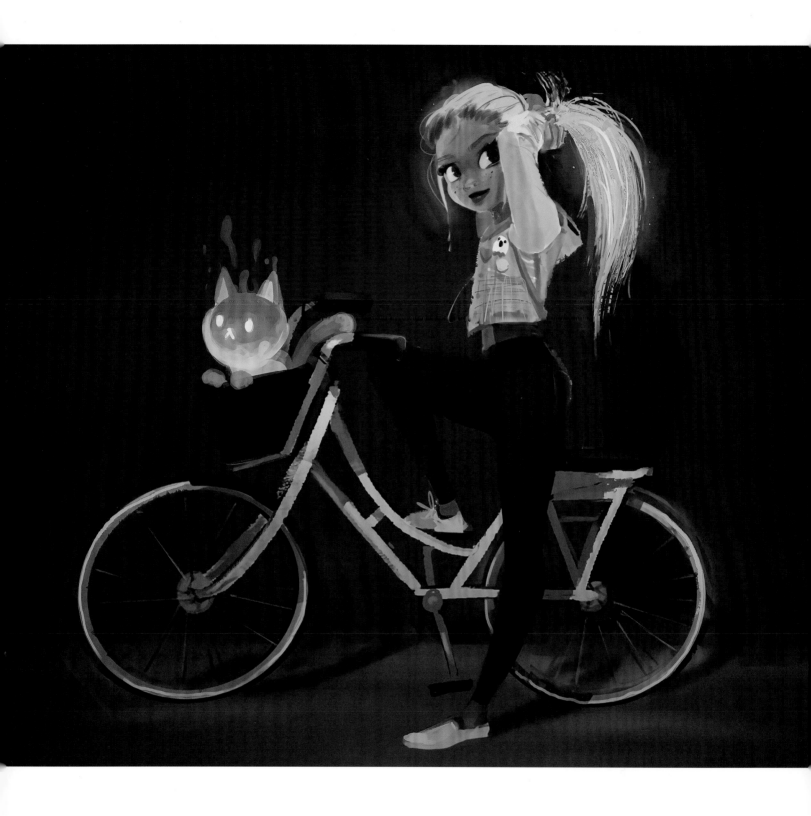

GHOST KITTY
What if there was a girl who had hair that glowed in the night? Posing this question to herself, Julia created this character design with her little cat friend.

that were being taught to her, yet Julia found her art becoming flat and dull and was unable to figure out why. She pursued a new approach and began to spend time with student friends sketching and painting around the city. Her focus shifted to plein-air painting and capturing moments of time. The transition was a struggle, but with time she noticed a major change. "I was so god-awful at it," she muses, "but I persisted. I would keep a giant sketchbook and blaze through the pages and not keep anything so precious. I did this mostly to understand how lighting works and how to compose a scene."

The majority of Julia's art is nature-based. "When you are outside, you see how shadow brings out the different colors and how light interacts through the trees," she explains. "Going outside and painting from life taught me a lot." Julia would set time limits for herself to prevent tight noodling and allow for looser pieces. "I would set thirty minutes to try to capture a moment. If it wasn't good, I would move on to the next piece. That made it so I was not so precious about everything, and it made me better at decision-making." When she decided to pursue a loose and impressionistic style, Julia began to have more fun with her work. This training continues to benefit her years later. Even now, Julia will go on walks and take a mental snapshot of a moment, then store it in her mind for future use. She has gained the ability to retain the mood of what a place made her feel like along with the general lighting of that place to infuse into her paintings later.

Julia's favorite medium to work in is gouache. She initially found it hard to mix colors and also expensive as she went through countless tubes of paint while experimenting. But she enjoys how you can treat gouache like watercolors yet build it up like acrylics and how it can blend like oil paints, making it a hybrid of the three mediums. Julia also likes how it brings forth brighter colors than when using oil paints alone. Working traditionally with gouache also gives Julia's eyes and mind a break from working digitally indoors during her day job. She also says this practice helps her digital works look more traditional.

After graduating from college in 2015, Julia fulfilled her dream of working in the animation industry. She started at Disney Interactive that same year, then worked at Paramount Pictures starting in 2018 and went to Netflix animation in 2020. She recently started a new role back at Paramount animation in 2021 as a visual-development artist. She helps to design worlds and what characters look like with an emphasis on environments. Julia also does lighting keys. "I'll get storyboards, and I have to come up with what it will look like onscreen," explains Julia. "I feel like color keys is what I really love to do. You can be loose with it, and quick with it. You can do a few of them in a day. I love studying movies and pulling inspiration from cinematography into my work." She also does prop design, such as a turn-around of something that a character is holding. Julia enjoys the challenge of having to turn an object in space, which she admits may seem tedious, but she likes how it helps with her draftsmanship. "It's really fun," she exclaims. "I go into work every day, and I don't know what to expect. It's exciting." The first movie she worked on was *Rumble*, scheduled for release by Paramount in early 2022. Afterward, she hopped on to *The Tiger's Apprentice*, which is due from Paramount in 2023. Then she moved over to Netflix and worked on *My Dad the Bounty Hunter*. Now she is working on an unannounced project at Paramount.

Outside of animation, Julia has done some children's book covers. Flashlight Press contacted her about illustrating *The Mess That We Made* by Michelle Lord, published in 2020. Its focus is on the ocean and the environmental impact of plastics and other trash in the water. This is an important cause to Julia, as she wants to limit her carbon footprint in the world. "I thought this was a good opportunity to have art have meaning outside of just being beautiful," says Julia. "Reaching out to kids and trying to make a small difference in the world is nice. I haven't had that opportunity before because I'm always working for large companies. A lot of times my work doesn't even come out, since a lot of projects are just shelved. So it was nice to have something actually out there. It was a really cool experience."

Julia still has extremely vivid and colorful dreams, like the childhood mermaid dreams that led her into the world of animation. When you talk with her, Julia will tell you the story behind every personal work she has made. She will share the mood and feeling of every moment that went into each plein-air brushstroke. And we are the lucky recipients who get to feel every happy emotion that went into her works as we marvel at her visions of light and color. The best way to describe Julia's art is that "it makes you feel good just to look at it." Not bad coming from a kid who simply wanted to draw forever.

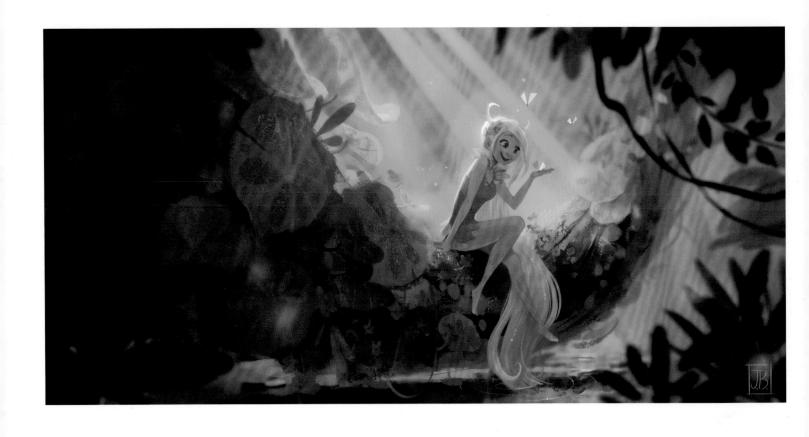

FOREST PRINCESS

This was a school project featuring a character who has a lava-boy love interest. He came from a volcano, and they made this island together but are also at war with each other. It was inspired by Disney's *Fantasia 2000*. This painting was made to capture the personality of the forest princess.

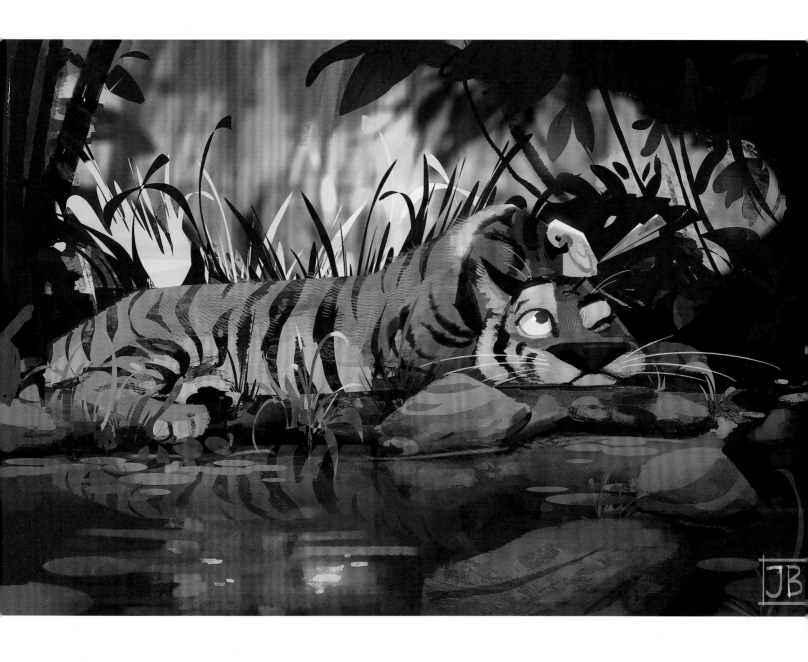

TIGER
Julia made this piece as an experiment with sharp edges and water effects while utilizing the lasso tool
in Photoshop.

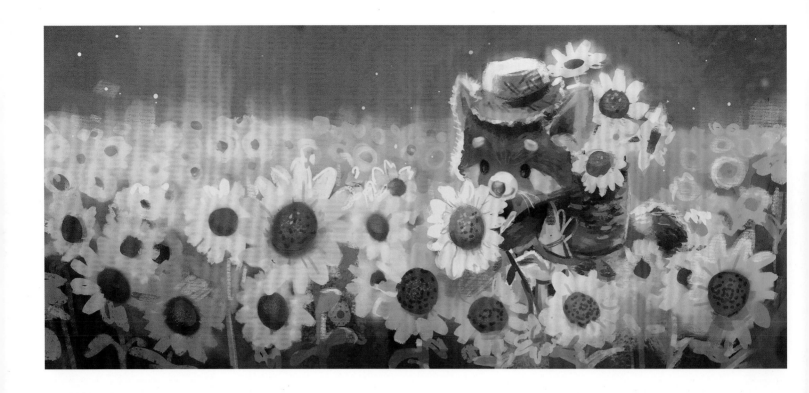

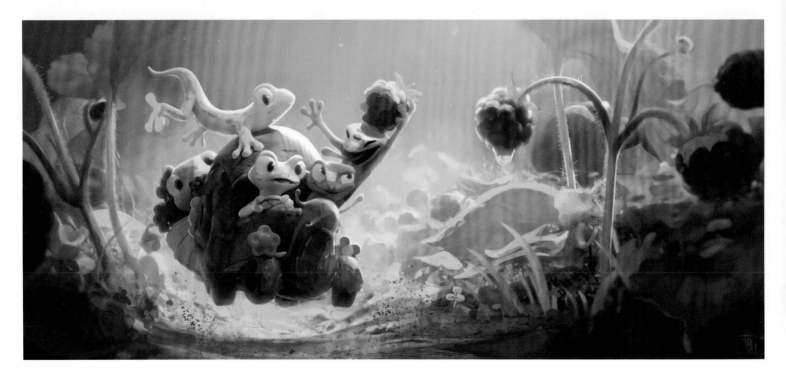

top
SUNFLOWERS

This is one of Julia's characters. "He's a little raccoon who owns a plant shop," she shares. "He has a little truck, and he travels around towns and sells his flowers and picks them all himself. This is him in his sunflower field, picking the flowers."

bottom
GECKO CAR

I came up with the idea for this piece while doodling on Post-it notes. Sometimes that's a great way for me to spitfire ideas without keeping anything too precious. I thought to myself, "What if a group of geckos were raspberry collectors for their town? What if they used a snail car that they had crafted to get around as a gang?" My goal here was to create a story moment as if it were a screen shot from an animated short.

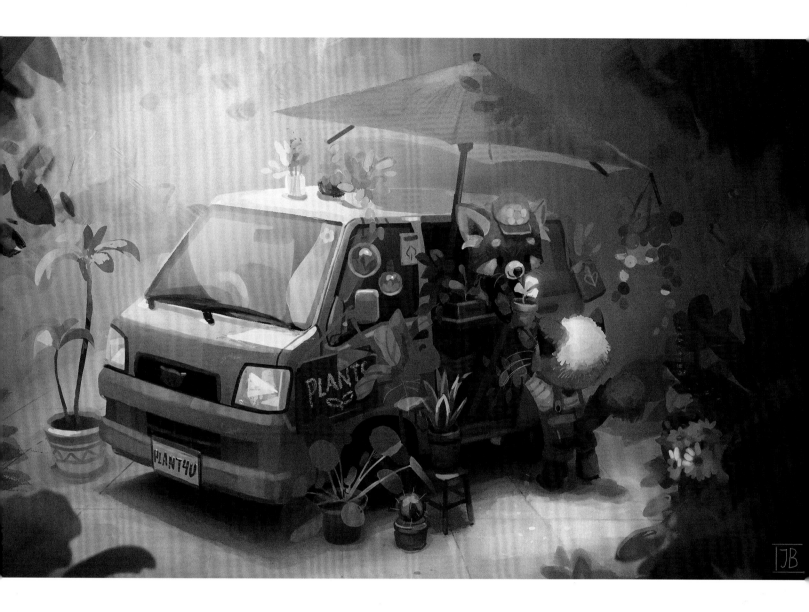

PLANT CAR

"When I was in Japan, there were so many cool cars," notes Julia. "All of the cars are so compact. I fell in love with them. There was this one truck that was a coffee stand and had an umbrella just like this. I took a photo of that truck and drew this when I got back to the States. I wanted to do studies from my trip, but I didn't want to do just exactly what I was seeing."

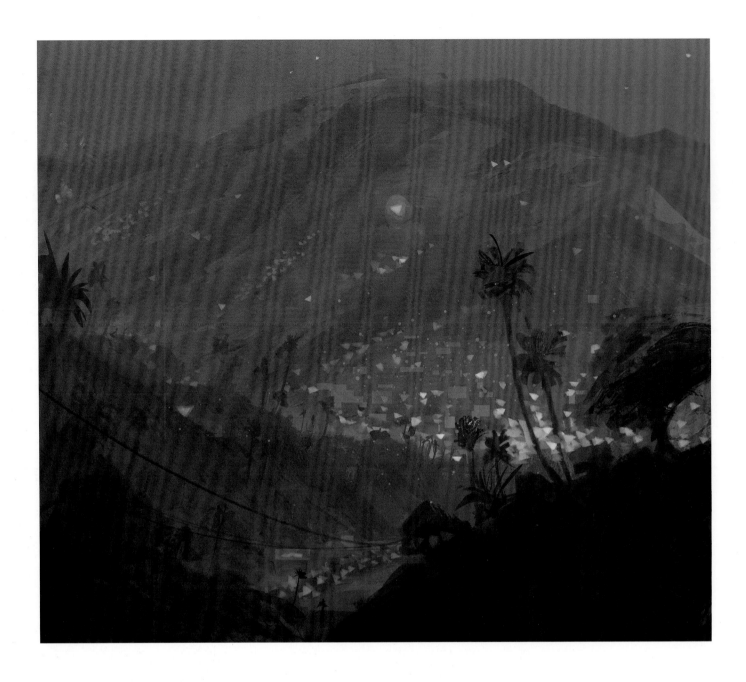

above
DUSK STUDY

One evening during a drive over a bridge in Glendale, California, Julia was enamored by the city lights. "The lighting was so pretty," she recalls. "I liked how the sunset turned to dawn and how everything was blue and purple. The distant lights in the city were twinkling, and I wanted to capture that with an abstract look. My favorite part of day is just when the sun goes down and there's thirty minutes of dusk. There are some magical colors that happen and in the way light interacts with the buildings. Also, we have so much pollution that it creates pretty cool lighting effects." This piece was painted upon her return home using a mental snapshot.

right
PINK SUNSET

"I based this on a photo that I found online and mixed it with the sunsets that I've seen in person," explains Julia. "I used to go skating a lot in the Venice Beach area, and the sunsets would be so beautiful and orange and pink. There's so much atmosphere from the mist of the ocean, and this is what I like about the mood of this piece."

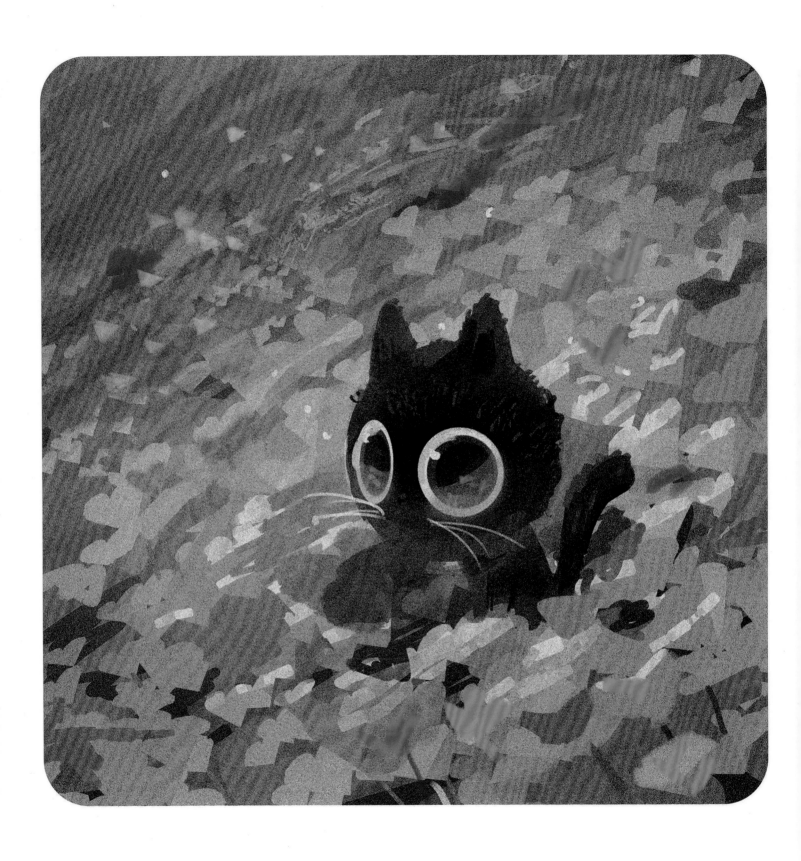

KITTY POPPIES

A few years ago, Julia visited a poppy reserve in California. She went plein-air painting there, and this piece was born from the experience.

SPRING

Julia likes to combine nature with characters and infuse them together. She views this character as the
spirit who brought spring to the earth.

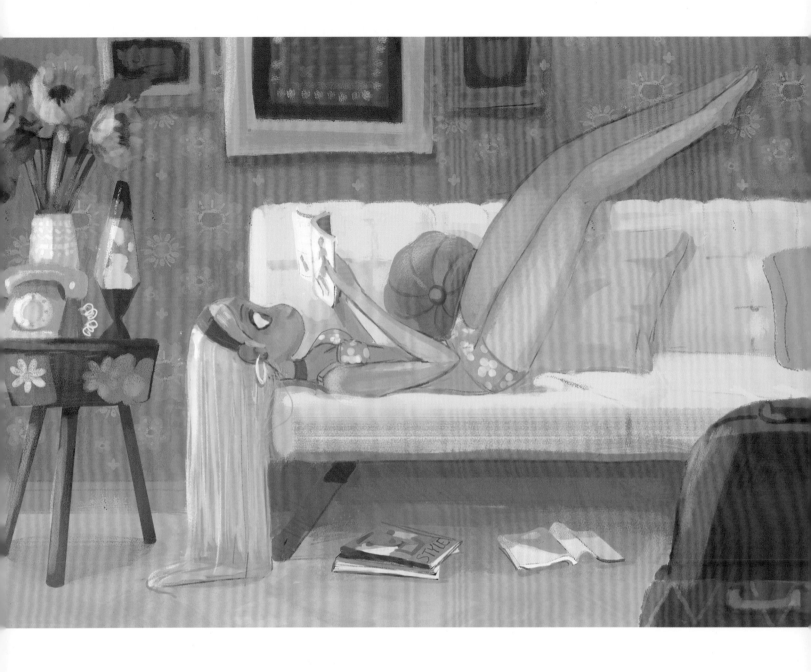

above
READING
"I'm really inspired by the Sixties," says Julia. "I love everything mid-century modern. This was inspired by some photos that my mom showed me of her bedroom. Everything was yellow and had flowers on it. Headbands were really in. I want to do more pieces that explore that time period."

right
SUMMERTIME
This is a personal character study that is loosely based on a photo. Julia does not strictly adhere to a reference photo but instead uses it as a jumping point. For instance, she changed the time of day and what the character was wearing for this painting.

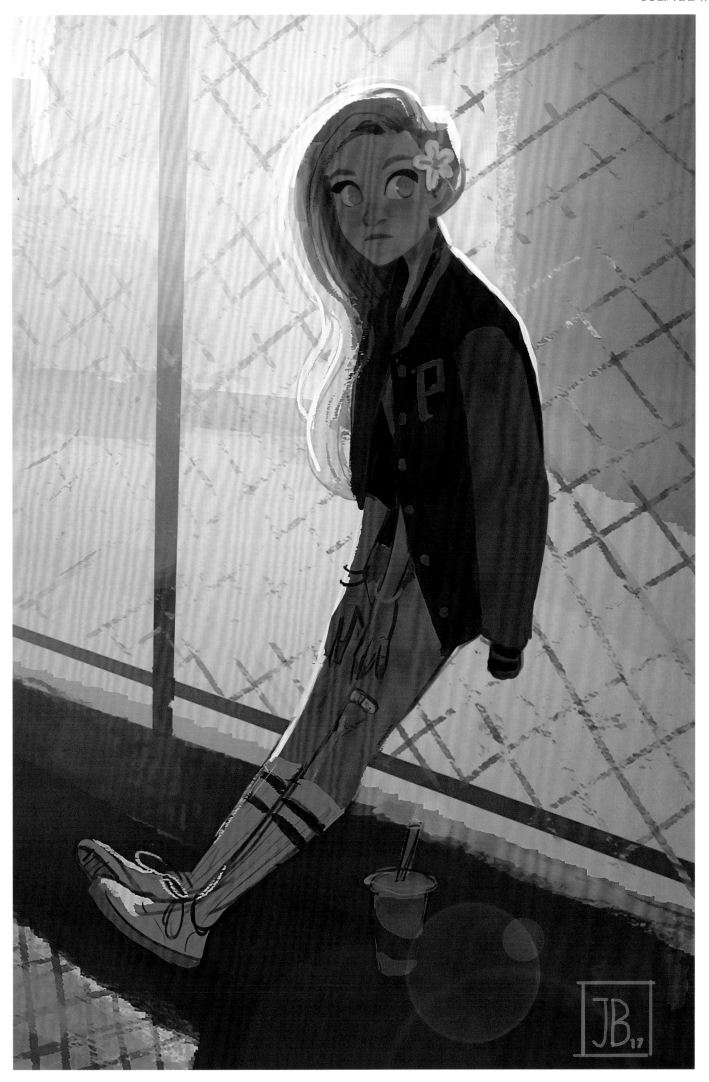

above

SPRING BREAK

"I wanted to capture how summer feels with your best friends and what joy and fun feels like," shares Julia. She didn't have much reference for this painting. She very loosely based it on the 2012 film *Spring Breakers*, which had inspirational compositions.

right

SILVER LAKE

Julia takes a lot of reference pictures while she is out on walks. This piece is inspired by a view in the Silver Lake neighborhood of east central Los Angeles. "Up in the hills can be pretty interesting," she observes. "It reminds me a lot of San Francisco with how stacked all of the houses are and how windy the streets are."

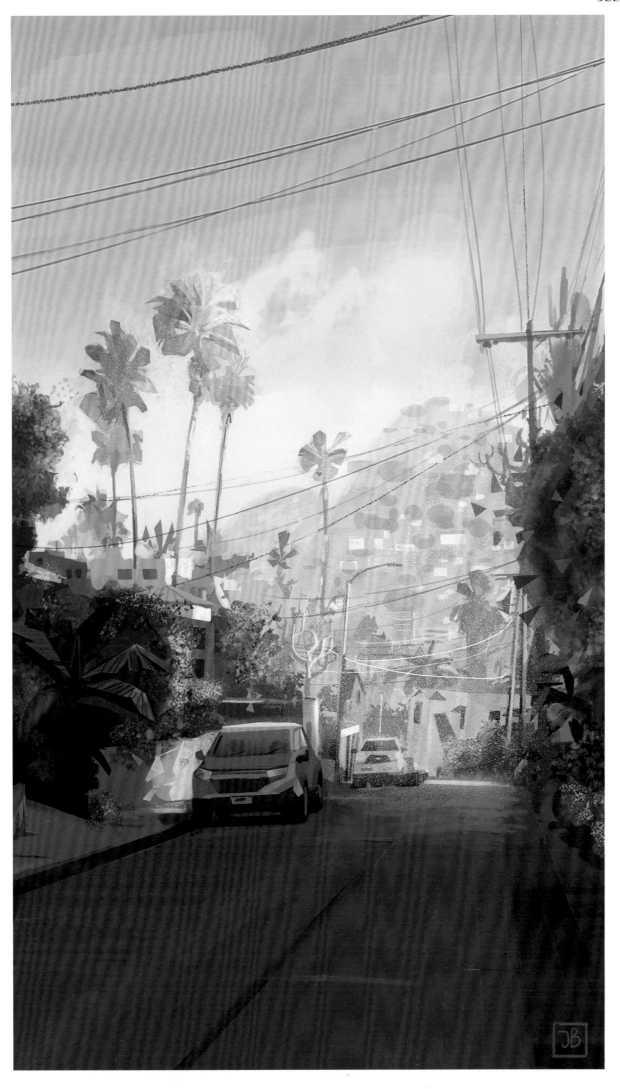

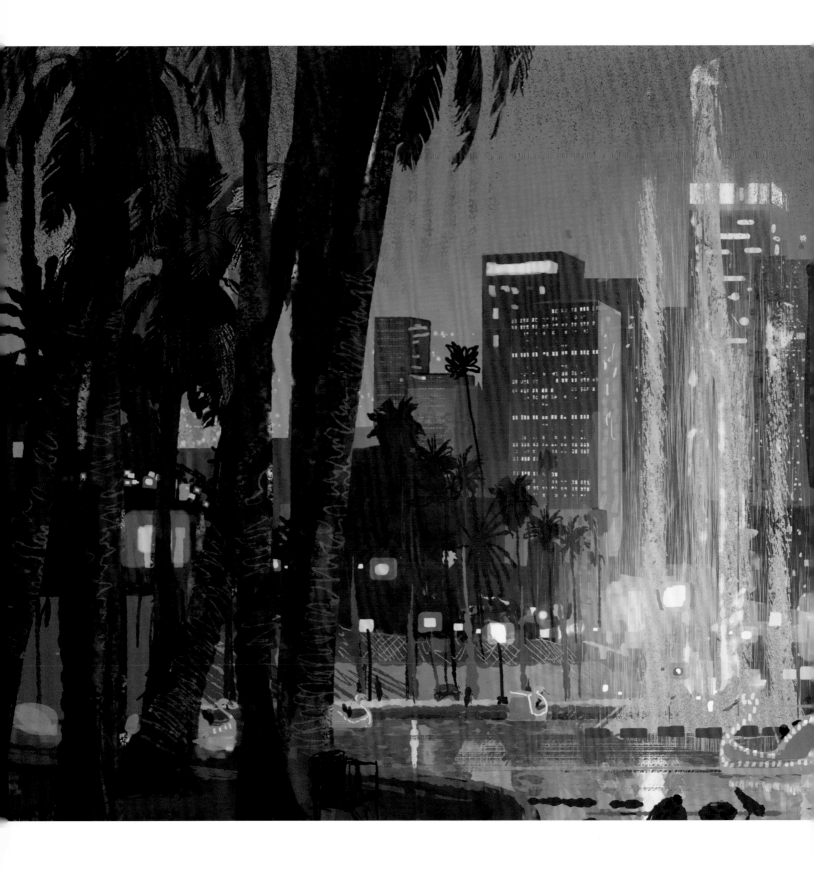

ECHO PARK

There is so much beauty in Los Angeles. I fell in love with the city while living here for the past five years. Each area of Los Angeles has such a unique color palette and look to it. When I moved to Echo Park, I started to enjoy night walks around the lake and seeing the candy-like colors of the city in the distance, reflected on the water where the swan boats were drifting along.

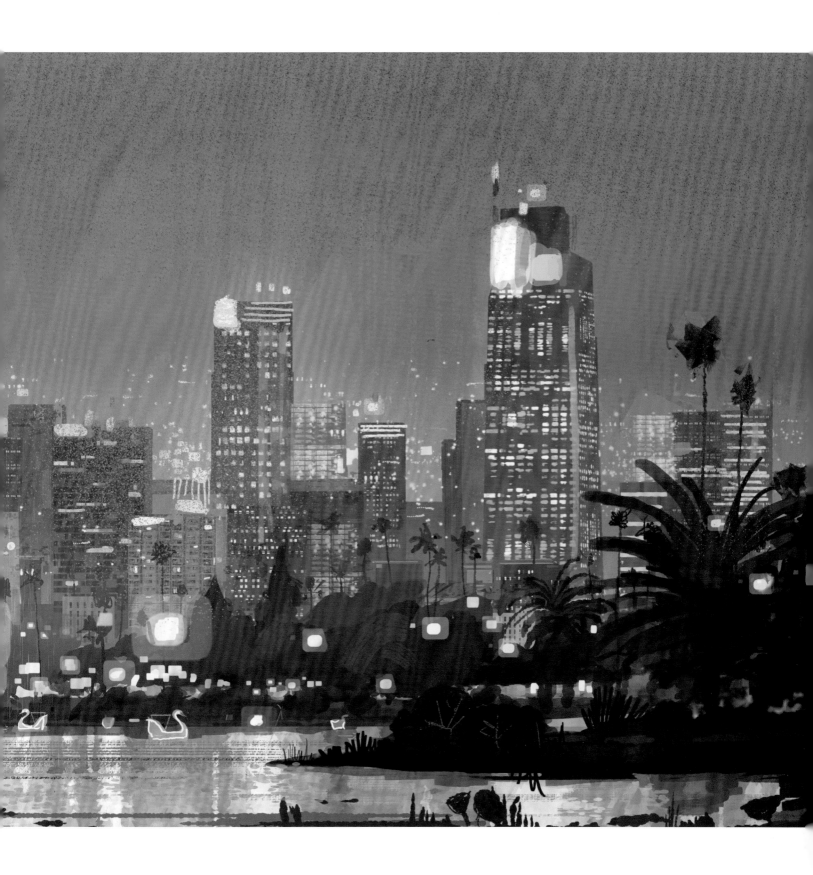

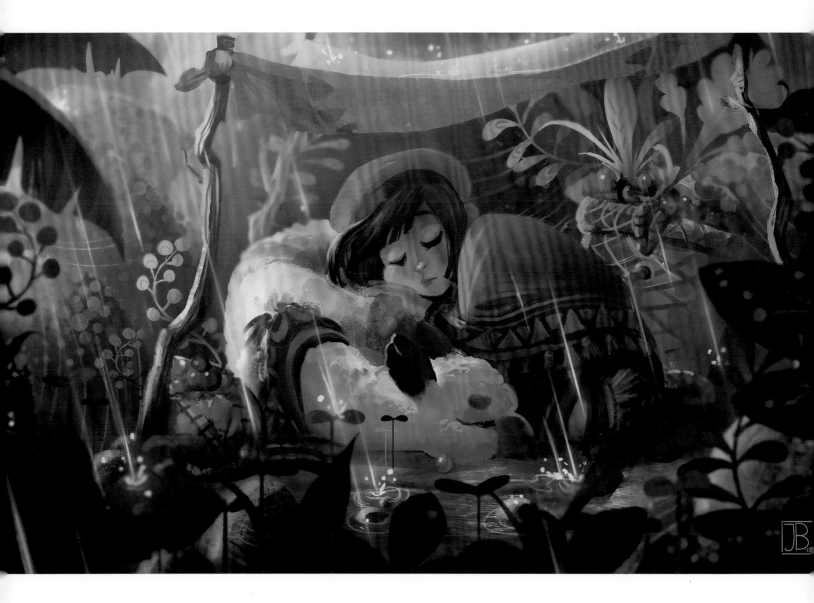

above
RAIN

This is Julia's own take on *Little Red Riding Hood*. It's about a girl who has an adventure with her alpaca while trying to find her grandmother. She never got too far into the story but did make a few sample shots, including this one. Many of her personal pieces are snippets from short films that she sees in her head. She creates key shots of the story to explore how it would look. This is the type of painting that she would show an executive at an animation company to pitch a story.

right
SUNSHINE

"I wanted to play around with lighting and exposure," says Julia. "I wanted to have the viewers feel the warmth on the woman's skin as they are looking at this."

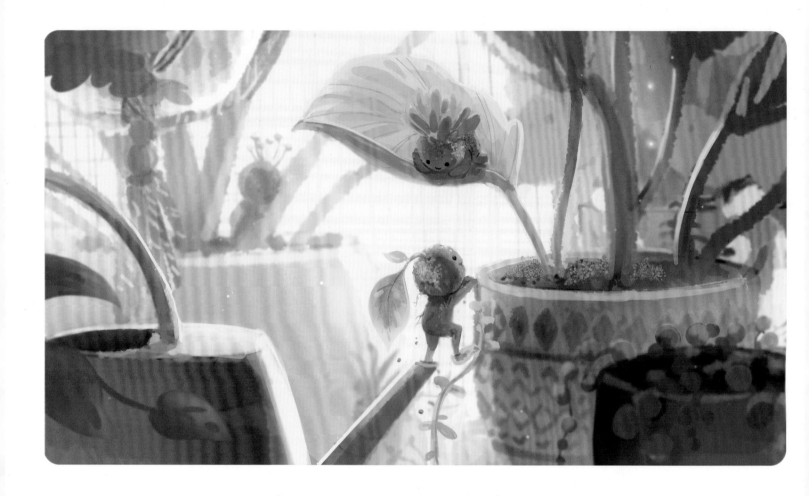

PLANT DUDES

Julia did this in 2020 during the pandemic. She noticed that her plants were changing a lot during the evenings and into the mornings. She observed that the plants changed positions, and she even could have sworn that a pot moved on its own. "What if there were these little spirits who messed with your plants, watered and moved them around overnight?" she mused. "And what if they worked together to get food from your kitchen at night?" This painting was born out of these questions.

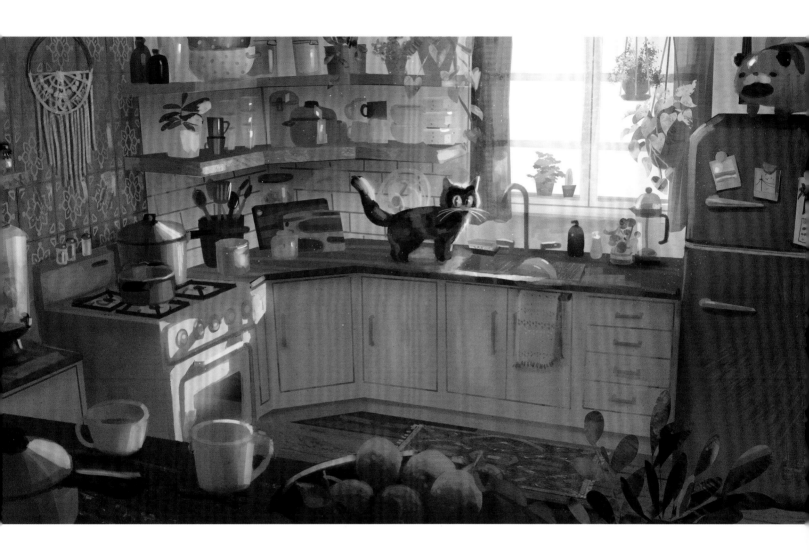

KITCHEN

This is Julia practicing set designing. She likes to tell a story about a character's life through objects. She asks questions, such as: "Are they messy? How organized are they?" It is a snippet of people's life to show their personality without showing them.

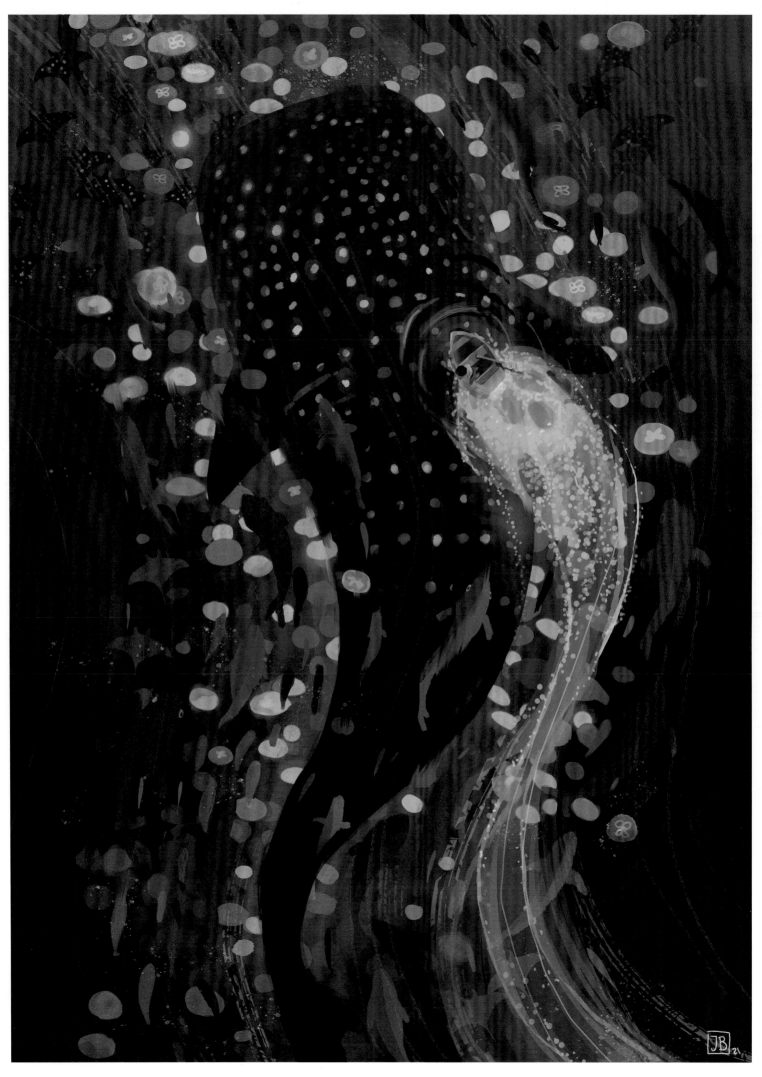

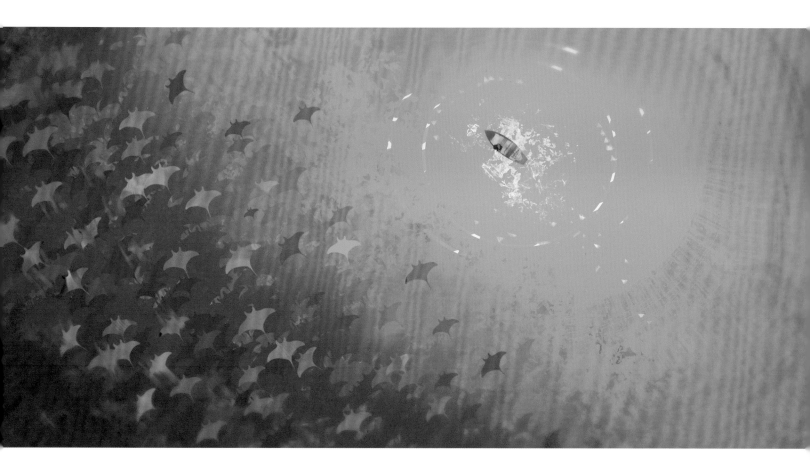

above
RAYS

"I was inspired by the repetition of patterns in nature and by my trip to the Bahamas," says Julia, "seeing tons of manta rays there in the crystal-blue water."

left
WONDERS DOWN BELOW

When I would scuba dive, I was always blown away by how many creatures are in perfect harmony together. It has always been a dream of mine to dive with whale sharks! I've always been fascinated seeing how many fish accompany whale sharks while they swim. For this painting, I wanted to capture the fluidity and flow of the ocean and the creatures below the surface.

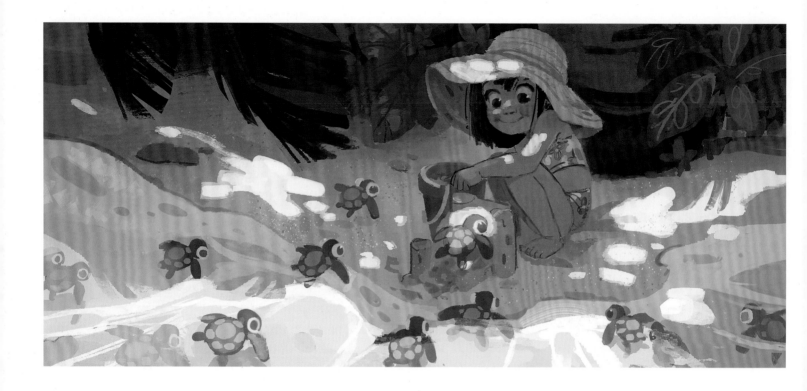

above
TURTLES

This represents another short story that Julia had in her head. "I was playing around with the coolness of the shadows and the warmth of the sand and that kind of contrast," she explains. "Also, I like having repetitive patterns in my work, so for this one it's a bunch of turtles."

right
WARRIOR MERMAID

This warrior mermaid is facing a fierce monster—a deep-sea angler fish. With determination in her fearless eyes, she goes up against the creature with her spear to defend her palace.

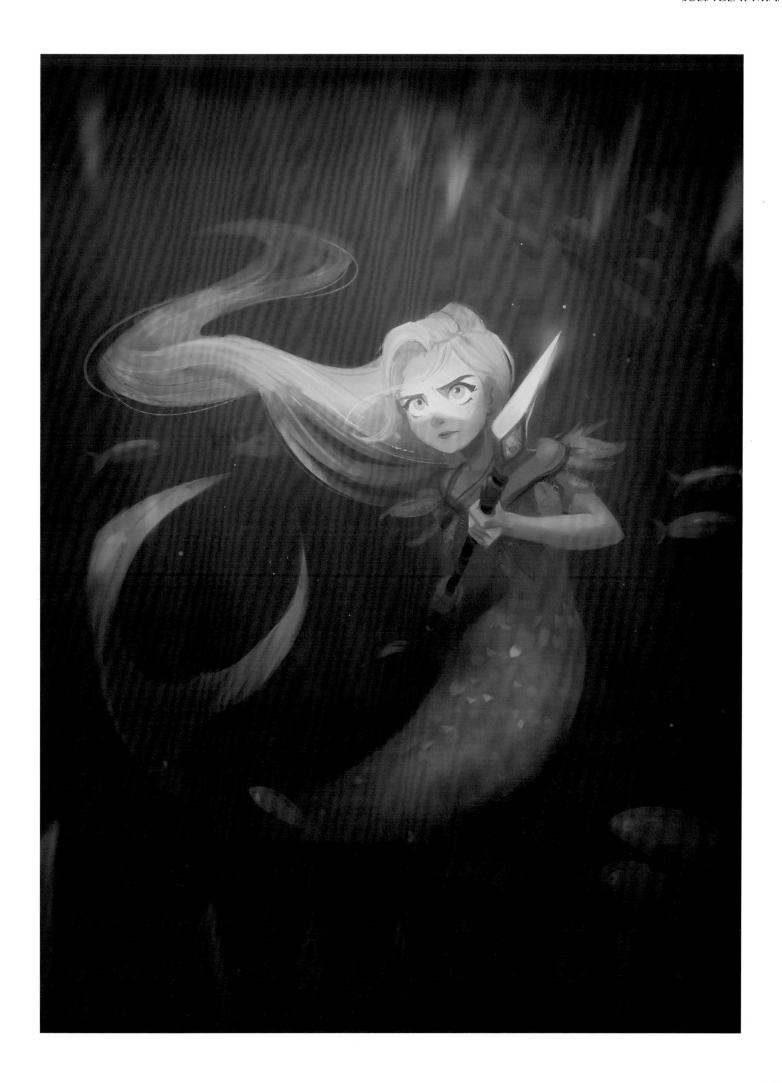

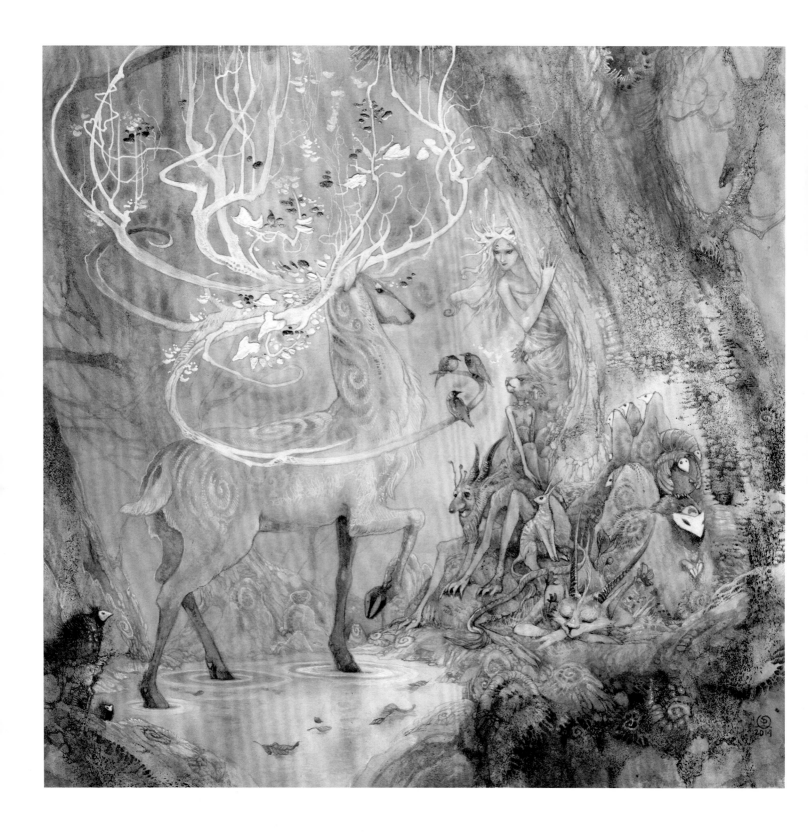

SCHERZANDO

This is part of a series called the "Stag Sonata Cycle." Stephanie wanted to play with the idea of using a musical motif for the mood in every piece in the series. She also wanted to feature a stag interacting in an enchanted world in each painting. This piece was meant to represent playfulness and curiosity.

STEPHANIE LAW

The artworks of Stephanie Law appear to harness ancient artistic traditions from the most-revered fantastical cultures. There is a radiance to her pieces that infuses tranquility within the viewer's mind. She has an uncanny ability to harmonize disparate shapes and swatches of color to depict the dreams that we want to live in. Her road to becoming an artist was an unusual one, but in retrospect Stephanie can see how the long, winding path benefited her unique approach to painting.

Many of the subjects and themes found in Stephanie's imagery were directly influenced by the stories that spoke to her during her childhood. When she was growing up in the Eighties, fantasy books for young adults were not as prevalent as they are today. She loved reading stories from this genre but found

it challenging to find books that met her interests at the local library. "I remember going through all of the young-adult sections in the library trying to find books of interest, but they just weren't there," says Stephanie. "I remember turning around, and there was this Mythology bookshelf. I started diving into those, discovering world mythology, folklore, and fairytales, and it was the thing that I locked onto."

The stories within these books made an impression on her. The fairytales introduced Stephanie to the lore of various world cultures—especially that of her own Chinese background. Until that time, she had heard only hints of classic stories from her mom and grandmother. The lore was more ingrained into her family life rather than verbally expressed. A good example of this is the Moon Festival and the references

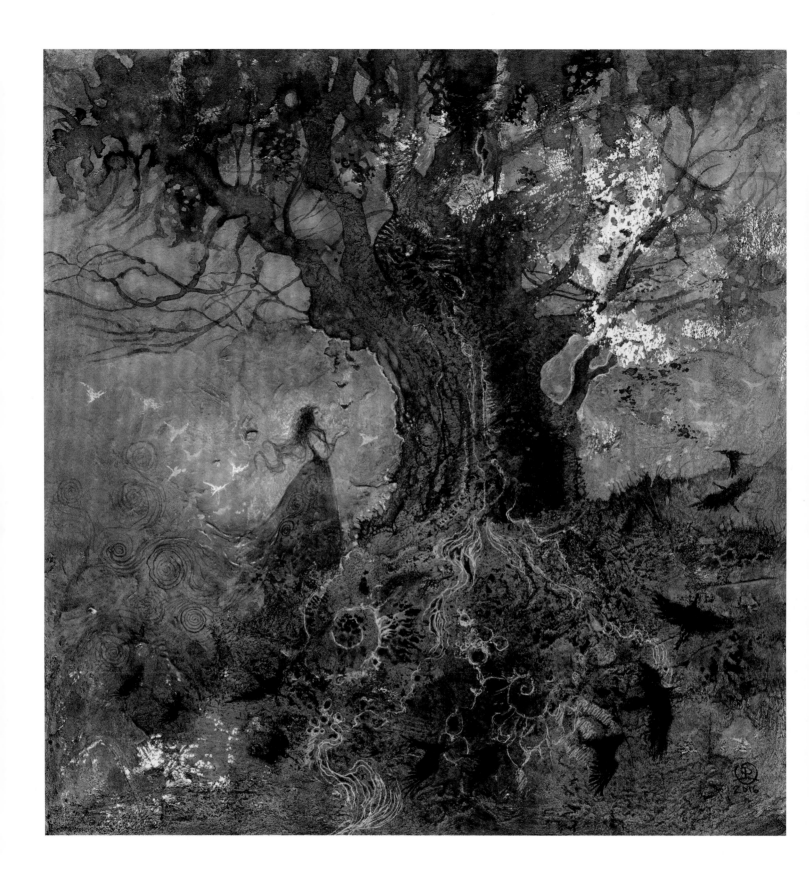

CYCLES

This was one of Stephanie's more-impromptu pieces. She will sometimes create abstract base paintings by using physically textural materials. For this piece, she used gold leaf, ink, watercolor and thick buildup of gesso. When looking for inspiration, she will pull one of these base paintings out and see what she can discover and create from the random textures. "I like to throw paint onto a page and see what emerges from there," Stephanie explains.

that she heard about "The Lady of the Moon." These magical elements floated on the edge of her consciousness and made Stephanie curious to learn more. During her college years at the University of California at Berkeley, she explored the used bookstores around the campus, in the city and in San Francisco. She absorbed the details and rich history as she pored through the Mythology sections. Many of the story elements she discovered at that time ultimately became a regular theme in her paintings.

Stephanie did not go to college to study art, however. "Art had always been perceived for me as not being a viable career," she notes. "It was going to be a hobby because everyone was telling me, 'Don't!' Career advisors, family...everyone just said that it wasn't a good idea to pursue art. They would say, 'Do something sensible.' So, I went to Berkeley for computer science." But because she wanted to continue to make art—even if it was just going to be a hobby and not a career—she ended up taking numerous art classes and double-majoring in art.

While the computer-science program was excellent at the school, the art classes offered there didn't fall within Stephanie's area of interest. "A lot of the professors had been active in the fine art communities in the Sixties," she explains. "The mentality and the kind of art that they appreciated was based in that aesthetic. There was a lot of abstract expressionism and not very much acceptance outside of that sphere." On her own, however, Stephanie created fantasy illustrations while using *Dungeons & Dragons* books, fantasy book covers and magazines as inspiration. "That was what I enjoyed doing by myself on the side," she recalls. "In the meantime, in class I'm hurling paint at the walls and dropping sandbags out of windows and stringing up installations across fish ponds. That was the kind of work I was doing there, which was the complete opposite end of what I personally wanted to do. But, in a way, it helped to broaden my idea of what kind of aesthetic appeals to me."

Unable to focus on what she wanted to do, Stephanie was not happy. "Beauty is something that I want to integrate into what I create and what I do," says explains. "It was a struggle for me to navigate the classroom environment and try to find beauty within what I perceived as ugliness." She viewed abstract art as chaotic but eventually learned how to discover the beauty within the field by finding her own way around the structure of the teachings. Instead of being bored

and dismissing the classes in abstract expressionism as not being of interest, she opened her mind and took valuable skills and lessons from the experience. Later, she realized how essential her training at Berkeley was for discovering her own style and focus.

Outside of the classroom, Stephanie focused on digital art for a time. The precise and technical nature of the early Photoshop program ultimately pushed her back toward traditional methods. "It took me a while after leaving the academic atmosphere to really understand what I got out of the skill sets I had built subconsciously," she says. "I started to work with watercolor and realized this is what I had missed. I missed this physical element to my art and the random textures that you can create with watercolor. Slowly, over time, the work that I had done within the academic sphere was filtering into how I was creating my art, where I found joy and what appealed to me visually. From there, it was just finding myself and doing art on my own."

Stephanie went on to work in software-programming for three years after graduation. Just before the dot-com bust hit in 2001, however, she decided to go full-time into art and has been doing it ever since. Her experience in the computer field gave her the knowledge and experience to build her own art website and shopping-cart system. She foresaw the Internet as a means to showcase her works and make online sales. This was before companies like Etsy or Shopify were launched in the mid-2000s and streamlined the online process for creative individuals. "Having that leg up was really crucial for my career," says Stephanie. "I don't regret my computer-science studies, even though I don't do a lot of programming anymore. I still manage my website, and it's all customized and written from scratch."

Stephanie continued to explore on her own and took an interest in botanical art. "I was enjoying that close, detailed dive into looking at botanical elements," she explains. "Botanical painting makes you focus and look at very small, specific, ultra-detailed parts of plants in the natural world. I like how that complemented some of the rough and unstructured, textural process-oriented painting that I was doing. The two of them combine—the completely randomized and the ultra-detailed—and where they meet is where I create." These opposing worlds balance one another and are ingrained in her paintings.

Another form of inspiration comes from her daughter. Stephanie admits that, as an adult, she

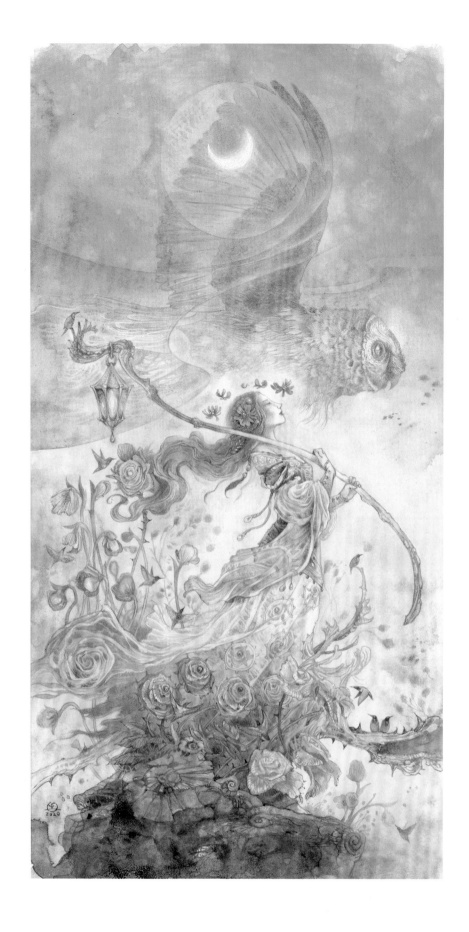

above
SUMMER

"Summer" is one of the four pieces in a series representing the seasons, and it features Blodeuwedd, a Welsh goddess also known as "Flower Face." Stephanie wanted to symbolize each season based on different shape-changer mythologies. For this piece, she decided to use the Welsh mythology where Blodeuwedd was transformed into an owl.

right
AGAINST THE FLOW

sometimes takes for granted the things she observes. Her daughter helps her to see them with new eyes. Through the process of answering her daughters' questions, Stephanie gains new insight while pausing and reinspecting her thoughts and ideas. "There are some things when you have kids where you have to speed up your life," she says, "but other aspects where you really have to slow down because they are curious about *everything* around them. They want to know about everything. They want to spend forever looking at a pillbug. I could be bored, or I could also get involved in really looking at a pillbug. The same with all of the plants and other things that are all around us."

The result has been the opening of Stephanie's mind to the smallest details found in nature, all of which has benefited her art. She has learned to find the beauty in all things—especially from things that often are overlooked or dismissed. These lessons have been imperative as she looks at the figurative boundaries between fantastical worlds and reality, then pulls from the visual contrasts between the randomized and the highly detailed aesthetics. It's where these elements meet and mesh that makes Stephanie's art so unique and moving. Along with the natural elements that are prevalent within her paintings, you will find a lot of creatures that add a mythological weight. The magpies, foxes, stags and other animals are often used for the aesthetics they bring to a piece. The subjects reach all around the world to tap into the subconscious we all share.

In 2016 Stephanie discovered the concept of the "mind's eye," the ability to imagine or remember scenes. She realized that what she sees in *her* mind, which is simply black with blobby colors, is not how everyone sees things in their minds. "I don't see anything in my head," she explains. "If I concentrate really hard, once in a while I can see a flash of an image. It's not detailed.

I have a hard time recognizing people's faces. For a long time I thought that was a failing—that I was not paying attention. It turns out that not having a 'mind's eye' is a critical part of facial recognition. If I look away, I don't remember what you look like. There are a lot of artists who have it. When I close my eyes it's not completely black, but it's pretty close to that."

Because of this, Stephanie understands motion, words, concepts and ideas rather than visual memories. She talked with other artists and discovered that there are those who *can* actually see things in their heads. She realized that artists who are more "flowy," like herself, are probably the ones who see fewer visuals in their heads. "Until I can draw it on a page, it's not fixed," she says. "For me it's in motion constantly. It's a concept, it's a movement, it's a sense of flow. But until it's on the page, it is in flux. I've come to understand that this is why composition, movement and flow have always felt like a strength for me, and is an important aspect of my art. I can feel how a picture moves through my body when I'm painting, like a kind of dance, even when there are no figures in the piece." (Stephanie was a Flamenco dancer for over twenty years and currently skates to experience flow.) As she learned about her "mind's eye," she discovered how her need for movement in dance played an important role in being able to pull from the abstract and see a randomized texture to build upon to create its shape and form.

Stephanie has used the experiences from her life to build vivid imagery. The works that she shares are a coalescence of people and animals in scenes within nature that tell enchanting stories. These magical works capture folklore and dreams that inspire the viewer. Her pieces create an excitement for things that we often overlook or take for granted. Stephanie reminds us how much more there is to see when we pause and peer between the boundaries.

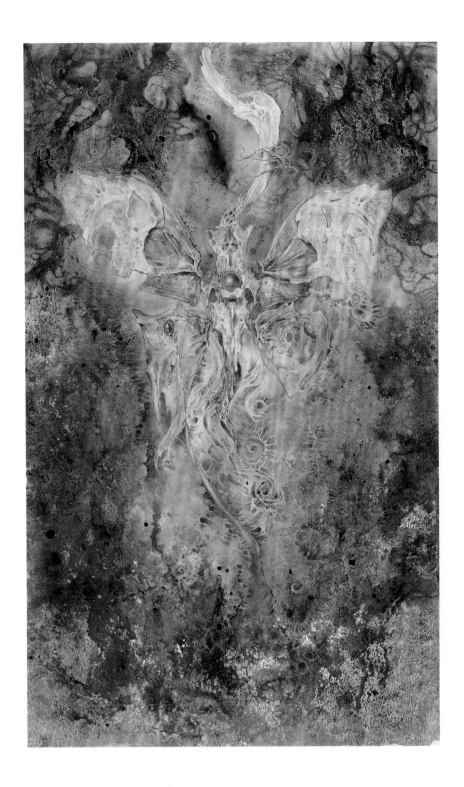

above
TRANSCENDENCE

This painting was part of a series of butterfly pieces that were included in Stephanie's solo show "Metamorph" at Krab Jab Studio in Seattle, Washington, in June 2017. To make this, she made a physical model in an assemblage she constructed using fish bones, pearls, clay and paint, and then created a painted rendition of it. "I loved making a juxtaposition of the bones of a creature of water with the form of a creature of air. They meld into a chimera creation," she says.

right
PRIVATE AUDIENCE

"This is a small piece, a tiny little one," says Stephanie. "It's mostly about the feeling of playing music for yourself and the pure enjoyment that you can have when you are just doing it without worrying about what the world thinks."

overleaf
TRANSFERENCE

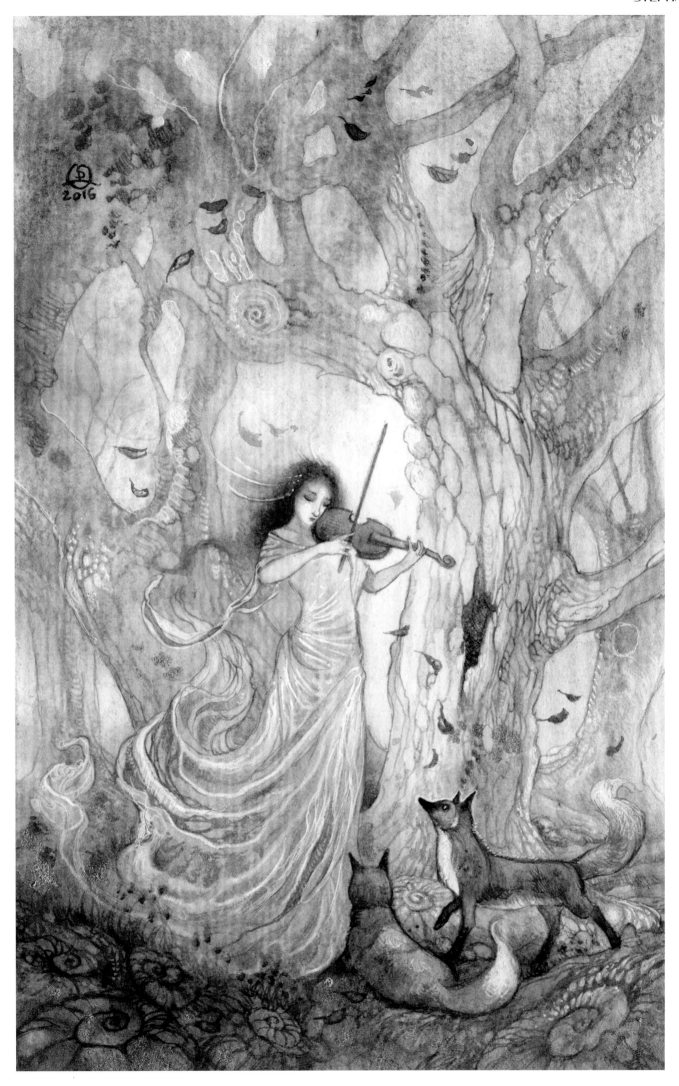

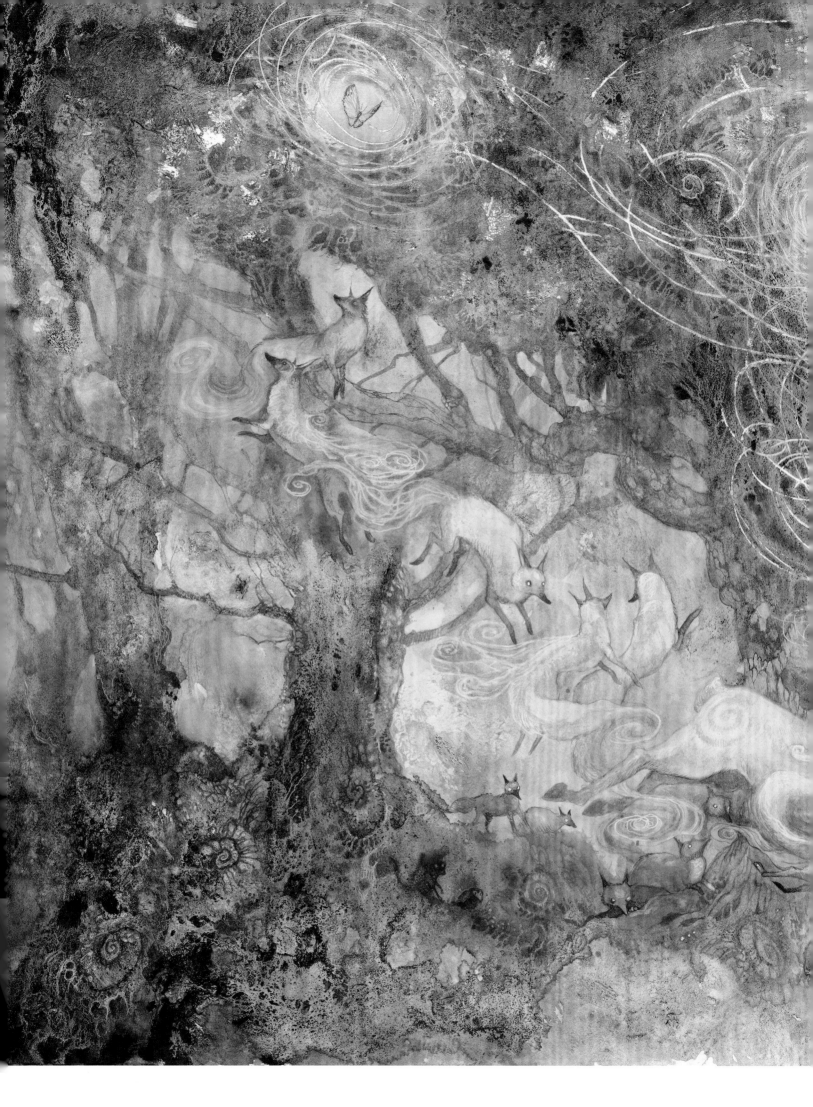

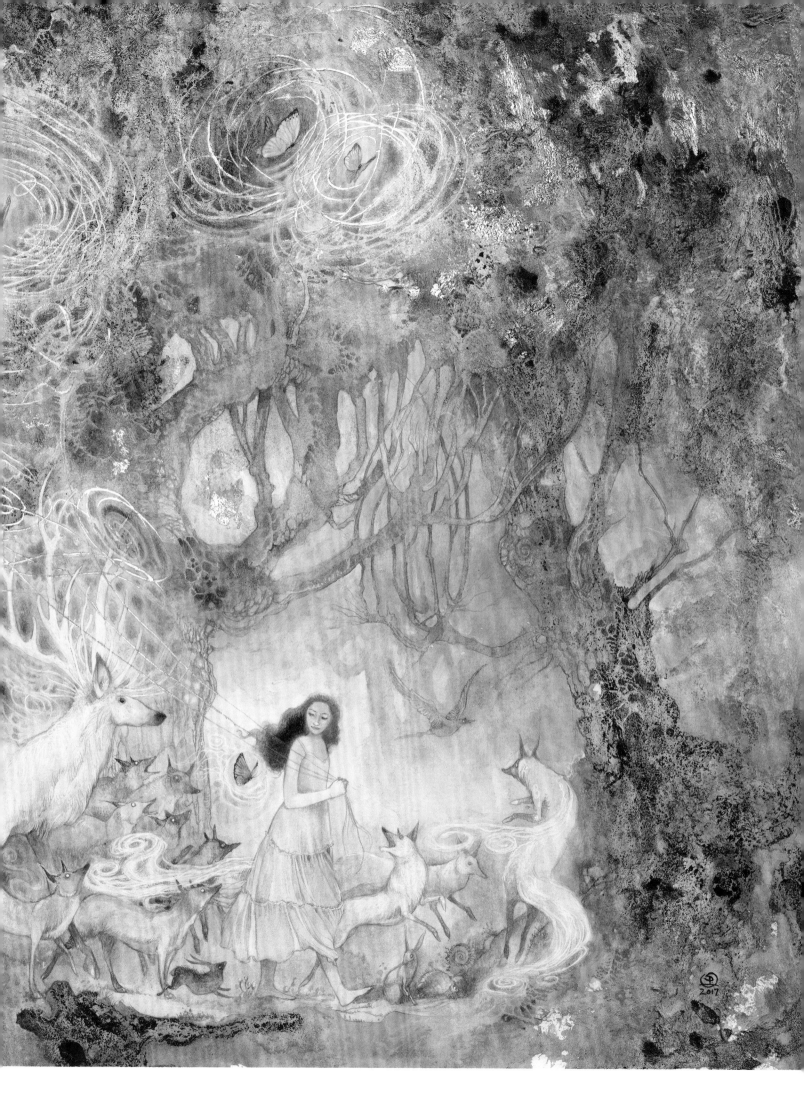

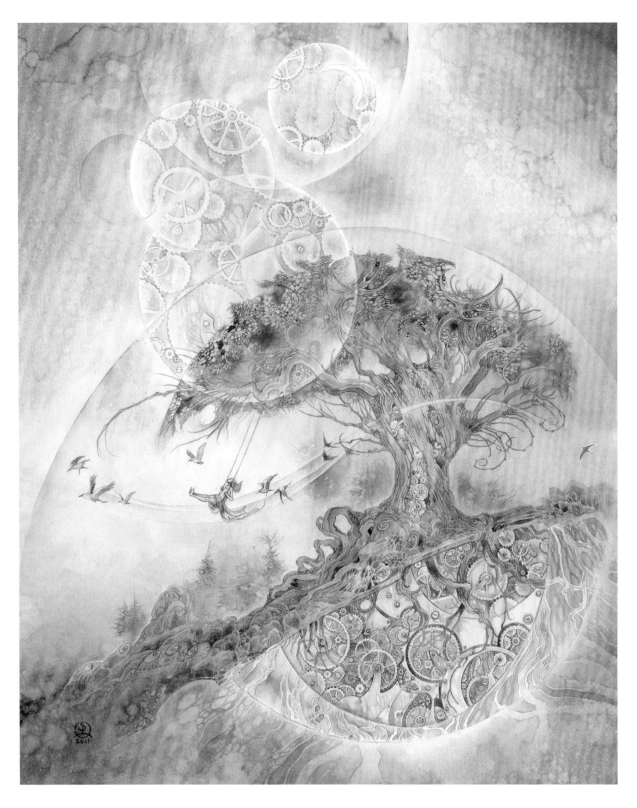

above
INNER WORKINGS

Stephanie's love and fascination for nature and life shines through in her work. She created this piece to represent how the intricate elements of the world fit together to create life, using a mix of nature and delicate clockwork pieces.

right
KLEODORA

Stephanie created this one for her solo exhibition "Immortal Ephemera" at Krab Jab Studio in Seattle in June 2015. Much of Stephanie's art is based upon the mythologies she found during her childhood and throughout her early life. This piece was part of a series that focused on insects and insect mythology, and it featured Kleodora, one of three Greek nymphs. All three—Daphnis, Melania and Kleodora—were revered as bee goddesses who, through bee priestesses, taught Apollo about prophecy and foretelling.

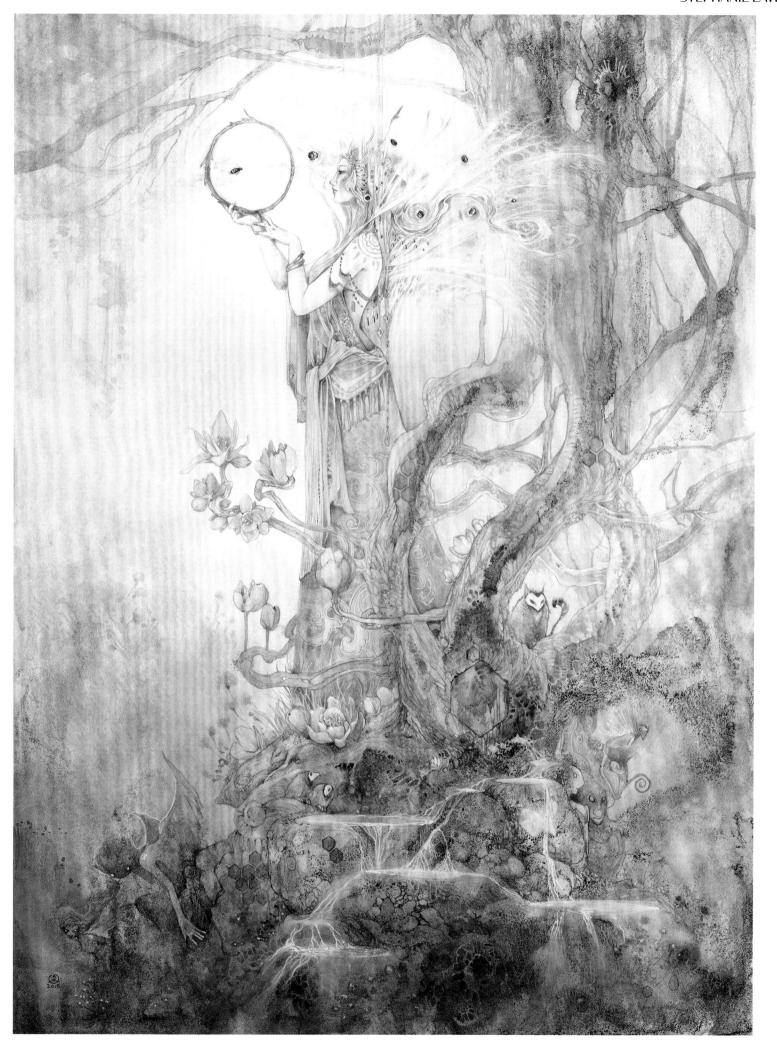

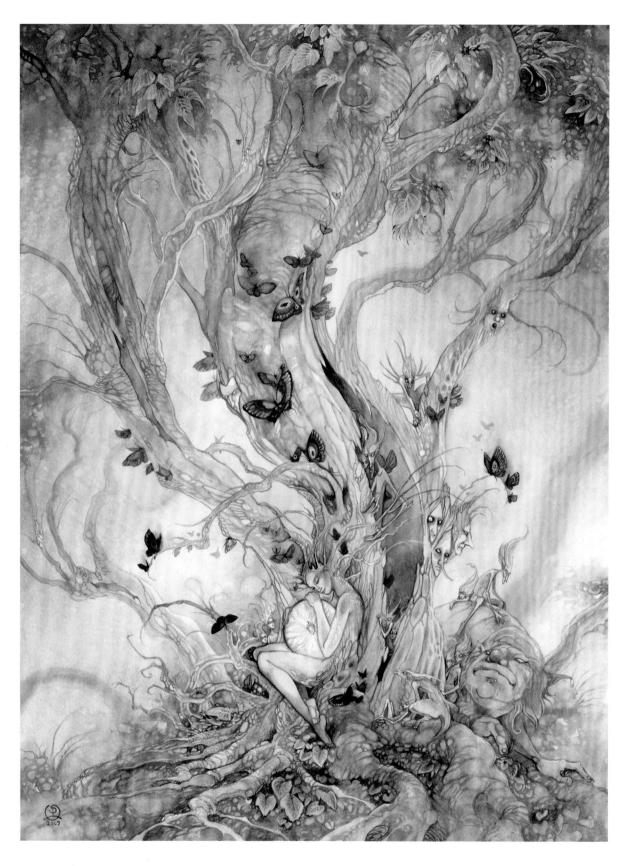

above
POTENTIAL

"This one was done when I was pregnant with my daughter," Stephanie explains. "She was just a little acorn inside of me. I was thinking about my baby and what that meant to me and his/her potential in the world."

right
WINTER

Like "Summer," this is part of the Seasons series. Stephanie borrowed from general Japanese mythologies about shape-changing cranes to create this piece.

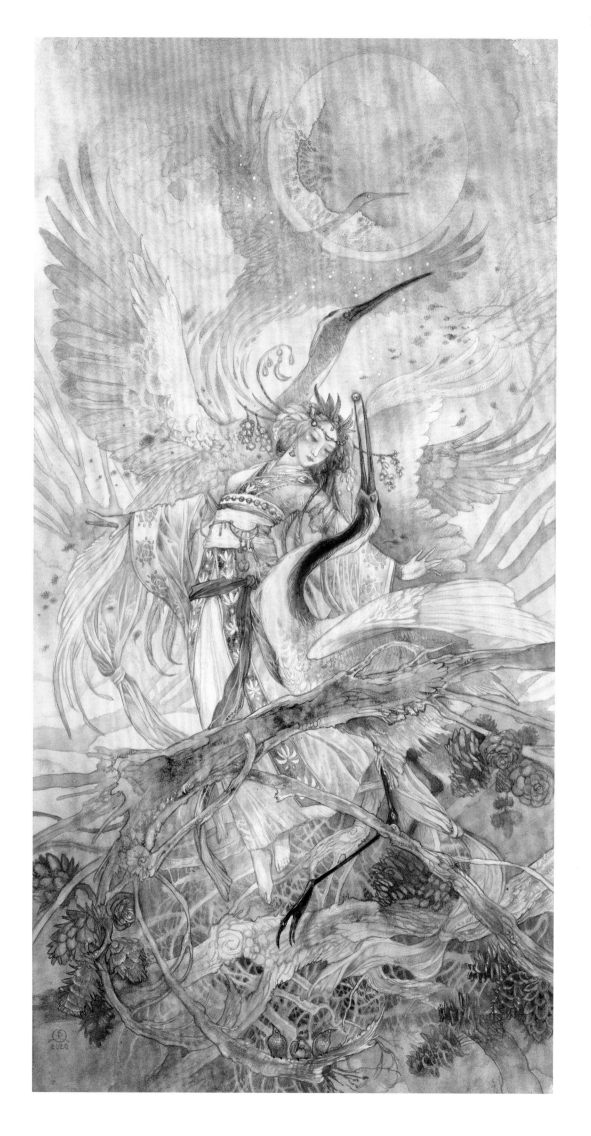

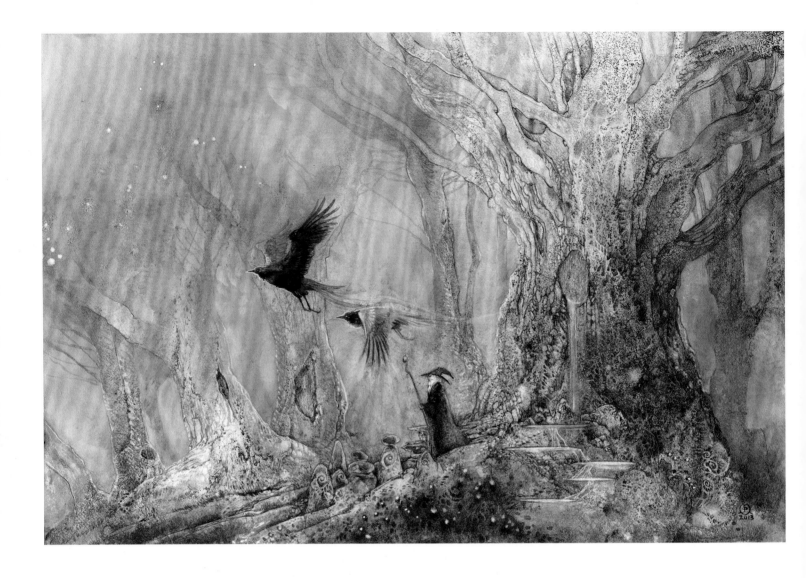

above
ODIN

This was one of the first pieces when Stephanie began to combine the chaotic and loose textural elements and influences from her college art experiences with her more tightly rendered watercolor techniques, and love of mythological sources for inspirations. "The backgrounds formed from texture and gold leaf, create a dreamlike atmosphere for this depiction of Norse god, Odin and his ravens, Huginn and Muninn," she explains.

right
HER GARDEN

Stephanie gets a lot of inspiration from her favorite childhood stories, one of them being *The Little Mermaid* by Hans Christian Andersen. She based this piece on the scene where the little mermaid is in her grotto with all of her treasures. Stephanie wanted to portray the mermaid surrounded by the things that make her feel curiosity and joy and to show her desire to explore the world outside her own existence.

overleaf
RESONANCE

This is also part of the "Stag Sonata Cycle" series. "It is the resonance that you can have with nature and feeling that sense of the sacred when you are in a beautiful space," Stephanie explains.

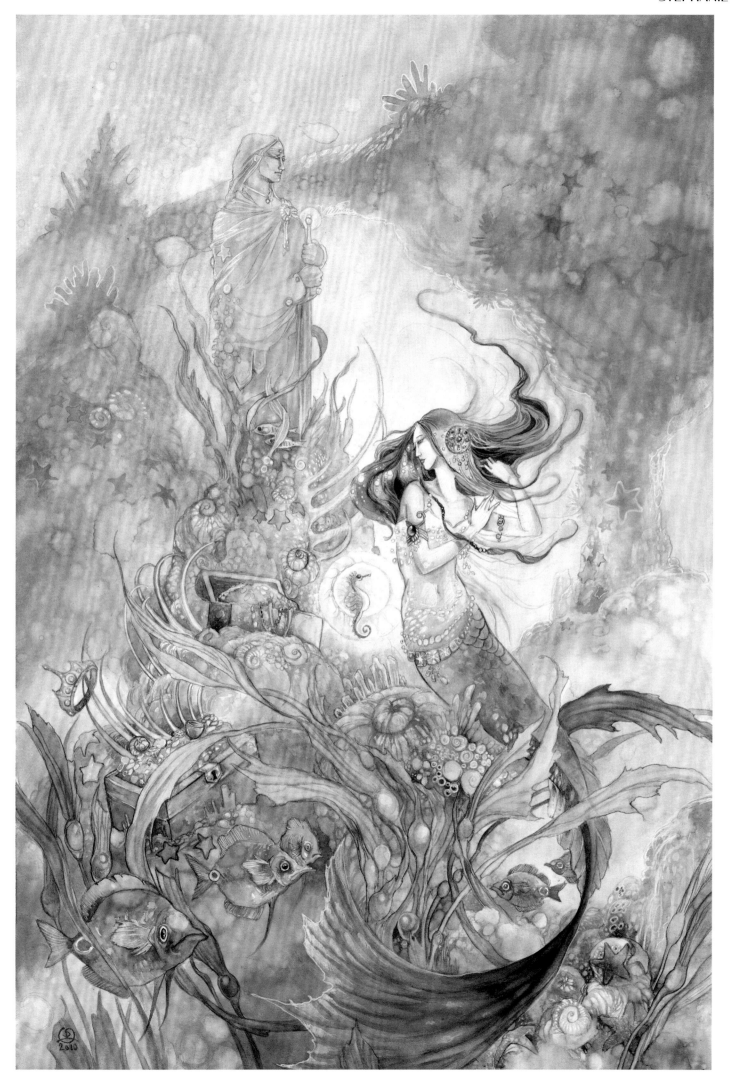

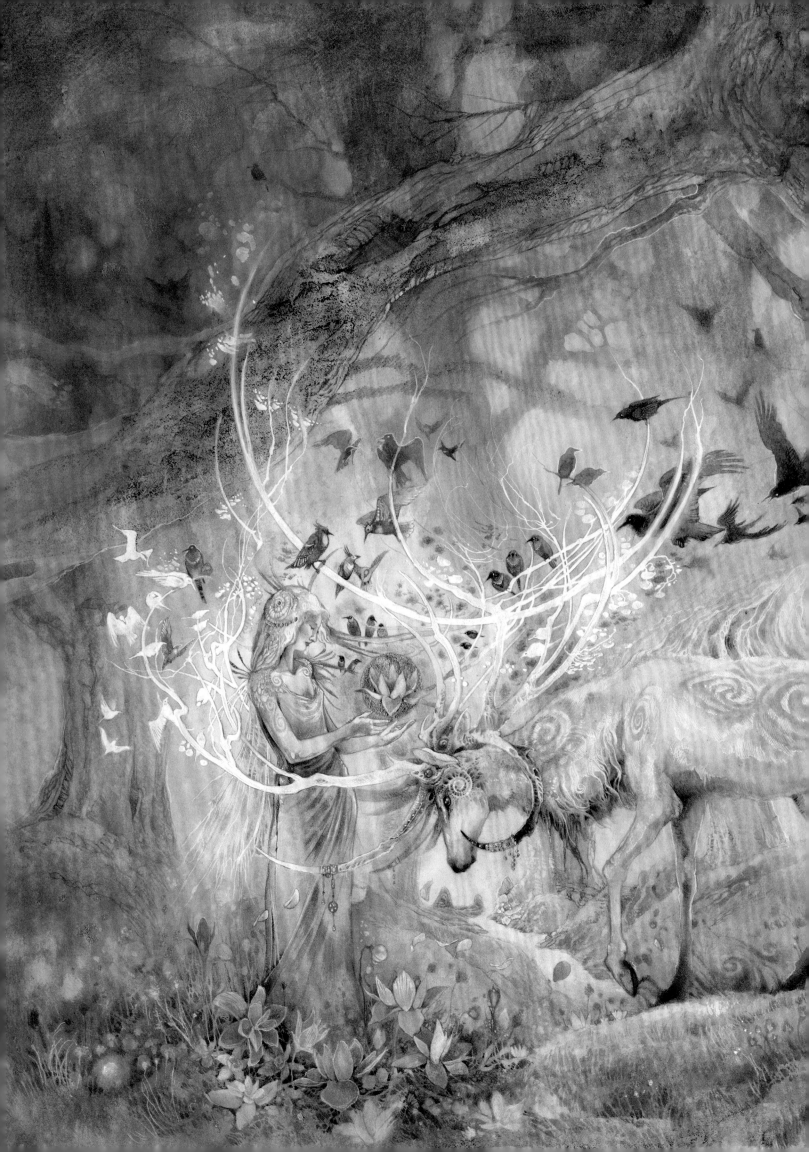

above
THREE FATES

For this piece, Stephanie drew from the wealth of the collective unconscious for multiple stories, meanings and beliefs that surround the magpie. This is another animal that appears in a great number of superstitions and mythologies and can be seen as an omen. Magpies are sometimes looked upon as creatures that can indicate your future or as good luck. Because these birds appear so often in different cultures and beliefs, Stephanie enjoys including them in her works.

right
VALUE OF A PEARL

Not all of Stephanie's art is based on the mythologies and stories found around the world. She also draws from her own personal experience or personal mythologies. One of those involves the use of pearls in her art. When Stephanie was just a baby, her grandmother used to take care of her while her mother was at work. One day her grandmother fed Stephanie a crushed-up pearl. (According to Chinese herbal medicine, ingesting something of value is supposed to imbue beauty and worth. There is also the superficial element that, by ingesting the pearl, it will give you beautiful pearly skin.) Of course, this greatly angered Stephanie's mother once she found out. But the story stayed with Stephanie, and she made it into something meaningful to her. "There was this whole other element that I sort of crafted into it as well," Stephanie adds. "The value of the pearl is my value and my own inner wealth—something that also appears as a scattered symbol throughout my art."

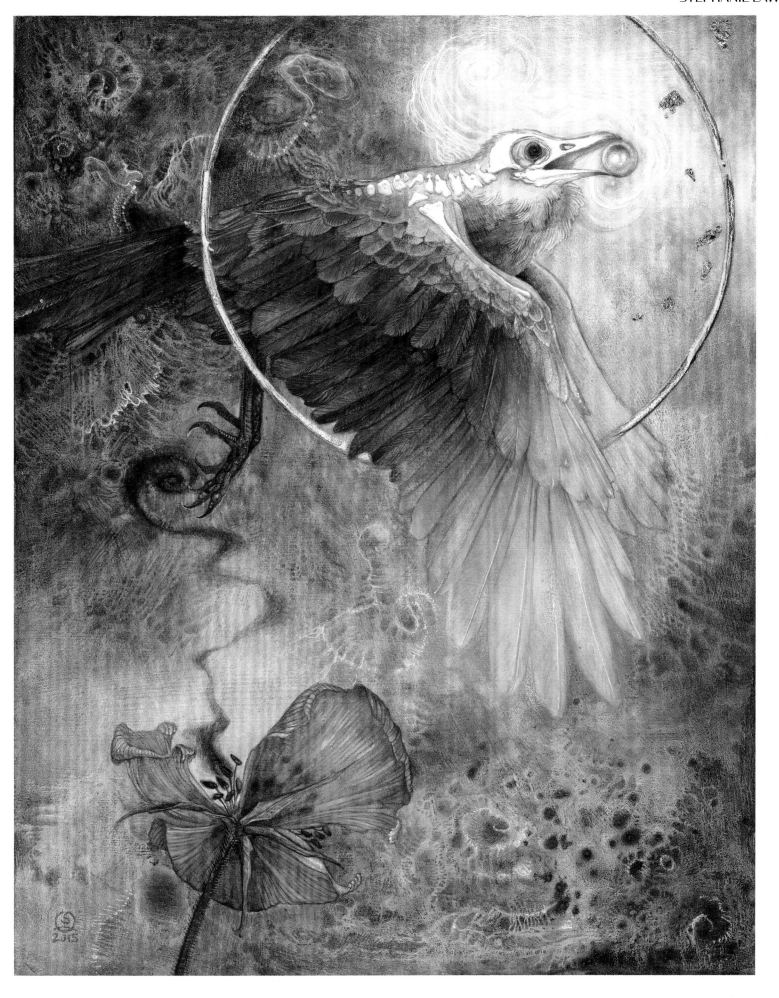

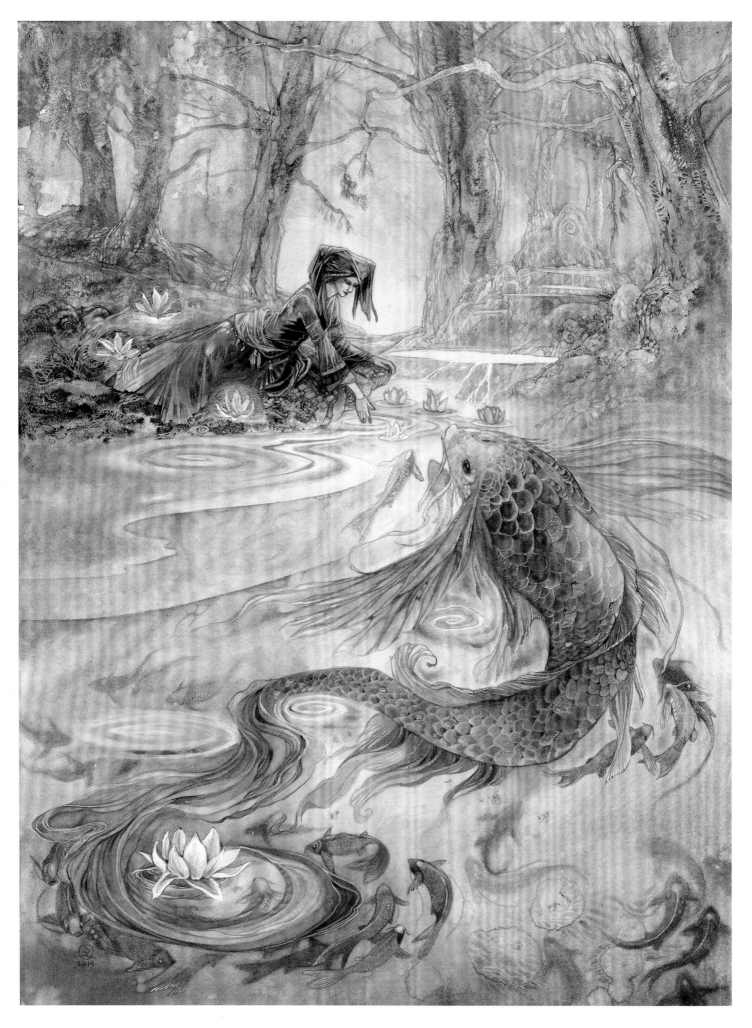

WITH PURE HEART

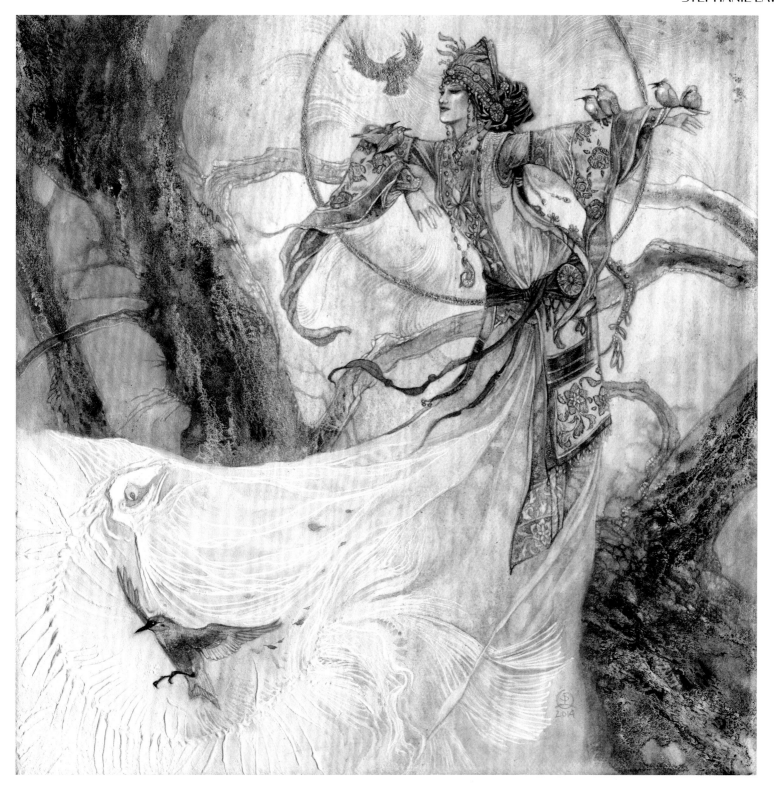

OF KINGFISHERS AND BONES

One of the fairy tales that has a lot of meaning for Stephanie is "Ye Xian," frequently called the Chinese version of "Cinderella." According to Stephanie, when Ye Xian's mother dies in this version of the story, she buries her mother and is left with her stepmother. She then befriends a fish that she comes to love, but her stepmother finds out and decides to kill and eat the fish to take away Ye Xian's happiness. Ye Xian becomes very distraught by this, so she takes the fish bones and buries them by her mother's grave. Later in the story, when she wishes to attend a celebration, Ye Xian goes to pray by her mother's grave, and the fish bones speak to her with her mother's voice, aiding her by granting her wishes and fulfilling her needs.

In this picture, you see Ye Xian after her clothes have been transformed into a beautiful gown with the colors of the kingfisher bird. The fish bones in the lower portion of the art symbolize Ye Xian's beloved "fairy fishbone-mother," who gives her the ability to attend the festival.

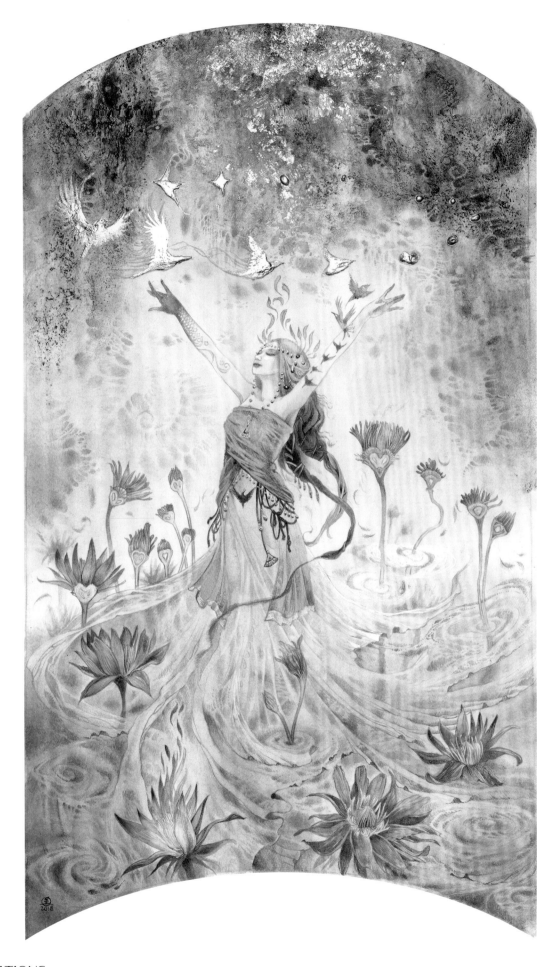

INCANTATIONS

This piece was created for one of Stephanie's solo exhibitions—"Awaken," at the Haven Gallery in Northport, New York, in May 2021. The series was about exploring freedom from daylit expectations, casting off fear of judgment, and allowing impulse to dictate creative urges.

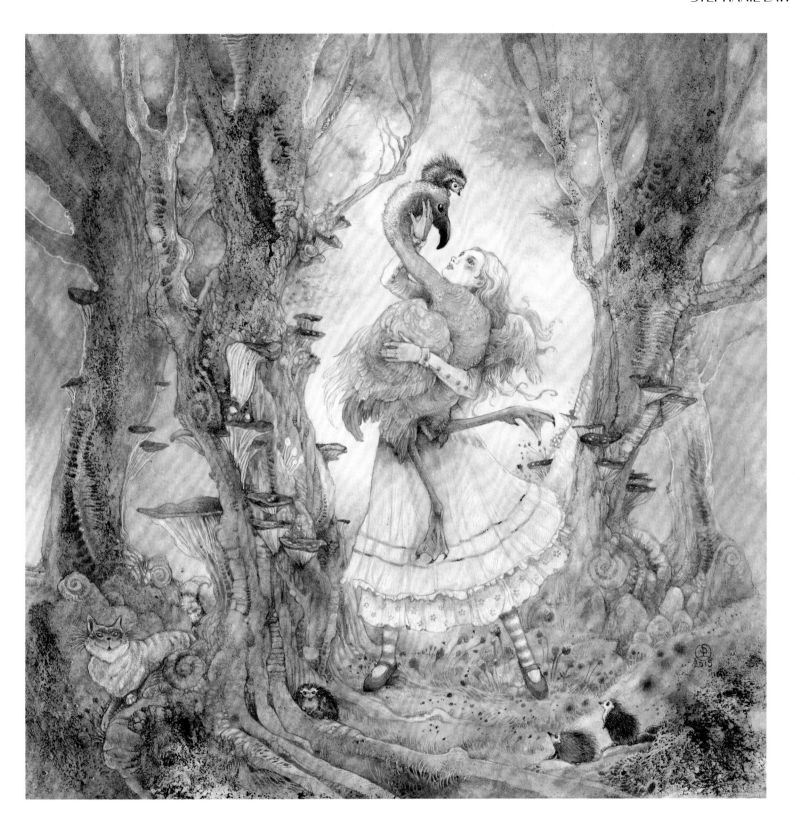

WONDERLAND—A DIFFICULT GAME

Stephanie created this piece for *Down the Rabbit Hole: A Lewis Carroll Tribute*, a show put together in March 2015 by Steven Russell Black at Bergeron's Books in Oakland, California. Her daughter was 7 at the time, and it gave Stephanie a chance to rediscover multiple children's stories, including *The Snow Queen* by Hans Christian Andersen and *Through the Looking-Glass* by Lewis Carroll. She was drawn to how both books contained scenes where the world was viewed through a plant's eyes and how humans were not central or important to them. "I dove into the world of Alice in Wonderland and it tied into the exploration of botanical art that I was just beginning to embark on. I began to weave botanical art with fairytales, and an insect's perspective of the world," she recalls. "That became the focus of a later gallery show series as well, which was the exploration of the world on a macro-level."

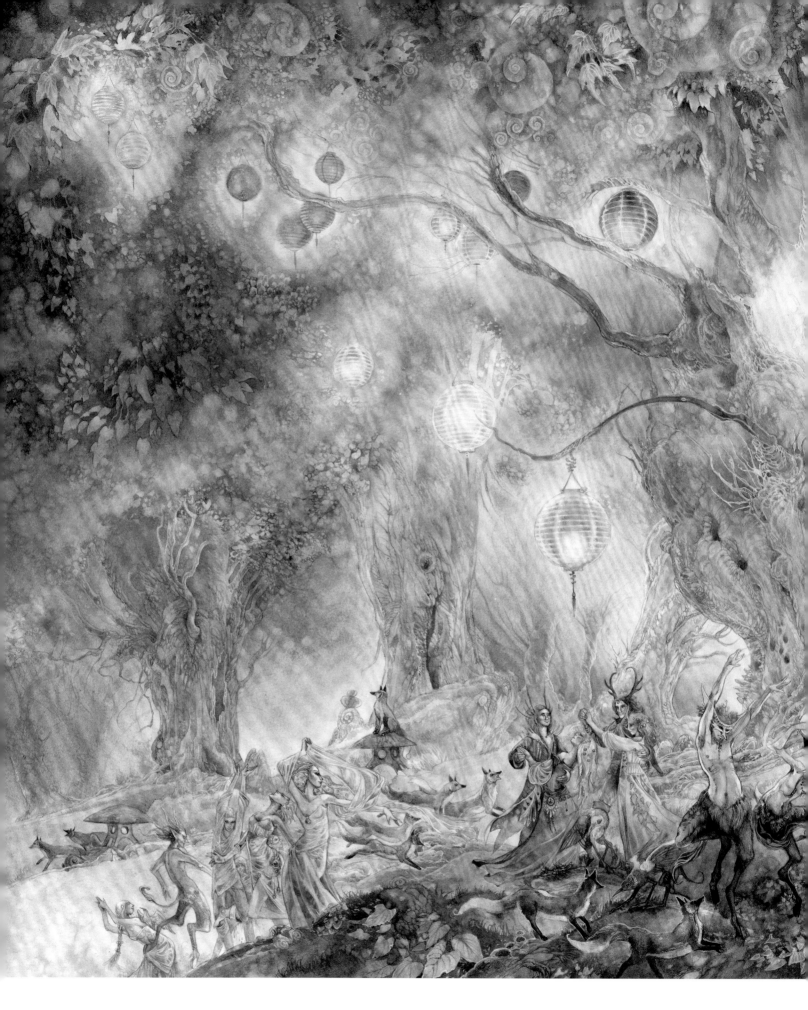

DARKEST NIGHT
"This is a fantasy faerie celebration with music and dancing and the overall feeling of joy and celebration of the natural world," says Stephanie.

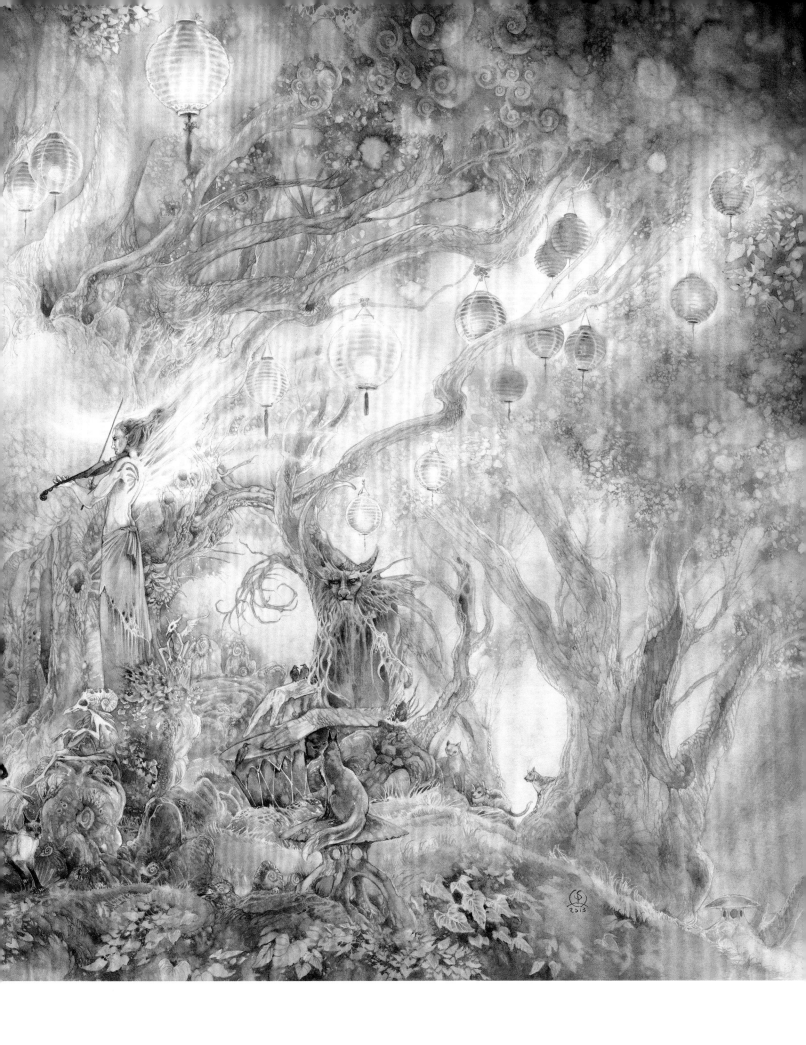

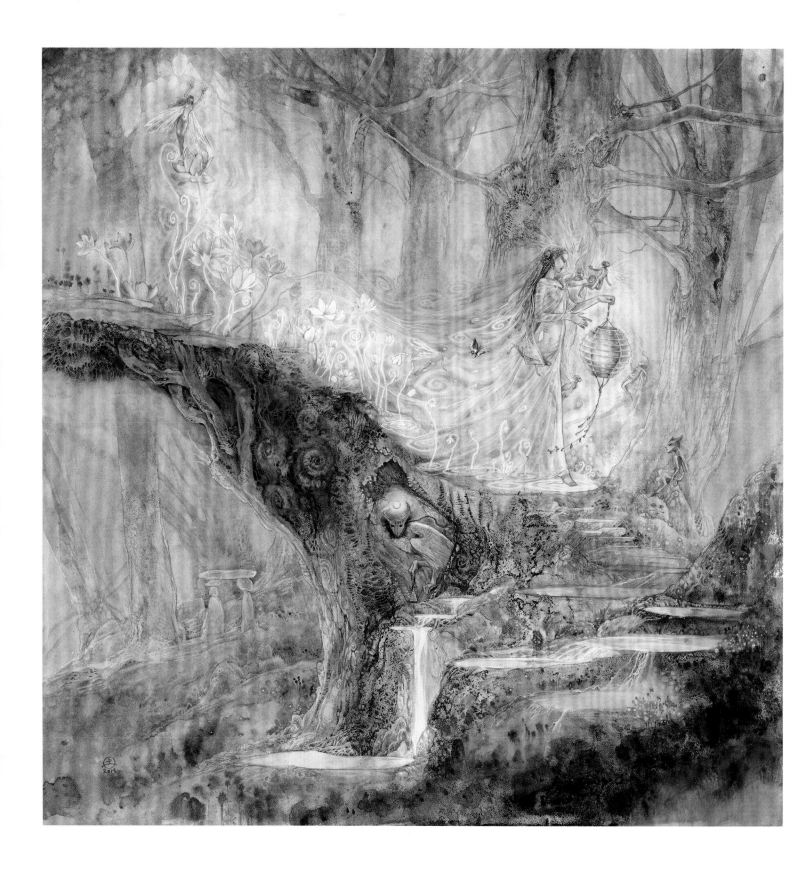

IN THE WAKE

Created for Stephanie's solo exhibition "Nocturnes" at Krab Jab Studio in Seattle in March 2014, "this one was about the boundary between our waking and sleeping worlds and about boundaries in general and where they meet—including the boundary between myth and reality," she explains. "I find fascinating combinations happen when you have to resolve two very different concepts, whether it be the abstract and the rendered, or what we imagine and what we see and where those meld. Transitions are where the interesting thing happens, because somehow you have to resolve two disparate existences." And because the worlds Stephanie portrays with her art and the mediums she uses are so different, something magical happens when she combines them.

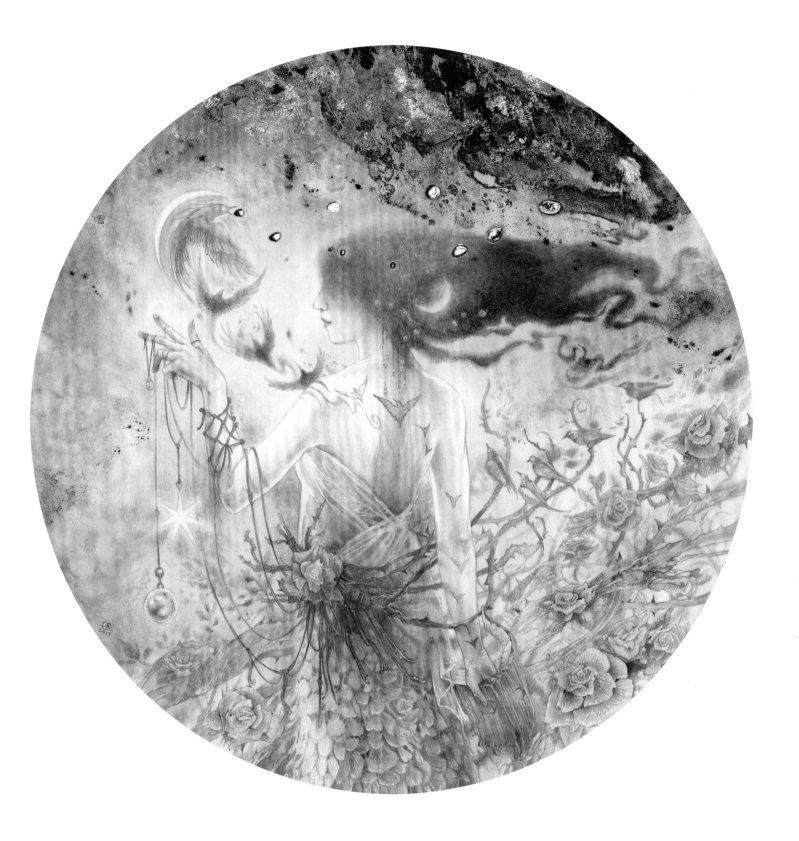

MAKING

This one also was created for "Awaken" at the Haven Gallery in Northport, New York. The series is about empowering yourself to take what you have inside of you and make it into reality, to find that focus and create things," Stephanie explains. "Creating art specifically for me is what this piece was about—the whole creative process of taking what is inside of me and finding a way to give that presence in the world." Stephanie is very passionate about sharing the things she cares about, and one of those things is empowering others to create and to be themselves. This piece is Stephanie's way of showing this, using her own experiences as a guide.

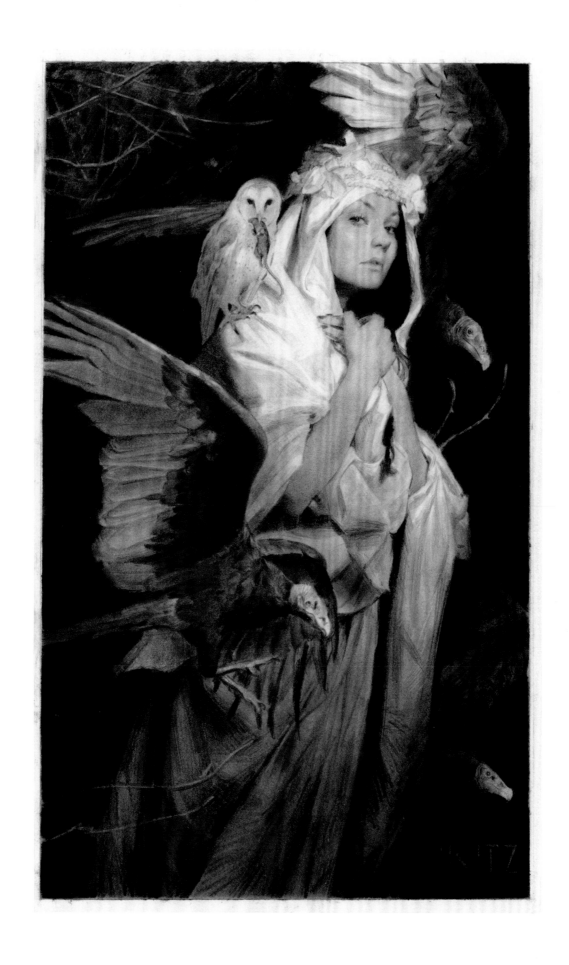

THE DEATH I BRING
Pencils, 7.5 x 4.5 inches. "Chimerical," Spoke Art Gallery, San Francisco, 2016.

KARLA ORTIZ

When I first met Karla, I wasn't sure what to think. As she approached me, her voice penetrated the room with excitement. Then she gave me a big hug—the kind you would get from your grandma when you were five years old. I swear I felt my feet dangle in the air for a second despite my being twice her size. I recall feeling completely overwhelmed by her exuberance. Over time I watched from afar, and it quickly became clear how much she loves people and how much she enjoys helping others. I quickly grew to admire and adore her while feeling inspired by who she is. Karla is a poster child for her work ethic and as someone who uses her power of positivity to challenge norms and to push boundaries through kindness. These traits have helped her to become a powerhouse in the film industry while working at Lucasfilm and Marvel Studios. I initially talked with Karla to gather some material for my introduction to her section in the book. Our conversation turned into what ended up being an intriguing and enjoyable two-hour talk that naturally was converted into the following interview. I offer the full discussion here where we talk about her origins, her philosophies and her journey. The art that accompanies her section focuses primarily on work done for her own amusement or for gallery shows. The captions are in her own words.

Flesk: I thought we would start off with your early days. Can you tell me a little about your childhood and when that first spark in the arts happened?

Karla: I was born in Puerto Rico. I have two wonderful parents who are both in the arts. My dad is a musician. My mother is a fashion designer. She's now working on Broadway in San Francisco. She was working on *Hamilton* for a while. And now she's working on *Jesus Christ Superstar*.

Flesk: Were any of you in Puerto Rico during Hurricane Maria?

Karla: Both of my parents were in Puerto Rico when Maria hit in 2017. I was in Portugal at the time for the "Trojan Horse Was a Unicorn" convention. It was a difficult task to be able to perform, share kindness—to be there for students—when in your mind you haven't had contact with your loved ones for three to four days, and you didn't know if they were OK. I was locking myself in the hotel room. I couldn't leave because I was so stressed out. But I started thinking about my dad and my mom, and both of them would be very cross with me if they found out I was not out there doing the thing I was supposed to be doing and helping people out.

Flesk: It must have been very difficult to stay focused. What did you do at the Portugal event, and were your parents OK?

ALESUND

Oils, 5 x 10 inches. "Four Dames," Spoke Art Gallery, San Francisco, California, 2017.

This is a personal piece for a group show called "Four Dames" in San Francisco with Eliza Ivanova, Nadezda, Ximena Rendon and myself. We all kind of knew each other, and I'm really good friends with Nadezda. We decided to do a group show between the four of us, and this was a piece for that. It was just a wonderful test, because I had been shifting from pencils to oils. There had been a lot of paintings beforehand, but one of the things that I missed is the black and white of pencils, and I wanted to try that with oils. I did this series, and it was just really fun to do. It was very freeing. I'm trying to think if this was the first series where I painted sparks and scratched the panel to get some of the wispy whites. I think this series was one of the first where I did that, and it just gave the painting so much movement.

Karla: I did a talk about one of the things that I like to talk a lot about, even though it is a broken record: It is about my own initial failures and how I gave up very early in my career. Not even a career really—I was just a student. And it came with an extra tinge of emotion and vulnerability to a crowd because I was in that state. People received it really well because it is a general discussion of, like, "Hey, we're here, and everything can change so quickly. Make the most out of your every day." It sounds clichéd, but there is nothing further from the truth. Everything that you love could so easily go away.

Luckily for me, my parents called a couple of hours after that workshop. They used the neighborhood's phone. Nobody had access to water or electricity, but someone had charged phones, and the signals came back up in four days. For Maria there was a whole month there where it was just survival, logistics and how to best support them even though I was so far away. I did get to visit the island back in March of 2018. So I really got to see the effects of it. It was one of the worst storms in the century.

Flesk: What is it like to grow up in Puerto Rico? How did you go from the lush warm environment of the island during your formative years to this cold, foggy city of San Francisco?

Karla: The weather in San Francisco is way better. It's so hot in Puerto Rico! It's nice to think of a tropical island, and it's nice to visit. But when you are living there it's all humid, and your hair looks like poop, and you're sweating. Growing up in Puerto Rico was really cool. My parents tried their very best to have me be in a neighborhood with a lot of kids, but they would always move to neighborhoods with no kids. I had to retreat to my own musings and my own imagination and worlds to be able to keep myself entertained.

I was always drawing. Recently I've been doing walks with my mom. And on one of the walks she was telling me that in second grade there was a teacher who approached her and my father. She was very worried about me. The reason why was because all of the kids would be playing, and I'd be just drawing under a tree. And I'm like, that is the most idyllic imagery of this kid drawing under a tree while all these other kids play. It was always my comfort zone. I love drawing, I love imaging stories, and later as you develop as a kid it almost becomes a currency. It's like, "I will draw your character if you'll be my friend!" It didn't work once you got past middle school. Suddenly people aren't that interested. But it did work for quite a while.

Puerto Rico was a very interesting place. Our identity is a very interesting one just because we have a very rich history out there. We have our own native tribe, the Taíno, that comes with very lush legends. We have a crossing between our African roots and Spaniard roots. It's a very varied place, but then we have American influence because we're a commonwealth. It's kind of this mix-and-match of a lot of different things. Sometimes it can be a very confused identity. Sometimes it can be very defined just depending on how you are raised. It's really interesting because I grew up with a lot of the same things that a lot of kids in the States grew up with. I grew up with the same American television, the same videogames and stuff like that, except I'm in a country that speaks mostly Spanish. We have different cultural perspectives. We're very loud, we're very excitable—very festive. Our Christmases aren't quiet or anything. They're very loud. Lots of booze.

Flesk: Are you considered an introvert compared with people from your area, or are there people louder than you? [Laughter]

Karla: Oh, there're very loud! One of the first things I learned when I came to the States was to moderate my tone of voice. Because what is considered regular out there is considered very rude out here. The other thing I had to do was to curb my touchiness with people. Americans tend to be very *not* touchy. I used to give hugs, and we used to do the kisses on the cheek. There were some very confused fellas in my early college days. I learned very quickly that people don't do that out here.

Puerto Rico was a cool place to grow up in. It had its problems. We're a commonwealth, but we're treated more like a colony policy-wise. I was very lucky to go to the school that I did go to. The one thing they do really well is they have different schools that are specialized in different arts. There's three of them. There's one for acting and dancing, one for music and then the visual arts. When I was around twelve, I entered the specialized school for visual arts. Now suddenly I wasn't the only one drawing. Everybody had some kind of ability to draw or sculpt or whatever. It honestly felt like a Spanish version of Hogwarts. Once you reached tenth grade you'd be separated into different artist disciplines. So you could go to the fine-arts section, the graphic-design section or the sculpting section.

Each one had its own culture, and the most-feared

DOS MEMORIAS

Pencil, 5 x 8 inches. "Lore," Hashimoto Contemporary Gallery, San Francisco, California, 2014.
This one in particular was done around the time I was doing a lot of personal pencil work, and I just had a blast doing it. I think this was one of the first images I did with two figures in it at the same time, and it felt so dynamic. A friend of mine ended up buying it. Artists buy a lot of my personal artwork. The people I worked with at the gallery always used to call me "the "artists' artist" because it was artists who would buy my work.

one was the fine-arts section because it had a teacher called Eluciano Vega. He used to be really intimidating to students. He had this thing where he used to grab a painting and if you were a student and didn't listen to him, or were stubborn or whatever, he would grab your painting and chuck it out the window. We were on the third floor! Only the janitor was allowed to pick it up. [Laughter] He changed throughout the years. He doesn't do that anymore. But that was a thing. I saw it once, and I was like, "OH, MY GOD! HE DID IT!" [Laughter] He would strike fear in the hearts of all the kids, but he was a great teacher! He would make us draw casts before I knew what a cast was. He gave us a lot of skills. I was in the fine-arts section the entire time. They were formative years. But one of the things about Puerto Rico is that there is no industry there.

Flesk: Did you have to apply, or did you get to choose the school that you wanted to go in?

Karla: It's one of the few schools in Puerto Rico where you had to provide a portfolio. When I was ten or eleven, my dad and my mom enrolled me in this art class in the neighborhood. I built a portfolio when they found out about that school. I wasn't doing too well in my previous school, and they thought maybe this specialized school would be more to my liking. So I applied and got in. That was cool.

Flesk: Were future job opportunities in the arts slim in Puerto Rico?

Karla: For a visual artist? It was fine art, and that was *it* at the time. Currently there is an effort to bring more game industries into the island. But back when I was a teen, that didn't exist. We had recruiters from art schools come in, mostly from Florida. I applied to various universities. I got various grants, but they weren't enough. Some schools were extremely expensive. I ended up going to one school that just wasn't great, and it's not worth mentioning since I hated it. The teachers were very nice, and they tried really hard, but the administration didn't really care much. The school later shut down in 2018. I'm still paying off those student loans.

Flesk: What motivated you to come to the mainland?

Karla: Mostly it was college, but also my mom was living in Florida at the time. So I decided to go to Florida. I didn't get what I was looking for. I went into animation thinking that if I could make things move, I would know it all. I quickly realized that animation wasn't for me, because to do one second of motion you need to do twenty-four drawings. And that's a lot of

drawing! I don't like doing that. I like to paint. I did find like-minded artists with similar aspirations online. For example, *conceptart.org* and DeviantArt were really big at the time.

Flesk: What year was this?

Karla: I graduated from high school in 2005, so this would be like 2006 or 2007. I was enthralled by all the different artwork. Something that I forgot to mention: Brom's and Iain McCaig's work was very informative to me in my teenage years. Near where I lived, a Magic: The Gathering shop had opened up, and it featured one of Brom's massive paintings of a Magic card called "Desolation Angel." At that time I was drawing Disney, Sonic the Hedgehog and game characters, but I never knew that a painting could be that cool. It kind of blew my mind. I was like, "Oh, my god, this is incredible!" Brom portrays women in a very mysterious yet elegant way. He was one of my biggest influences back then. The other one was Iain McCaig. I was visiting the Barnes & Noble in Puerto Rico at the time, and I was like, "A *Star Wars* book—what?!" I opened the book, and one of the first things that I saw was one of Iain's drawings. That's when I found out about concept art! It blew my mind. So those two artists really impacted me as a teenager.

Fast-forward to my college years, when I became a part of those online communities. I wasn't satisfied with the schooling that I went to college for. It wasn't meeting my artistic needs. *Conceptart.org* had a workshop in Montreal. That's where I met a lot of heroes of mine at the time who, oddly enough, are now my peers. It's a very small world—very small industry.

Flesk: Did you learn pretty quickly how much support and help you get from others in this field?

Karla: I think it's because we tend to be very empathetic. There's a lot of failure in being a painter. It just comes with the territory. That's how you learn. And so it's something where you can empathize with others really deeply. When you encounter someone who is really hurting or doesn't know exactly where to go, it's really easy to see yourself in that position, because you were once there as well. In fact, right after that Montreal workshop, I went back to Florida. I was so in awe of the level and the skill. I was like, "I don't know how I'm ever going to reach that level," so I actually gave up art for a little bit. I quit completely because every time I picked up a pencil, I thought, "I can never be like one of those great artists that I met."

Flesk: This goes back to the talk that you did in Portugal. How long did you quit for?

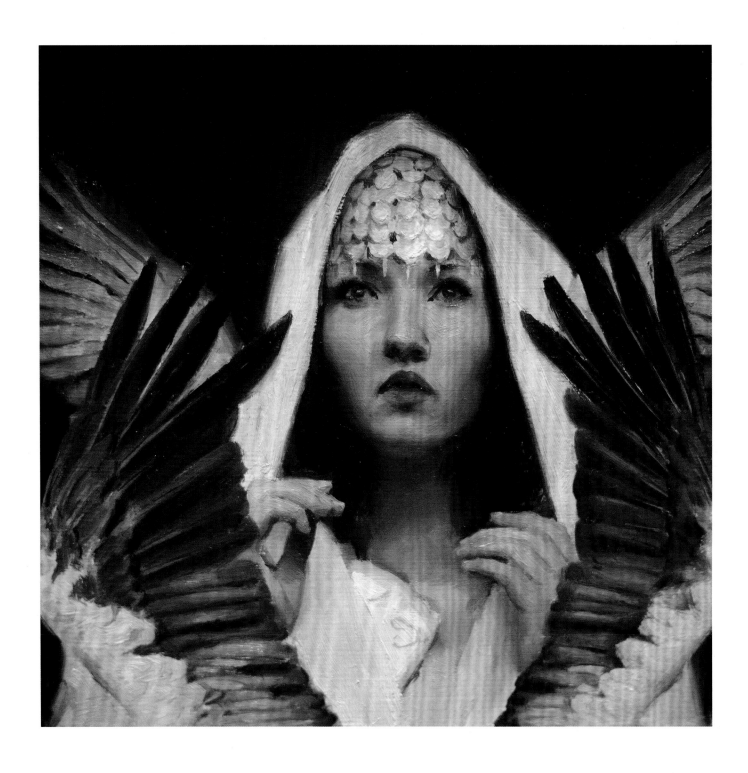

EXITUM

Oils, 6 x 6 inches. "Four Dames," Spoke Art Gallery, San Francisco, 2017.

This was also for "Four Dames." Nadezda, who is also an artist, was my model for a lot of these early images that I did in my twenties and early thirties. She's a great model who gave such emotive expressions. It's really hard not to use a lot of her references, because she's that wonderful. I had a great time. It was just really funny for this painting of her to be in the same gallery show where she herself was showing art! For this and other paintings, sometimes I just paint things because I think their shape is fun and they give a certain emotion that I might not always be able to pinpoint, but it exists in me. There's a certain mystery to these paintings, a certain melancholy. Some of the elements have meaning as well. A lot of the birds in my images have meaning. Other times they're there because I like how they look in a composition. This particular painting was really fun, but it's really tiny. It has traveled to Paris too.

Karla: For about two to three months. And I was seriously considering other fields. I was thinking of getting into physics. I was thinking of getting into acting too. In another alternate reality, I'm an actress somewhere because I had an acting teacher in Fort Lauderdale. She was well-connected to all the acting schools in New York, and she was like, "Karla, go, do it!" And she set me up with interviews and everything. There was a period where I could easily have gone in a different direction, which would have been silly. I would have been typecast. I would have played "Latina Number One." [Laughter]

Flesk: You would have been typecast as the best friend in all of your movies.

Karla: I would have been the best friend! Yeah, I know. I don't want to be the best friend. I want to be the hero! [Laughter] Because we all know how Hollywood is. Then, when you reach a certain age, you're stuck playing "Mom" forever, and then once you reach another age, you're a witch or an evil character, and it's exhausting.

Flesk: Speaking of Hollywood being shallow and you being in Hollywood now, do you get a chance to push against the old stereotypes and do things and portray people in ways that weren't normally done before?

Karla: Part of my whole job is designing the looks of certain characters who will be played by actors and actresses. To be able to shift people's perspectives and perceptions just by what they wear alone or just by what they do alone, that to me is very powerful. It is very simple to get a prompt, and I have in the past been on certain productions where it's like: "Here's this very stereotypical perspective or view of this character." Then you get the prompt, and you're just like: "Hmmm…I'm not doing that!" I'll just paint alternatives and push and be like: "Hey, this portrayal of this marginalized character is very stereotypical, and I don't think it's very helpful. But here's something that will address the same needs of the character but in a way that's empowering—in a way that someone could look up to." So I *have* had that opportunity in certain projects. I can't tell you which ones.

Flesk: Typically, what's the response like? Are they pretty open and like, "Oh, wow, that's an idea I never thought about," and they appreciate your effort?

Karla: It depends. In my recent years in film, people tend to be a lot more receptive to that. Where it wasn't nearly as receptive was when I was in games. But it was pretty funny, because my art director would be like, "Ah, Karla, you kind of have to do a little of what they tell you to do." But then I would do just the bare minimum of what they asked—just so they were happy. It's not even really that they want to see exactly what they demand to see when it comes to things like that. I think they just want to be heard. And they want to feel like they are being catered to.

There was one instance a long, long time ago in a gaming company where they wanted to portray this warrior woman as an oversexualized character with little armor. And I was like, "There's no need for this. The character serves no purpose. This doesn't make sense. She going to be a warrior. The lack of armor will hurt." And they were like, "No, you gotta do it anyway." I would find ways to placate both—*my* need to not offer a stereotypical, damaging portrayal of women and *their* need to itch that false belief that that's what it takes to make money.

Flesk: That's a strong belief that a lot of people still have. If that is all you are offering people, then that's all they have to buy. And if you want to include women in buying this stuff, from a simple business standpoint, wouldn't your sales explode if you cater the material more toward women? But it's an investment in the future for so many reasons beyond the sales potential. The reason why is that these guys hold on to these concepts because that is what they see in their head. Nothing else. They want to see sexy women and mask their desires with the false notion that it is necessary to make sales. If they didn't project women as sex objects, I think they would do better in the long term.

Karla: Bingo, bingo, bingo! I worked at another company, called Kabam, where they did a test that was really interesting. Their whole company had been like, "Let's push for sexy characters!" I was working on *The Godfather* at that time. Our "sexy" character was this buxom, curvy lady who had a cigarette. She was a super-powerful character in the game. And there was this sexuality to her, but it wasn't because she had this crazy pose or crazy outfit. No, there's an intensity to her eyes, there's grace to her—an elegance. They put my painting alongside some paintings from the other teams to check their metrics. The one I did, which was still a sexual character but not overly sexualized to the point of ridicule, got three times more engagement than anything else. It became the most-popular character of the company. And then they went to me and said, "This doesn't make sense," because it isn't what a game executive typically thinks is sexy. What they thought was sexy was bikini-clad rogue chicks holding

VOCES DE VENUS
Pencils, 5 x 8 inches. Thinkspace Gallery, Culver City, California, 2013.

their bows with their butts up in the air, which was impressive. If the character could speak, she'd say, "I'm holding an arrow very uncomfortably, but I'm doing it!" That's what they thought was sexy. But what was *really* attractive was far more in depth, far more approachable, than what they imagined, and we had the numbers to show it! It changed their approach.

Flesk: It has changed a lot in recent years. I like seeing where art is going right now. It's moving slowly. I know a lot of people wish it would move faster. But it really takes time for all of these people who are in charge to change. Because fantasy has been this "thing" forever. That's what people think it's supposed to be. There are a lot of old ideas that don't work anymore. It was what it was at the time, but it isn't the future.

Karla: I feel like there's room for kitschy. It's like a B-movie type of thing. Kabam was one of the most-diverse places I've ever worked at. Our art team was about fifty-fifty women and men, all ethnicities and all gender orientations. And one of the things that became really apparent is that our approach to our work became much more worldly. Solutions to visual problems would have a wonderful variety of thought. I think it made us give a more-honest product. A more heartfelt product. Just because our own perspectives were diverse. It reflected the majority of people as a whole.

We as a society are very diverse. The last time I checked, we have 49 percent men and 51 percent women. We're very evenly split. A lot of the stories don't really reflect our world as much because they only come from a singular group of people. They might reflect that group of people, and that's fine, but when you're looking for mass appeal—the masses are diverse. It was a very interesting thing to have come across. There's another thing too, which is that there's so much talent out there. There's so much amazing work being done out there by people all over the world, all genders, all ethnicities and sexual orientations. It's giving that talent a chance to thrive, to see what it creates, and that talent creates really fantastic art! New stories that will pull at you. Visuals that you will go, "That was amazing!" It's a really exciting time. Personally, I'm in love with it.

Flesk: It's the best time. It's absolutely the best.

Karla: It really is. But, yeah, even with all that, I still quit art. [Laughter]. And the quote that I give everybody in every one of my talks is about the time I called my dad because I couldn't paint. I was constantly thinking like, "Oh, god, I'm not like this or that person. How am I ever going to get there? It's like everyone is an amazing wizard, and I don't even know how to do magic!" That's how it felt. So I called my dad and told him, "I haven't drawn for two months," and then said, "I'm quitting art!" He started laughing and said, "You're not an artist unless you want to quit at least once. That's just what it is to be an artist." That really struck me. It's been with me ever since.

You might be in a room with some of the world's most-successful artists, and they're all like, "*Your* art is better!" It's not that they're looking for praise for their own work, it's that they genuinely feel that way. Being an artist is a very personal, very emotional career. A lot of us tend to be really attached to art and see it as an extension of ourselves rather than something that we just do. That can be very damaging because if you fail as an artist and you think that your self-worth as a human being is based upon your art, then you'll believe you're a failure as a human. That can be very damaging for a lot of people, especially students. It's something I always tell students not to do.

Flesk: Is this a common thing that you see in young people?

Karla: Yeah. It doesn't need to be young people *per se*. It's any artist who's starting out, any age. When you're starting your journey as an artist, a lot of people take those failures really personally. Because they see the work and sort of understand how to get there, but when they can't reach where they want to go, they see it as a personal failure. That can be extremely damaging especially in their formative artistic years. One of the lessons that was given to me by my dad is that failure is a part of it. Wanting to quit is a part of it. It's just how it is. Separate yourself from your failures. See it as just a puzzle to be solved. You solve it by knowledge and by practice—that's it. I always tell students to be honest with yourself. Do you know about what you are painting? If you don't, then learn about the subject you're painting. If you do, OK. Cool. If it's still not working out, then practice. Just keep at it for a while and eventually your knowledge will merge with your practice. That's how you learn, and that's how you improve as an artist. But to be able to also separate yourself from the work allows you to be strategic with the work. Imagine someone doing a jigsaw puzzle and being really mad and wailing because they can't find a puzzle piece. You would worry for that person! It's the same thing with artists: It's just a visual puzzle. Sharing these lessons to starting artists is my thing. I want to push healthy mindsets onto them.

EL PASAJERO

Oils, 9 x 12 inches. Maxwell Alexander Gallery, Los Angeles, California, 2018.

This one is a very personal piece because I was moving from my apartment in San Francisco where I had lived for ten years. It was also for a gallery where I had wanted to showcase at least once—Maxwell Alexander. It felt really good to paint, because it felt like an ode to my studio that I had been in for a decade. I was painting among a bunch of boxes and everything packed up. That was the last painting of that space, and it will always remind me of that old studio.

Flesk: Looking back to when you were a student, didn't Iain McCaig take you on as a student and become your mentor? How did you two connect, and does his teaching philosophy play a role in why you now give back to students and new artists?

Karla: He's 100 percent a mentor to me. I had published a couple of Magic cards that got a lot of attention. One was "Teysa, Envoy of Ghosts." This was before I met Iain, but I was starting to get people coming up to me at conventions. I remember calling my dad, and he told me, "This is a responsibility now because people will look up to you." I remember when I was a student and which artists gave me the most, which artists were attentive or the ones who listened. The ones who empathized with me. The ones who could have had the power to crush my soul as an artist. And I remember the ones who *did* try to crush my soul as a student. When someone does that, it doesn't feel good, and it certainly doesn't do anything for that student. I didn't ever want to be that person. I wanted to be a person who could meet people where they are at: "I traversed this land, and I can tell you it's going to get bumpy. Maybe take a left here." It's as simple as that.

It became even more apparent when I met Iain. I hadn't quite met someone as kind and as human as him. He will give his time to everyone and anyone. It doesn't matter who they are. It doesn't matter where they're at in their life. He will take the time to listen, to find ways to encourage them. To find a way to make that person fall in love with art and life. It was striking.

I met Iain at a workshop he taught alongside Brom in Seattle—the Tara Lang workshops. I was working at Kabam, and I thought, "I'm not going to miss this!" So I went out there and had a great workshop with them. I really understood Iain's energy. I thought, "This is how I get when I get hyped up!" We got along really well. When portfolio day came, I showed him my work, my Magic card specifically, and he said, "Karla, you're hired!" I asked, "Hired where?" And he said, "I don't care, but you're hired!" I thought, "This rules!" I was over the moon even though I didn't expect anything to come from that.

Three or four months passed, and I emailed him just to keep in touch. I sent him recent art to show him what I was up to. To my surprise, we were both in San Francisco. I asked if he ever wanted good coffee to let me know. Iain said, "Actually, I'm at ILM, come and visit me here." I'm like, "OK, cool!" So I went and visited him. I didn't know that was

an impromptu interview at ILM. I'm glad I brought my portfolio. When I got there, he said, "Let's go get coffee. Now you're going to go talk with the head of the department!" I'm like, "What the fuck!?" [Laughter].

Flesk: Wasn't that the best situation? If you knew it was going to be an interview, would you have freaked out?

Karla: I would have been very nervous for sure. I tried not to let that nervousness show in my interactions. Acting classes helped with that. I was very nervous, but I did talk with them. I remember the interview because the guy was very wonderful but very serious. Deadpan face. So it was very intimidating. He asked me all these questions. Technical questions and wonderful questions. There's one question that I remember where he's like, "Do you do 3-D?" I said "no." "Are you able to do matte paintings for final keys?" I said "no." "What do you want to do?" I said, "I want to paint." [Laughter]. That was close to the end of the interview, and I thought I blew it! I thought I should have said "yes" to everything.

About two weeks passed, and I hadn't heard anything. Then they hit me up on a Friday and asked if I could come in on the next Tuesday. I was like, "Oh, my god, YES!" And the job where I was then, Kabam, was like, "Oh, my god, NO!" But they still helped me take a leave of absence. Eventually Kabam had some layoffs, and I was included in those layoffs since they knew I was gone to filmland. That is how I entered ILM.

Iain was a fantastic mentor throughout that too. I had a rough time being in that space because it was very different from Kabam. Kabam was a place where at 3 p.m. we would all go as a team to get drinks. Our office was on the top of a Whole Foods, so we would go downstairs, get wine, then go back up to paint and chat. It was like a little family. ILM was a very high-stakes, a very monumental company. Everyone is very sweet and nice, but it's a lot different than Kabam was. I had a hard time early on and thought I wasn't fitting in. Iain would always come by to check up on me, and he would often say, "Hey, you're doing great! The first few weeks are always hard. But don't worry, you'll get it tomorrow." He was always very encouraging. I'm so grateful to have had him there.

Little by little I became a part of a loving team. It was a very wonderful time. I think I was at ILM for about a year and a half to two years. I worked on *Lucy*, *World of Warcraft*, *Jurassic World*, *Star Wars: Rogue One* and a bunch of other projects. It was really good to be there. We worked on an early iteration of the film *BFG*. I don't

ENTRE SEGUNDOS
Pencils, 8.25 x 10.25 inches. "Moleskine V," Spoke Art Gallery, San Francisco, 2016.

think our work made it because they chose another VFX [visual effects] house. Then things started to slow down. As things happen in Hollywood, when a project slows down, you can't keep people on. So they said, "Sorry, Karla." And I said, "I understand. No problem."

At the exact same time Marvel desperately needed another character concept artist. Iain was also a mentor and friend with Ryan Meinerding, head of visual development at Marvel Studios. So Ian reached out: "Ryan, I have someone for you!" That's how I got my interview at Marvel. Iain facilitated that. Marvel also was another funny "I think I blew it" interview. I was interviewing with Ryan, and he was like, "So, Karla, what do you think about L.A.?" I said, "I don't think much of it!" [Laughter] I said, "If I need to move out to L.A., if you need me to, I will! But if I can do it from San Francisco, I would love to." And he said, "OK." That's how I started being a freelancer from home. My first project with Marvel was *Doctor Strange*. It was a real honor to be able to be assigned the Doctor Strange suit as my first project.

Flesk: That's a big deal for the new person, right?

Karla: Yeah! With Marvel it's really interesting because they will give all these different artists a shot at designing the characters in the beginning. They want to get as many different perspectives and as many different artistic takes as possible. Then they send that to the director. The directors choose the artwork they like best. Whichever art gets chosen, then that becomes the artist for that character as long as they can have it. For example, Black Widow is Andy Park's character. He established that look, and he's the one who has been doing her costumes for a long time. For Ryan Meinerding, he handles Captain America, Spider-Man, etc. Each person has his or her characters—for me it was Doctor Strange, at least for most of my time. COVID put a pause on *Doctor Strange 2*, and they switched directors. By the time that the project was started again, I was on another project, so I couldn't finish my boy. But that's OK. You let your darlings go. He ended up in good hands!

Flesk: Somebody else gets a chance to do something else.

Karla: Exactly. Iain told me this about Darth Maul: They're kind of like your kids who grow up and go to college. But, yeah, I've been on and off with Marvel now for...gosh, since 2014. I took a year's break to work on some stuff with Universal. And now I'm back with Marvel.

Flesk: Can you give me a quick scenario? I know it's probably hard because there is so much involved, but what's the scenario of getting an assignment, doing the work and turning it in, and it becoming the final thing that they need to see?

Karla: The best way that I could describe character-concept art is that you're kind of a visual detective. Someone will give you a written prompt or goal. And you're like, "What are the clues? What is their age? What's the mood? Do they have actors and actresses in mind? Is there any information that I need to know to find this character or to find this painting?" Then you get all of your information together and do some solid sketches. I like to do really developed sketches. They look almost identical to the final, minus the detail. You want to give your client something that is easy to visually read. Something that is about 30 percent done feels good to me. That way there's no room for guessing. Let's say the client loves the sketch. Then you move forward to finals. Sometimes they'll have certain notes: "I'm really liking this. I'd like to see this."

And then you go through another round of iterations. Sometimes you render out the sketch a little bit further and add the client's requests. Sometimes you just need to start over and make new sketches. You play this game, back and forth: "Here's an idea that's 30 percent there. What do you think about it?" And if someone says, "Yes, that's it!" Then you render the sketch to final, you deliver it, and that's that. It depends on what industry you're in: If it's a book, then that painting becomes a cover. If it's for Magic: The Gathering, then that painting becomes a card. If it's a videogame or film, then it goes to other artists to create it—modelers, costume designers and so on.

Flesk: Apart from concept art, you do personal work. You said not as often right now because you are so busy. Is it something that you feel is necessary as an artist, or do you do it since a gallery tells you that it needs some pieces for a group show? [Laughter]

Karla: A little bit of both. This is such a good question. When I started working at NCsoft—my first professional job—I quickly realized that my day-to-day job wasn't going to meet my artistic needs, because I had to deliver specific visuals. For instance, I really wanted to work on massive illustrations. But the job didn't need massive illustrations. It needed quick ideations, it needed quick characters. Every once in a while I would get to do a massive illustration, but then I found myself rusty. So, to help with that, I would often do other

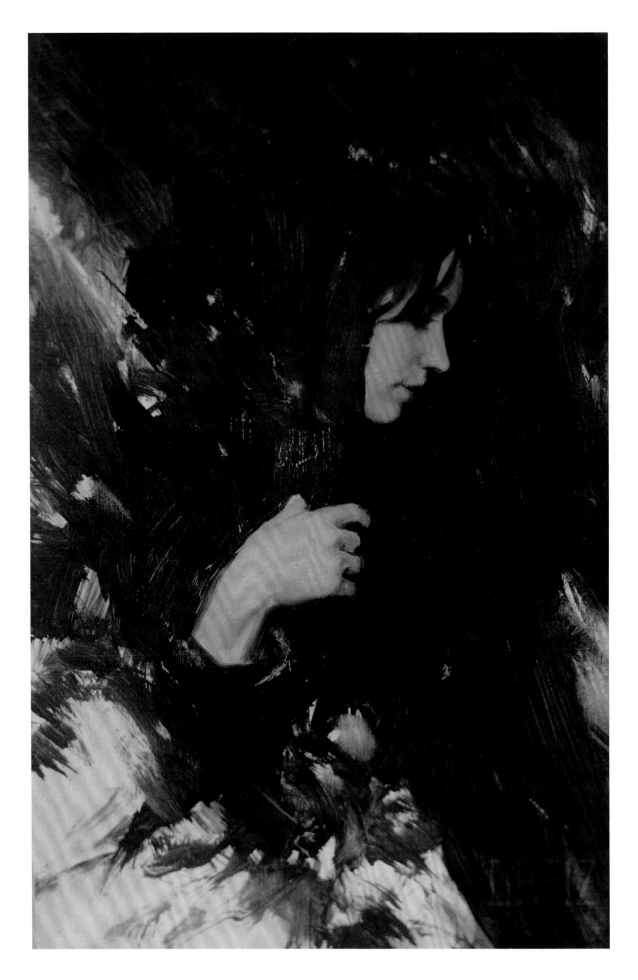

LILONE
Oils, 8 x 12 inches. "Four Dames," Spoke Art Gallery, San Francisco, 2017.

classes. I'd do life-drawing on the side. I would say "yes" to online gallery shows or calls for entries—just to give myself personal work that I could do that would meet those artistic needs. That's something that I learned very early on in my career.

Another person who touched on this subject was Allen Williams when we were working together at Kabam. Allen told me that it is really important to do your own personal work, because otherwise people get burnt out. It's true! In this job, you give all of your artistic energy to clients who have their own visual needs to meet. And when you're in constant service to others, you can run the risk of losing your artistic self. So I would always push myself to join galleries. The other thing that is really helpful for me is deadlines. I need deadlines! Otherwise I noodle forever on a painting. So when you give me an actual goal, I can work and schedule toward that. There is no room for second-guessing yourself as you see the deadline approaching. So I would often take side work or gallery shows that had deadlines as a way to push myself to meet my own artistic needs outside of my daily job. Nowadays I'm a bit too busy, and it's been a bit more hectic schedule-wise. Completely different subject, but I've gotten into bullet-journaling to mitigate this. It's fantastic.

Flesk: What's bullet-journaling?

Karla: Bullet-journaling is a method of writing down your schedule in a way where you are very aware of what is important in your day and what's not. You write down events and tasks that you have to do, then you cross it out at the end of the day. If there's something that you didn't do, you move it to the next day. Or you move it to future days, weeks or months. The act of writing all of that down keeps your schedule well in mind. I used to lie awake at night thinking of all the things I had to do. Now I just write it down, and I'm comforted that I won't forget it. I know what I have to do. Another thing I like about bullet-journaling is that you write events and tasks from different time perspectives: first a yearly view where you write down important dates, then a six-month view where you write down the important dates/tasks that have to happen in those six months, then week by week. I really don't worry about my schedule anymore. I'm finally on top of it now. So hooray for bullet journals!

Flesk: And going back to your personal artwork—does it help for you to not be defined by your pop-culture work? And does your style have to shift to the style that the company expects for the campaign?

Karla: It serves double things. It's funny the amount of projects that I have gotten because of my fine-art work. That to me is an absolute joy. When a client says, "I want exactly this." And then they show you *your* fine-art work, and you're like, "Oh, so you want me to just be me?!" It's fantastic! And the other thing is you don't get lost in the many visions of other people. Like, for example, I love working for Marvel. Marvel has a certain aesthetic. It could easily become my aesthetic if I'm not mindful. My personal work helps me be grounded and allows me to keep my own voice.

Flesk: Ten years goes by, and all of a sudden no one wants you anymore because you have become that Marvel house style rather than a unique individual.

Karla: Yeah, and Marvel didn't want me for doing the Marvel style. They wanted me for what I had to bring. The best way I can describe it is this: You know how people are in relationships for a really long time and then they have a whole year or two to be by themselves? And it helps them define themselves as a person so that, when they're in another relationship, they're more themselves, and it's easier? That's how it feels like to be your own artist. [Laughter]. I never thought I'd put it that way.

Flesk: So you should break up with your boyfriend every five years?! [Laughter]

Karla: Yeah, absolutely. [Laughter]

Flesk: And take a year off and get yourself another one. [Laughter]

Karla: No, no, no! [Laughter] I don't want angry people who read this book to then message me: "I broke up with my boyfriend/girlfriend!" [Laughter] Even when you are in a healthy relationship, one of the things that makes it healthy is to have a strong sense of self. It's the same thing when you're painting. Especially for concept art and commercial art, where you are constantly meeting other people's needs, you've really got to have a strong sense of self. It's easy to get lost. And that's when people get really mad when their work doesn't get chosen or when someone asks for a revision that they don't agree with, because that's their only outlet. That can really exhaust you.

Flesk: I would also think that there's a fear that if you get rejected too many times, you could feel like your work is not being validated. Or you could think that people don't want you or that you are less desirable as an artist.

Karla: And that's not a great place to be mentally,

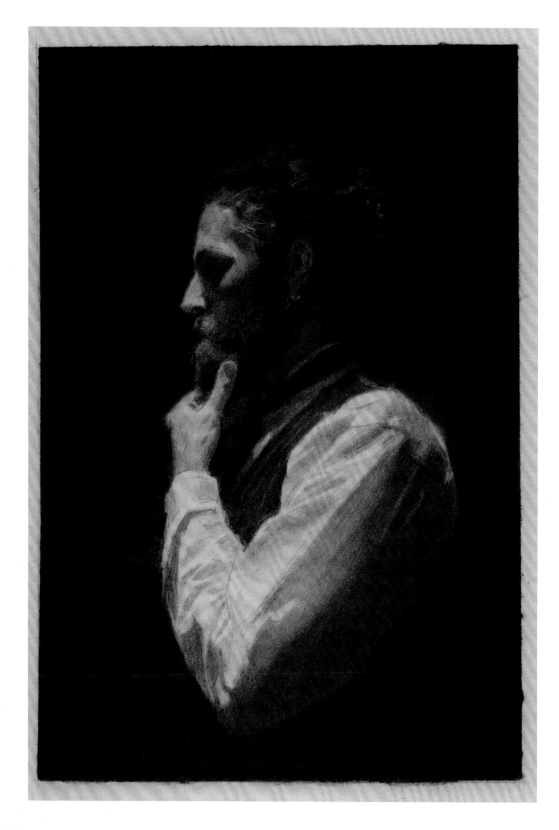

III. THOUGHT AND CHOICE

Pencils, 5 x 8 inches. "Chimerical," Spoke Art Gallery, San Francisco, 2016.

This solo show was very interesting. I was doing different observations of my relationships, my dynamics with others and how I felt at the time. I did a series of portraits called "Nurture," "Nature" and "Thought and Choice." This was supposed to be a trio of the same person in different moments of thinking, feeling or being. Those were very personal and wonderful pencil pieces. Not just that, but there was another one, "Omens," that kind of kick-started all of these pencil pieces. I not only felt an emotional connection with the art, but I also learned new techniques that really pushed my artwork to a next level. I have a rule that once I reach a certain level, I can't go back. So it's almost like an increase in difficulty, and now all the following pencil pieces after "Omens" needed to be just as good or have the same intent to be as good. I'm not always successful, but it was a wonderful time for me, artistically and emotionally. I was really excited!

because so much of this work is rejection. There are so many ideas that get rejected before people find the right one. Your ability to provide something that allows them to say "no" eventually helps them get to a place where they understand what they want. It's kind of like, you don't know what you want until you see the thing that you *don't* want. It helps them define things. Your artwork is a process in that. That can be very exhausting if you're not balanced.

Flesk: That's right. I look at it the same way. Sometimes it sparks a new idea. We don't look at anything as a failure. It's a step toward the creation. If you have the type of attitude where rejection will make you angry, no one will want to work with you.

Karla: That's a huge lesson too. It's important to take the time to care for yourself and nurture yourself so you are able to take those rejections. That's important to being a professional, and it's also a part of the job. There's another big lesson there too—for people to not be jerks and to not get really "agro." This industry is so in demand. There are so many very talented people, so many wonderful and deserving people who want to be a part of it and *should* be a part of it. All those lovely people could easily take over the space of a talented jerk. People also reach out to people who are good to work with. I think the concept and illustration industries in particular are very much in that ethos. Jerks just don't survive very long.

Flesk: You have to get along with the team and the people.

Karla: Time is so limited. I want to work with good people. I've been very fortunate that my clients mostly have been wonderful, but I have had a few clients where I've had to say, "I'm sorry, but we're not working together anymore. Here's a refund. Take care." That's just part of it. You have such limited time. You just don't want to spend it working with someone who makes your life miserable.

Flesk: It's not worth it. I have the belief that there are people whom you get along with and people you can do without. It doesn't mean they are bad people. It just means the two of you are not clicking—so don't work together.

Karla: It's like living with roommates who are friends that you click with. Some are great, and with others you're like, "Oh, no, I made a mistake! I love you, and you're still my friend, but we can't live together!"

Flesk: On another subject, as a well-known professional, how do you manage social media and avoid getting sucked into negative situations? I ask since I have seen very caring and considerate comments by you in the past in heated online discussions. What is your approach, and what are you hoping to accomplish?

Karla: I try to reach out to people in good faith, especially when it involves people in our industry. Talk to people as if they are right in front of you, because you have different conversations with people when they're right in front of you as opposed to behind a screen.

I think it's also important to share that information with empathy. We all have different experiences after all. However, sometimes there will be some random person on the Internet who will engage with you cruelly or in bad faith. And that to me, personally, is when I really have to watch myself, because I'll turn into Bugs Bunny. You know how Bugs Bunny fights bullies? He's never the bully, but he *will* bully bullies. That's how I feel. I don't like when that takes over. There's no need. It doesn't do anything except feed my own anger. I've been working on it in the past few years, but my sass still comes out every once in a while if someone's really cruel. Because it's hard not to, especially when it's egregious. But, yeah, I mostly try to engage in good faith. If it doesn't reach the person, at least I've reached the people reading it. It might offer a different perspective.

Flesk: Are you able to talk about any projects that you are currently working on?

Karla: I have so much work that will never see the light of day. I've been producing one painting a week for the last four years, but it's all for Marvel Studios or other companies. The only projects that get to see the light of day almost immediately are book projects that I do. However, I rarely get to do those anymore because Marvel and games keep me so busy. I was working with three different game companies in the past two years. One of them is one of my dream companies. I got to work with Luminous Productions, a Square Enix subsidiary. They do a lot of the JRPGs [Japanese role-playing games] like *Final Fantasy*. That's always been a dream for me, but I won't be able to show any of that for the next four years. The most recent work I got to showcase was the stuff that I did for HBO's *The Nevers*. I worked on it back in 2018. It takes a while. I'm hoping for a nice break from commercial work, though. I've missed just doing oil paintings for myself.

Flesk: Karla, thank you so much for sharing so much about yourself and what you do. It was a delight to talk with you.

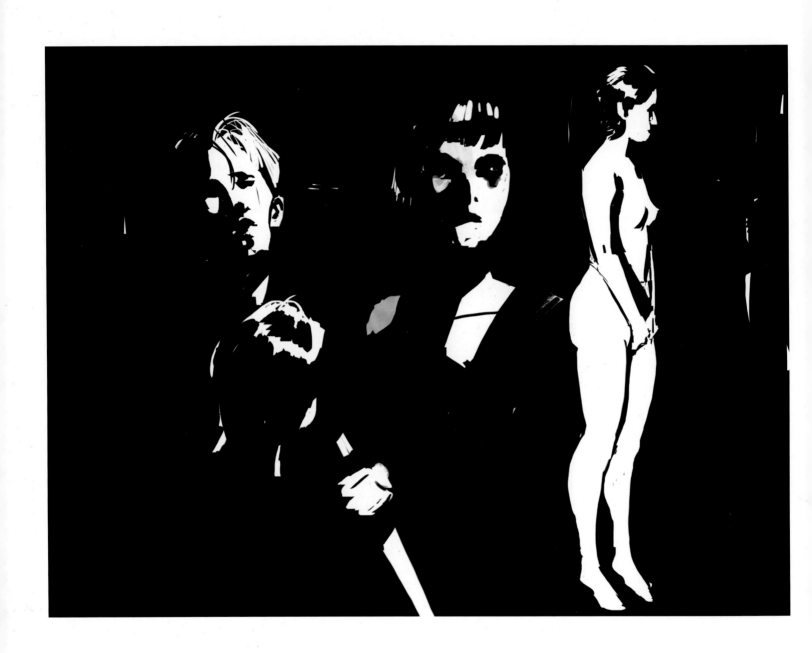

above
DIGITAL INK SKETCHING 2
Digital, 2021.

right
DIGITAL INK SKETCHING 1
Digital, 2020.
In between meetings, projects or even as a warm-up, I like to randomly sketch. These are some of those results.

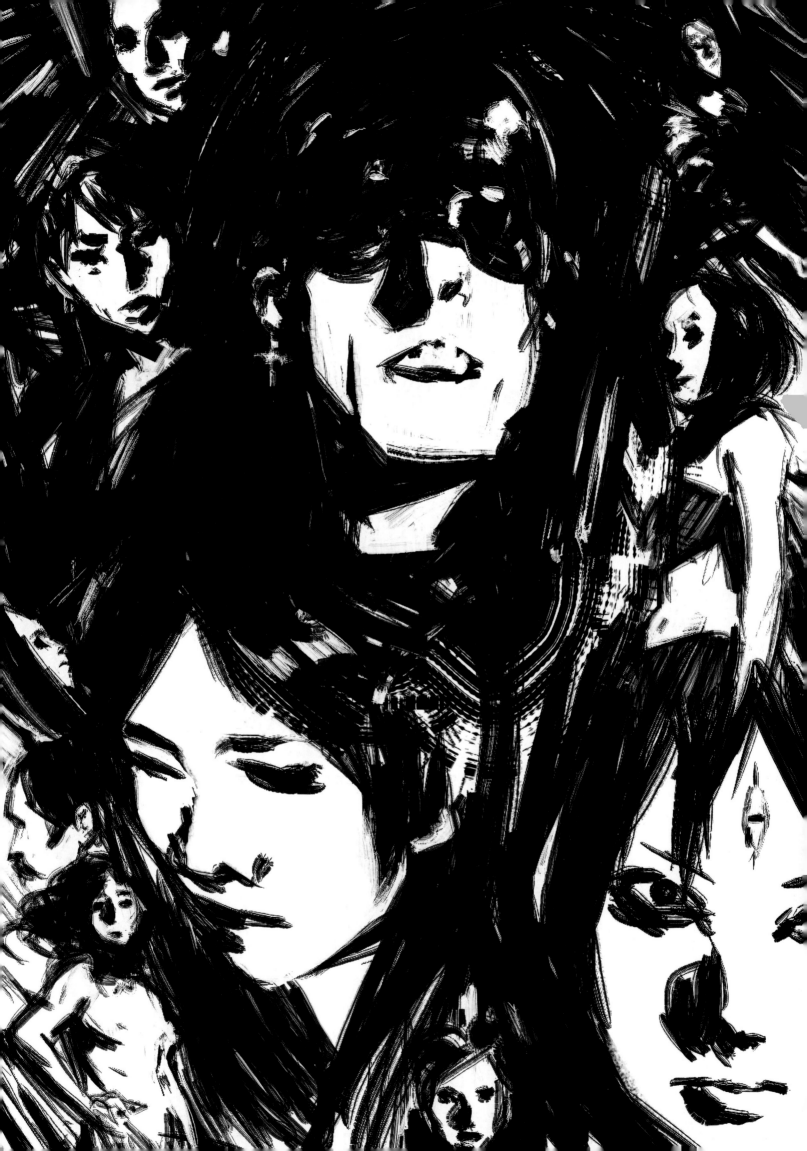

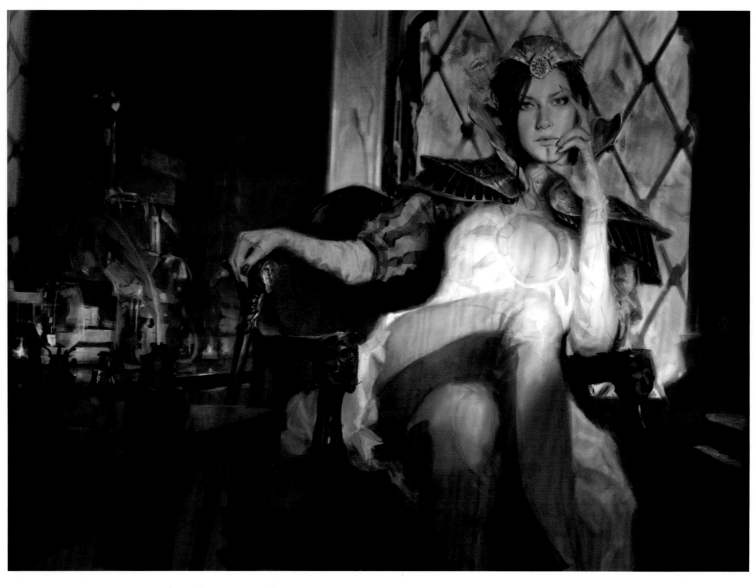

above
TEYSA ENVOY OF GHOSTS
Digital, Wizards of the Coast, 2013.

right
MTG: WAR OF THE SPARKS
Digital, Wizards of the Coast, 2019.

I took a long break from Magic: The Gathering because my schedule would not allow me to do any work with them. Robert Drawbaugh had approached me. He was a Magic director at the time for the marketing branch. They wanted to do these awesome marketing images for a new release called *War of the Sparks*, and it's like a giant climax of a story for Magic: The Gathering. They wanted to represent this grand epic in a series of three massive images, and this was one of them.

The only thing that made me really sad—that I didn't know about these—is that they weren't going to be playing cards. I thought they would be, but the marketing material is always just marketing. They don't do playing cards based on that. I was like, "Oh, no!" Because fans have a different attachment to the cards, and they have very strong appreciation for the art. But I still had a blast doing those. I think the other thing I really loved about it is because there was a long period of time where I didn't do any Magic work, or was releasing *any* work, because most of the stuff I was doing was NDA [non-disclosure agreements]. It was nice to be able to share with the public more-recent work, as it showcases where I'm at artistically. Especially since I evolved a lot in my time working in film.

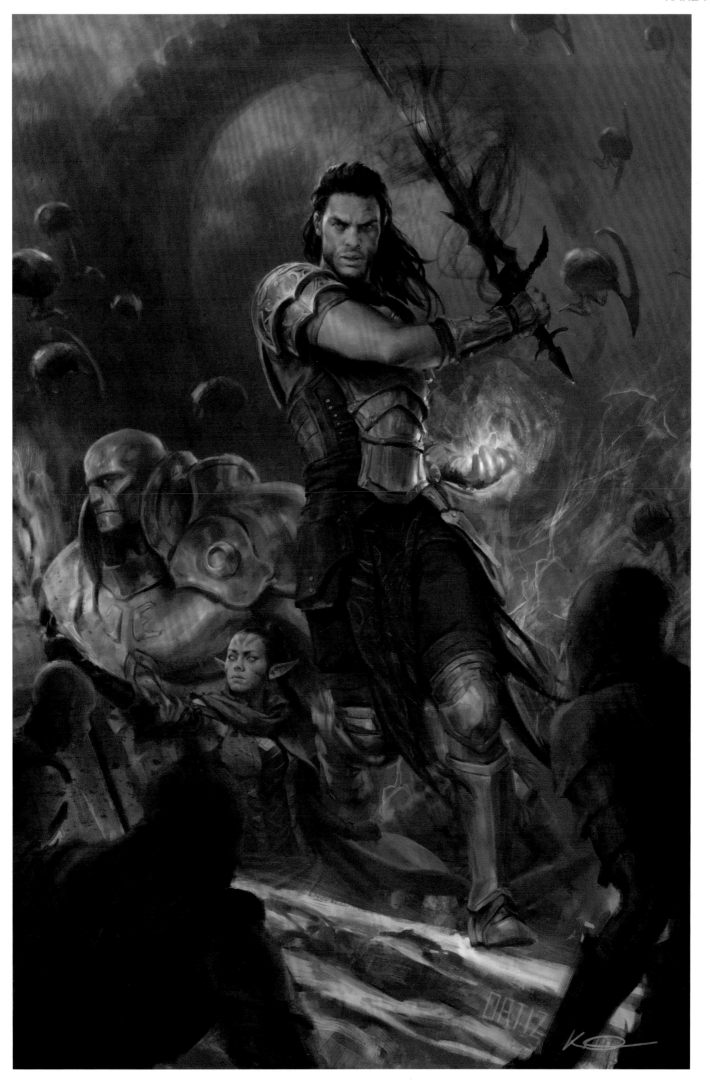

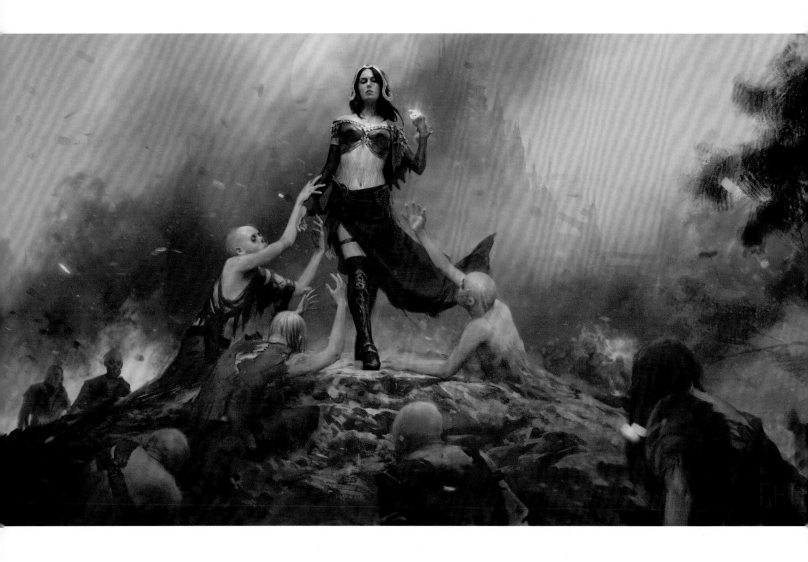

LILIANA DEFIANT NECROMANCER

Digital, Wizards of the Coast, 2015.

That's Liliana. This is one out of two paintings. Magic: The Gathering did this really cool thing where you had two cards in one, and each side of the card had a different painting. One of them was Liliana as her past self and then Liliana as the current awesome character that she is now. This one was really fun, because I remember they had hired a bunch of artists that I loved.

I think Tyler Jacobson was another artist doing these. Wesley Burt was one of them too! I was among this incredible group of artists doing different characters for Magic: The Gathering in these epic formats. I gave these paintings my all at the time. It's also one of those paintings where you learn something new. With every painting there's an intention that you set, and when you get to reach that intention, you learn something new about your artwork and your capabilities as an artist. This was one of the few that I think achieved that intention. It's like, "Awww, yes! Here we go!"

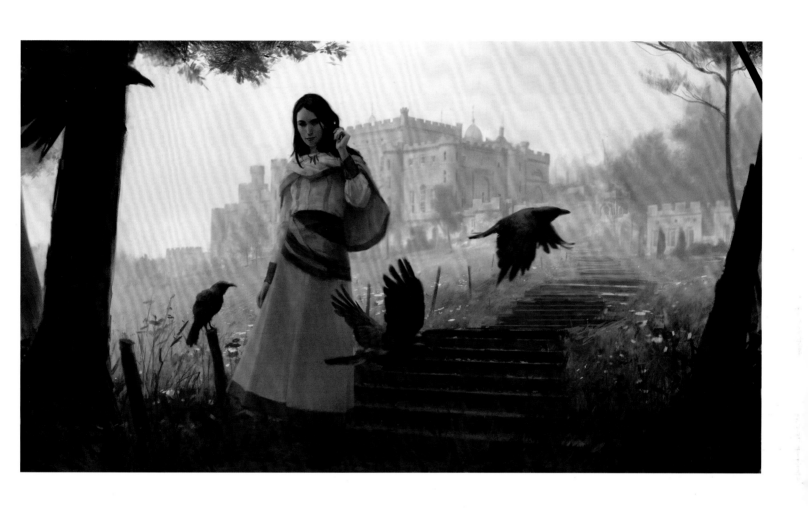

LILIANA HERETICAL HEALER
Digital, Wizards of the Coast, 2015.

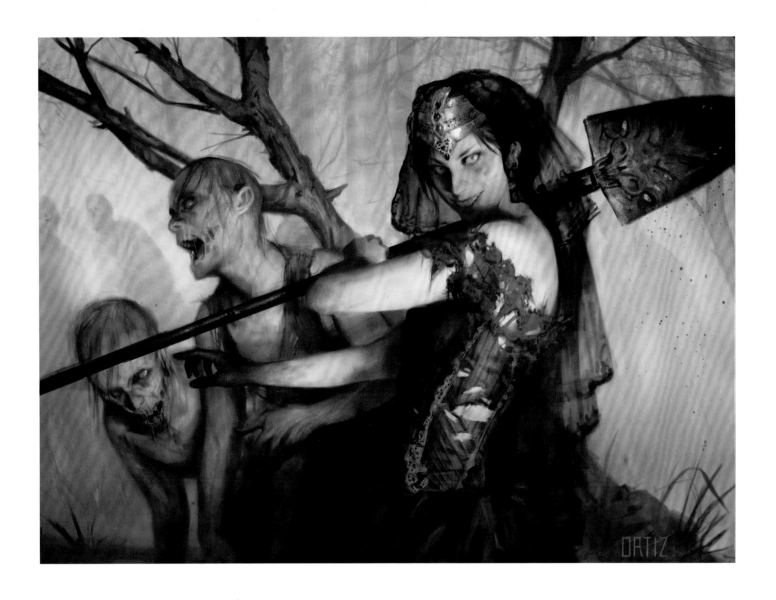

above

GHOUL CALLER GISA

Digital, Wizards of the Coast, 2014.

These were just super-fun prompts. I did a lot of these while I was working at Kabam. So some of these are from the 2012-2014 time era. They wanted someone with a certain intensity in her eyes, where you know something is not quite right with her. She's the direct opposite of her brother, Geralf. He is a necromancer who meticulously builds zombies and stitches them little by little. Gisa just digs them out, splits them together, and she's like, "All right, GO!" I really wanted to capture that energy, and it was just really fun to make this. I was doing a ton of magic cards back then. They were fun.

right

THE SORCERER OF THE WILDEEPS

Digital, "The Sorcerer of the Wildeeps," by Kai Ashante Wilson, Tor.com, 2015.

THE WALKING-STICK FOREST

Digital, "The Walking-Stick Forest," by Anna Tambour, Tor.com, 2014.

This was a painting I did for Tor.com art-directed by Irene Gallo. "The Walking-Stick Forest" was the name of the short story the painting is based on. It was cool because it was a moment in the story where this woman is walking into a forest that is alive, and it does not want her to be there. The prompt was to bring a sense of lack of stability and a little bit of horror. I don't always get asked to do things like that, so I was really excited when Irene proposed this one.

A funny note on this one is that we were at a "Spectrum Live" event, and the image was due. I still had to finish a couple parts of it because I wasn't happy with it just yet. I brought my laptop, and I hid in my hotel room, ignoring everyone's messages to hang out because I couldn't imagine drinking with friends when Irene was there, knowing that I owed her a painting! I locked myself in the room on the first day, and it was on the second day that I delivered it to her! Apparently she told me she was with some friends when she got the email and thought, "Oh, my god, this is awesome!" It was great, because you never get a chance to have an art director tell you in person how they feel about a painting they have just received from you. Also Irene was literally the first person I saw as soon as I left my hotel room, so I was correct to not leave my room. Once I heard her say it came out great, I was like, "Yay, thank you! I can finally relax! Now where's that drink?"

RHAEGAR TARGARYEN
Digital. *The World of Ice & Fire: The Untold History of Westeros* and "The Game of Thrones,"
Bantam Books, 2014.

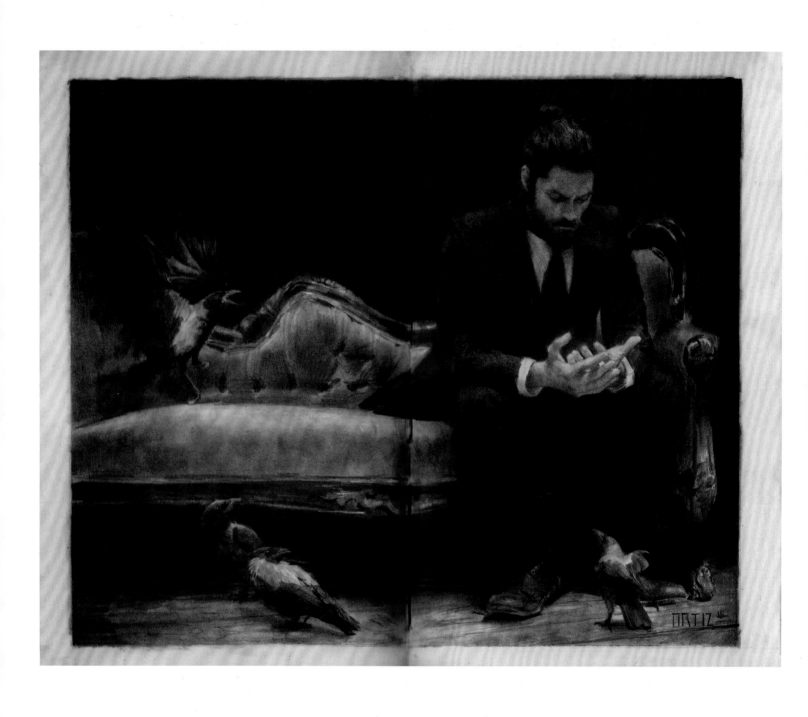

OMENS

Pencils, 8.25 x 10.25 inches. "Moleskine Project IV," Spoke Art Gallery, San Francisco, 2015.

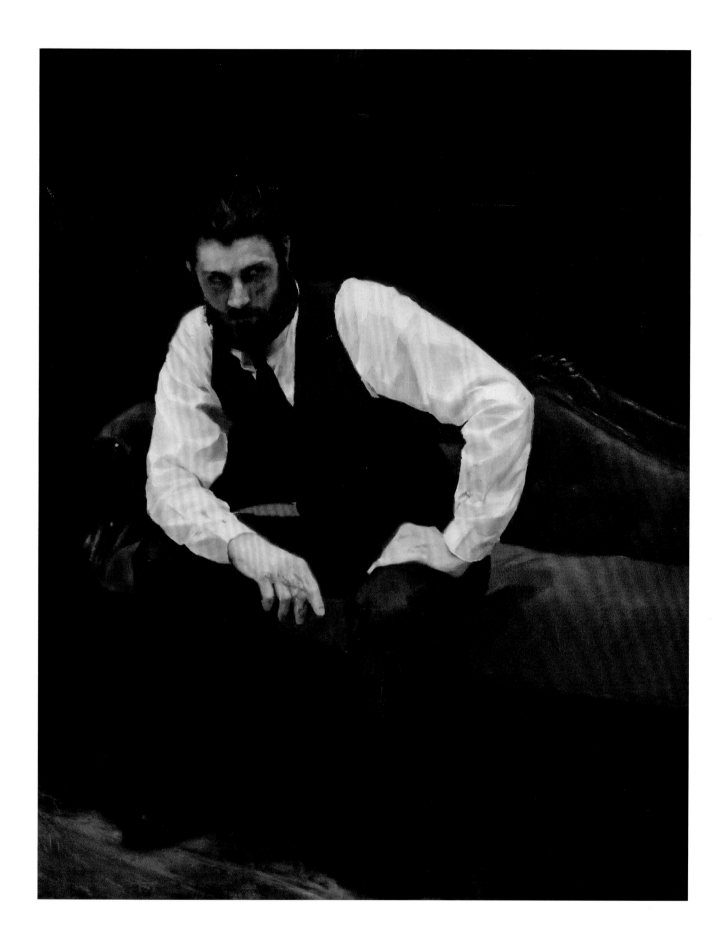

RIGIDUM
Oils, 30 x 24 inches. "Chimerical," Spoke Art Gallery, San Francisco, 2016.

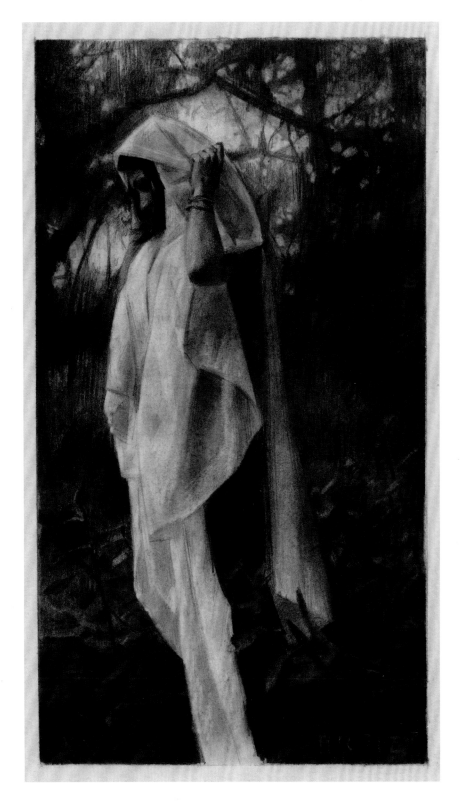

SEGUNDO PASADO

Pencils, 5 x 3 inches. "Chimerical," Spoke Art Gallery, San Francisco, 2016.

This was also for one of my solo shows. It was also fun to do because I started including more background elements to my paintings and to my pencil pieces. The thing about most of my personal pieces is that they were done with very limited time, because I was always working a full-time job while freelancing. So, yes, VERY limited time. Much of the haunting, mysterious, dark backgrounds I used to do were not necessarily intentional but rather because I had no time to do more elaborate work. I think this was one of the first pieces where I was like, "No, I want more elements in there. I need it." So even if the cost of it was sleepless nights, I got to add that plant life. I started to fall in love with adding more elaborate backgrounds to my work, and that's something you see a lot in my commercial work. A lot of my Marvel work at that time started having more environments as well, and now I have become more of a key-frame artist. It's not just characters on a flat background. It's now characters interacting with their environment. Funny how that one decision to add plants to a pencil piece helped me discover a love for backgrounds!

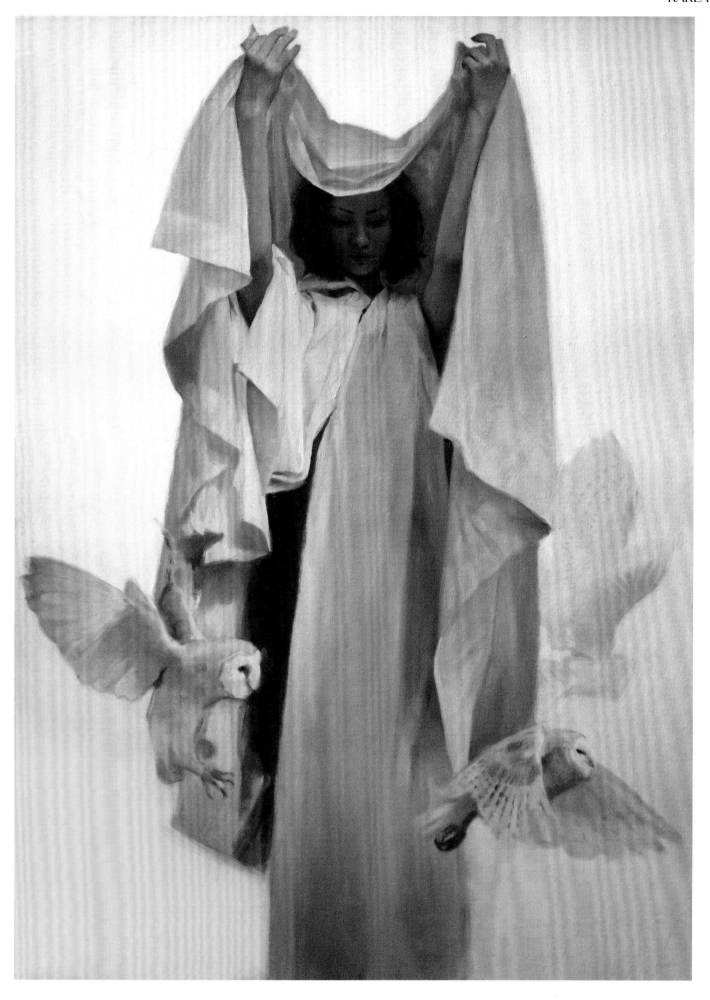

ULTIMUM
Oils, 30 x 40 inches. "Chimerical," Spoke Art Gallery, San Francisco, 2016.

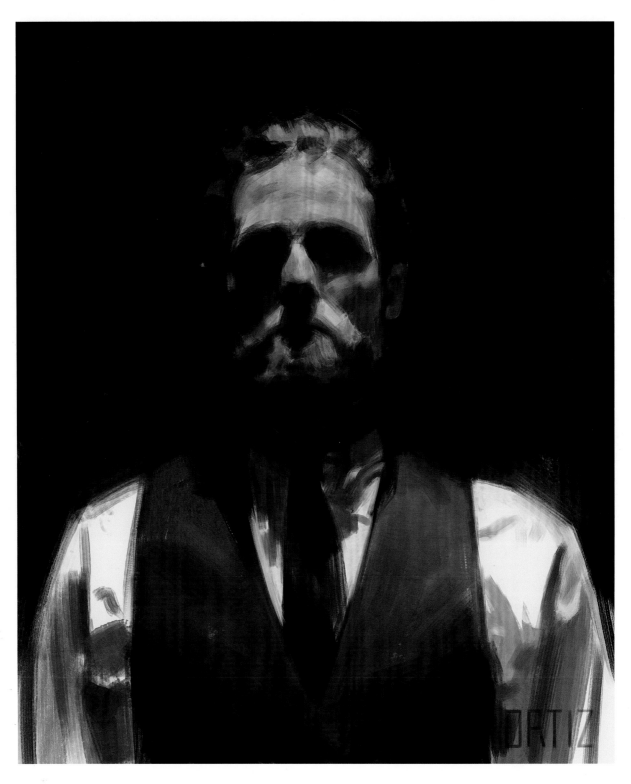

above
THOUGHTS ON DIGITAL
Digital, 2020.

right
HIGH PRIESTESS
Oils, "Amour et Légende," Arludik Galerie, Paris, France, 2017.
I name a lot of paintings based on songs that I like, because I will listen to the song a lot while I'm painting. I loved the name "High Priestess" by Active Child, and I used to listen to that song while creating this painting. I love the aesthetics of robes on people. I love the aesthetics of interesting jewelry. I love the things that feel like they're from the Victorian era, or some unspecified time in our past. It almost feels like an ode to my favorite artists, like a Sargent or Jean-Léon Gérôme, or so many Golden Age illustrators. I'm fascinated by that era. I find great pleasure in painting things that feel of that time but with my own twist.

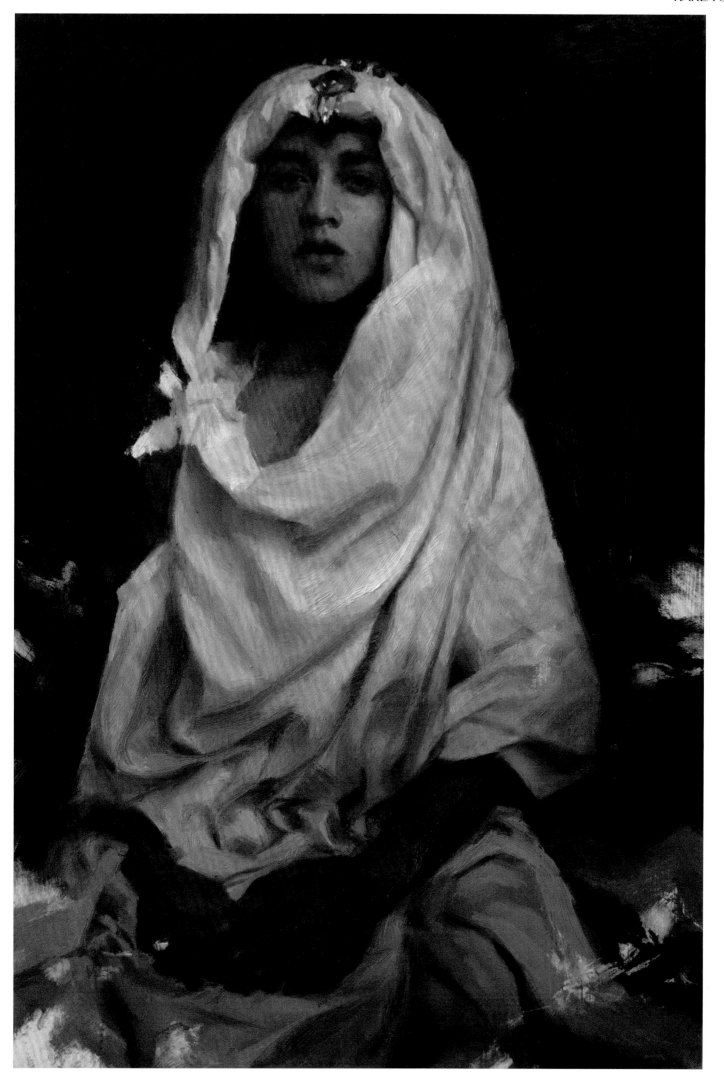

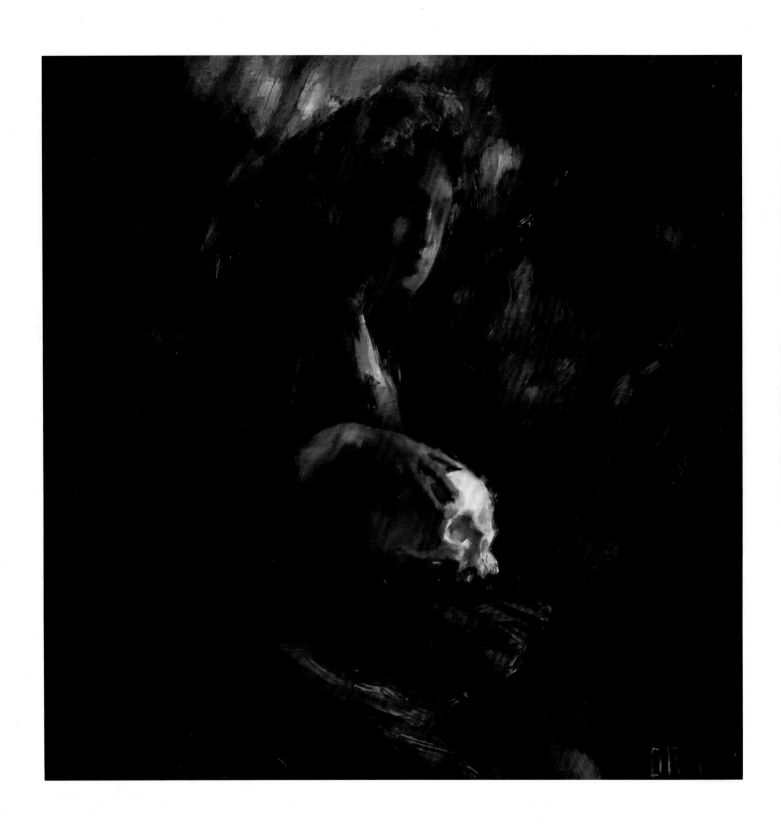

MEMORIAS EN SEPIA
Oils, 12 x 12 inches. Spoke Art Gallery, San Francisco, 2018.

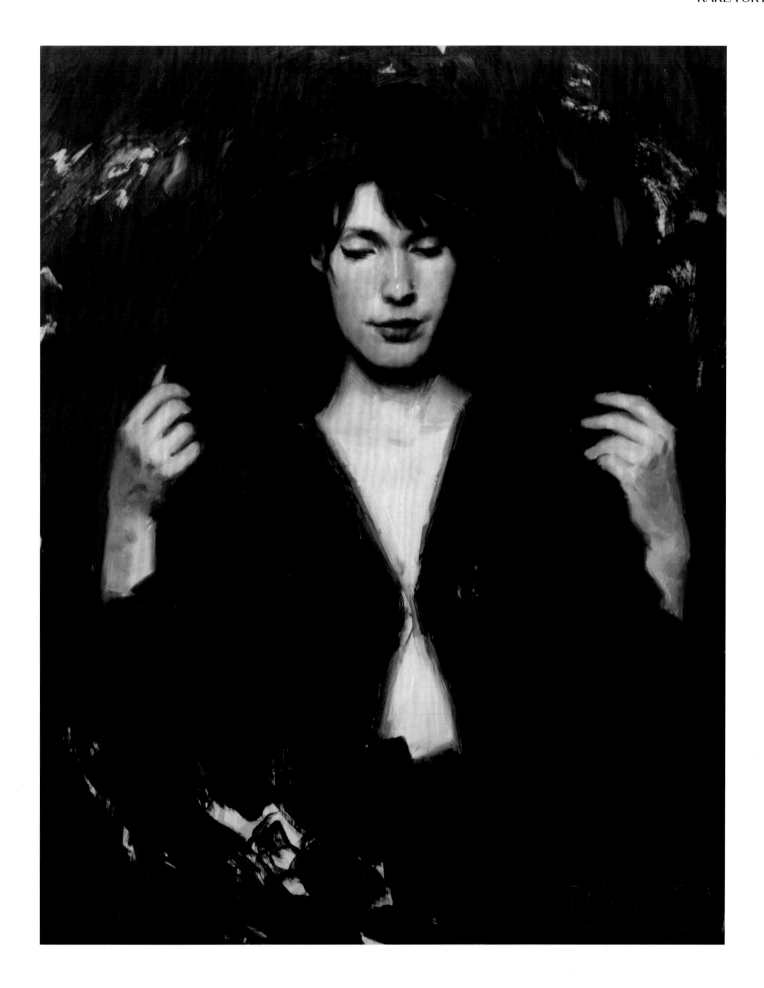

SERENIDAD EN CAOS
Oils, 14 x 11 inches. "Fantasia," Paintguide and Spoke Art Gallery, San Francisco, 2018.

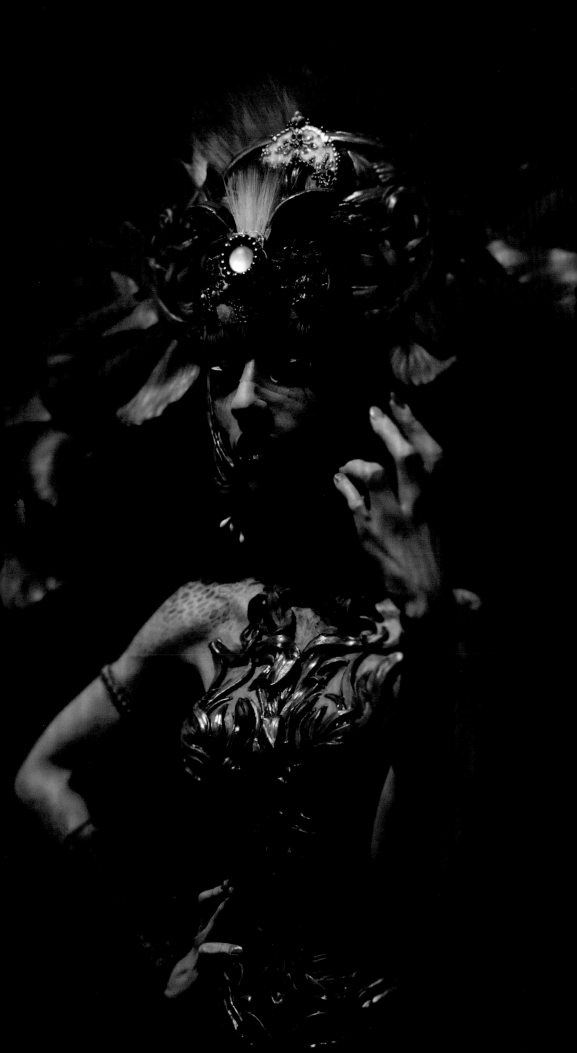

VIRGINIE ROPARS

Virginie Ropars' dolls are deeply personal. The structure, armature, hands, clothes and every other component is meticulously crafted and then joined together by pulling from her life experiences and interests. Her motivation is defined by the mood of any given moment, and nature often serves as a major influence in her work. For instance, Virginie can be inspired by the current season or by how light illuminates an object. Simple items, such as an interesting texture on a piece of fabric, may serve as the beginning of something elaborate and exquisite. She has an uncanny ability to capture inspiration and intertwine it with her fantasy-fueled mind to infuse a heartbeat into her lifelike figures.

Her interest in crafting things began when Virginie was young. A strong bond with her parents and their encouragement instilled an early confidence as she explored her creative side. "I've always been making things—drawing, of course, being the first thing," says Virginie. "But I loved making jewelry with practically anything and sewing clothes for my dolls. I think the spark has always been there, and I can't recall a specific thing or time or day when I started. Being an only child, I was solitary by nature and raised in the French countryside, which might have helped my

creativity. You can't really survive time alone without being imaginative and getting ready to create your fun. Luckily, my parents were true enthusiasts and had the same temperament themselves, so they helped me when I wanted to do something. Like giving me materials and some help and room and time to create and play. Along with opening my mind to different knowledge, we discussed a lot about many subjects. Nothing was taboo, and everything could be questioned and discussed. Thoughts and ideas, as strange as they are, can sometimes be very welcome. And things had to be done seriously even if it was just a hobby."

With her path firmly pointed toward the arts, Virginie entered the MJM art school in Paris in 1993. "I was in the advertising/graphic design section of the school, and it was supposed to lead to a job in advertising," she explains. "I thought that could possibly lead me to anything related to graphic arts, and I was quite happy just being in a creative environment. Working in an agency, for instance, has never been a goal for me."

Virginie began her career by working at Kalisto Entertainment, a videogame-development company in Bordeaux, France. She worked with its racing-car games team for just over five years, from 1997 to 2002.

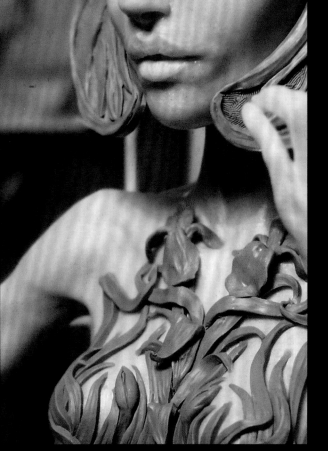
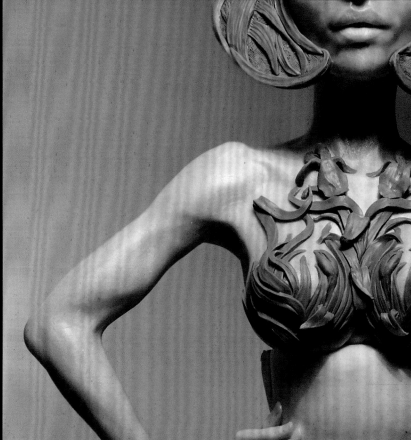

IRIS NOIR

Virginie created a series of dolls based on a single flower. Her first effort used a poppy for inspiration.
This was her second effort, and it was inspired by a black iris. When designing its look, she found some
fluorescent pink-colored materials and thought they would provide an interesting complementary color
to the black found in the flower. She decided to use pink highlights for some of the details, such as the
nails and hair.

Thinking back, she admits that this is a little humorous, since she doesn't drive or even have a license. She started by focusing on textures that would appear in the game, then she went on to make props. The company eventually ran into a problem, however. "Kalisto shut down after the dot-com bust in the spring of 2002," says Virginie. "Then I was unemployed for nearly a year. I was approached by Ubisoft in Montréal, Canada, during that period. They tried to get all the French CG artists who were unemployed and struggling to find work in Europe. I wasn't ready to be an 'expat,' so I declined. Instead, I got a job for nearly a year working for Antefilms, making modelization for Season One of the cartoon called *Pet Alien*, a French/American production. I made some inside and outside sets and tons of props. I was working from home, as the company wasn't able to get enough room in their building to have all the employees working in the same place."

While it was a job, Virginie felt unfulfilled and was not enjoying her work at Antefilms. "At that time, working conditions and salaries were dreadful," she explains. "The impact of the dot-com bust lasted for many long years. I was a bit fed up with the whole thing and wasn't optimistic for the near future in this field." The pressure created a stressful environment at the job, and Virginie also grew tired of working solely on computers.

Needing a break, Virginie visited her parents in Brittany, France, in the fall of 2003. Over a weekend, she decided that she wanted to work on something personal and had a sudden urge to make a doll. Virginie didn't know anything about crafting one, nor had she met any other doll artists. "I wanted to make them with fabric at first," she says, "but not specifically just the clothes in fabric. I wanted to make the faces and hands with fabric too. I knew the work of Julien Martinez, who was a doll artist in Bordeaux. He used to decorate a shop window with his dolls for the end of the year festivities, and I really admired his work. He used polymer clay, so I changed my mind and told myself it would be good to start with polymer instead of fabric for the head, hands and feet, because I loved the result he had and also it looked much more limitless in terms of creativity."

Virginie's first attempt wasn't ideal, but she persisted. "The thing I like the most about what I do is that there is so much that is involved in making one piece of work," she shares. "You have sculpture, but you also have

to make clothing and to paint. There are a lot of fields in what I do. You can always improve in one field. I never get bored." Virginie wasn't sure what the future held for her at the time. Her ongoing struggles in the animation and gaming work environments in France pushed Virginie to focus on her own works. It didn't take long for her to realize that she wasn't interested in working for a company again.

After making her first doll in November 2003, Virginie immediately made a few more. She visited Paris Création, a local doll show that ran just before Christmas. "I wanted to get some feedback about my work from doll artists who were exhibiting there," she says. "I also met Julien Martinez there for the first time, knowing his work had already been shown in Bordeaux for several years. Several doll artists to whom I showed my work told me that there was a doll show coming up and they all thought I should submit my work for participation." This resulted in Virginie being accepted to Pygmalion, a one-day doll artist event in Paris that was held in April 2004. She then exhibited at Paris Création twice a year for several years.

As the internet became more widely used, Virginie created a page on the social-networking site Myspace in late 2005 or early 2006 to promote her dolls online. This effort paid off, as she was noticed by the Strychnin Gallery in Berlin. The gallery featured many well-known artists in the lowbrow genre and was owned by Yasha Young, who continues to support creativity and artists through her Yasha Young Projects activities. She also organizes a yearly art prize for *Beautiful Bizarre* magazine. The two women met in Paris, where Yasha proposed that Virginie participate in future exhibitions at her gallery. Virginie started to show her work in October 2007 at Yasha's new location in London, followed by her original location back in Berlin. While the gallery is no longer open, it helped by getting Virginie recognized by a larger fan base. She also started to show her work in Moscow during the Christmas season each year. "The place in Russia was called the Wachtanoff Gallery, but it doesn't exist anymore," says Virginie. "They used to host an international art-doll show in December. I exhibited four years in a row, from 2006 to 2009."

Meanwhile, in February 2007, Virginie and several other artists were pulled together for an exhibition in New York City titled "Magnum Opus." She arrived in the city for the first time in her life carrying a big cardboard box with her latest doll. "The 'Magnum

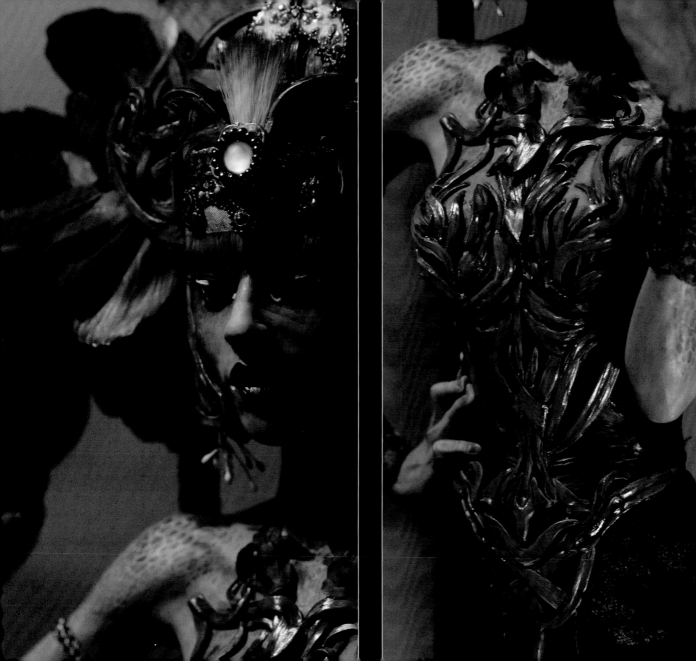

Opus show was a special one-day exhibition organized by the doll artists Tom Francirek and Andre Oliveira," says Virginie. Her name grew across several continents as she traveled from Paris to London, Berlin, Moscow and then the United States. Her dolls resonate with a wide variety of cultures and regions throughout the world. "A lot of people respect my work for being very original and one-of-a-kind. But also because each one is artistically very different." Always looking for new ways to showcase her dolls to a wider audience, Virginie submitted her work to the fantastic-art annual *Spectrum 15* in 2008. A handful of pieces were selected, which helped garner additional attention for her pieces in the United States.

Ever since striking out on her own, Virginie has learned to embrace her vision. She quickly realized that she thrives when not working under the supervision of others. "When it comes to personal work, it's important to have your inspiration and your own flow of ideas in your head," she says. "Having fun while you work is essential. The work won't be good if it wasn't fun to work on, and it shows eventually, leading you and the viewer to disappointment. Feeling yourself happy with what you do is the most important thing."

Virginie also avoids the trap of following the guidelines or rules imposed upon her by those who commission her work. "When I started, it was clear for me and clear for people who have been following my work that I'm the only sailor, the only master in the direction that I want to go," she says. "When you read interviews about people talking about their work and the bad experience they have with a company—or how they struggle with contracts and such—it's sad, because those people have an inner world to express and are trapped into a certain kind of work or way to work. They can't get out, since they don't have the time or possibility to get out. When you can get yourself in a sort of job/money flow and work a lot, you are able to be more comfortable in your life eventually. It's natural. It makes the future less uncertain for you and your family. Or you can be in a situation where you struggle a lot to find contracts and jobs but there is no other way to go, because you have yourself and a family to support. Or you simply don't want to work without contracts or without getting hired. It can become risky to say 'no' to these ways to work in order to exclusively do your own stuff, even for a while. It literally means taking the risk to lose jobs or to miss jobs. But when you do your own stuff and follow your heart as your working compass,

you learn to deal with a perpetual foggy horizon."

"The fact is you have no choice—it's part of the package, and you must get used to it," she adds. "So you have to love solitude, trust yourself and your guts all the time, learn to be relaxed about what may or may not happen and be 100 percent sure about all this, or you get an awful lot of anxiety that leads you to many dead ends and disappointments. I know, when I talk like this, some people think I am crazy to make this choice for my life. But I learned it's the only way for me to be happy at work and in life. I understand that not everyone can do this. If you want certainty about the future, also for your family, you can't really work as I do. It's not safe. Many said to me, 'It's a luxury.' True. But it is also a great risk and a high price to pay. Fortunately, it also comes with great rewards."

For these reasons, Virginie rarely takes on commission work. She prefers to work on whatever she wishes, and collectors can buy her dolls if it moves them. "Some people will come to me with a theme to work around," she explains. "I always tell them that I will only do something if I am happy with what I do. I don't follow what they want. It's very clear at the beginning, and most of them are OK with that. I previously had requests for commission pieces for people who were eager for a very special look. They would ask me to make a face that looks like a piece I did years ago, or to use the position of a body that I made years ago or a set of colors that they liked. But it's very painful for me to work like that. In fact, I know from instinct that my work will be weak, and people will be disappointed, and I will be disappointed. It's no use trying to make something this way because it's the wrong way to make it. I actually always said 'no' to this kind of commission. And I always try to get all the freedom I want. If they are finally OK with my requirements, I can possibly work for them. But, really, it's not a good place to start a work, because it is I who eventually bent the person's demands. I prefer when it's clear from the beginning, with people coming to me like: 'I give you this theme to work on, and I have total faith in you, your eye and your skills to make something good.' When you bend an artist, you won't have good work."

There are a few exceptions, when Virginie *will* take on an assignment. "I worked for Wizards of the Coast for a Dragon+ magazine cover in 2015," she recalls. "I enjoyed working for them because it was very easy. The art director left me free to imagine things, and she

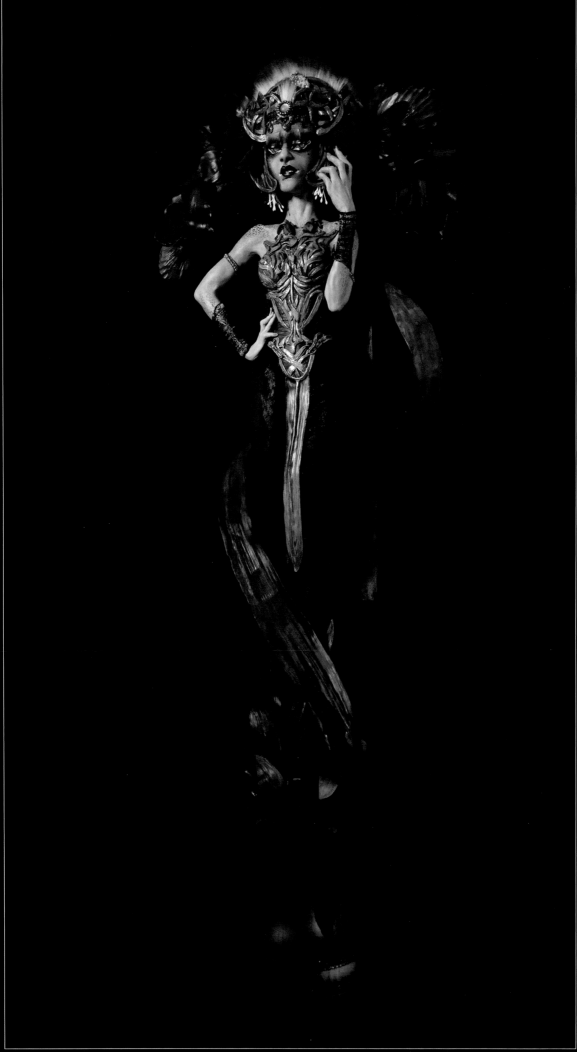

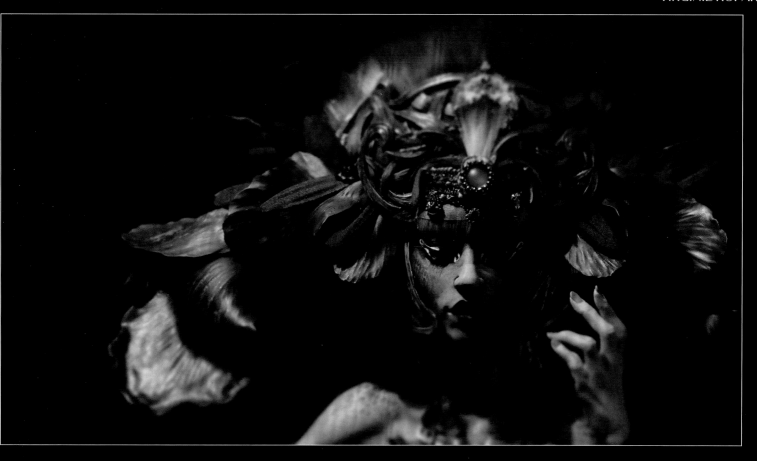

understood that the work will be better at the end. I like working with others. Especially when the team is working well together. Yet my core and essence is solitude."

Virginie starts a new piece by focusing on the head. "The face is very important," she notes.

"It gives you a character, mood and emotions to follow." If this initial stage is not working out, she will destroy it and then start fresh the next day. "I think to destroy and get rid of things when it's not good enough is a good thing. You can't rely on anyone. If you are tired or having a difficult time, you have to deal with that all alone. Even if you have friends helping you, you are the work itself. Without you, nothing will come out. If you did not get the results that you wanted, you are the only one to blame. It requires a lot of dedication to your work. If you aren't prepared for that, it's not good."

Once Virginie has finished a new doll, it is not difficult for her to let it go. She likes to have them around for a few days, however, to give her a chance to have a fresh look and make sure she did not miss something. It has never been a problem to sell her work. "The next work is always the most important," Virginie explains. "I have my mind ready for the next thing. I'm always creating and pushing things in my mind. I still have the first one that I made, because it was the first and I wanted to keep it. It's the only one I have."

Virginie is a naturally curious person and open to learning new things from others, such as when she recently took some jewelry and silversmithing classes. "When someone knows more than I do, I am open to learn from them," she admits, "but I really learn things when I do them myself. If someone is giving me advice or telling me what to do or what would be best for me, I take the thing they say—but I will always focus on what I really want for myself, what my instinct tells me. I've never just followed what people tell me to do. Imposing things on me is not the best way to get things from me. Aside from that psychological aspect, there is always a moment when your body tells you things. You know when you are doing things right or not—especially when you've learned to deal with various materials and techniques for long years. Being connected to your body and hands really helps you to deal with any new material or technique. Whatever you make, everything is about trusting yourself."

Virginie is someone to admire for her dedication to her craft. It is rare to find an artist who is so personally invested in her own creations and who can channel nature and her own emotions into works that resonate across the globe. It is as if she takes a part of herself and sculpts it into the heart of each of her dolls. Perhaps this is why Virginie has no trouble letting them go— knowing that each doll is an extension of herself and will be cherished and preserved for future generations with a life of its own.

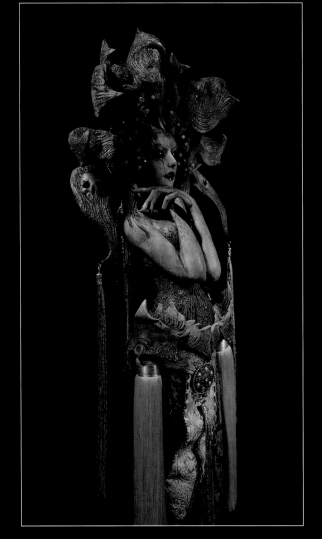
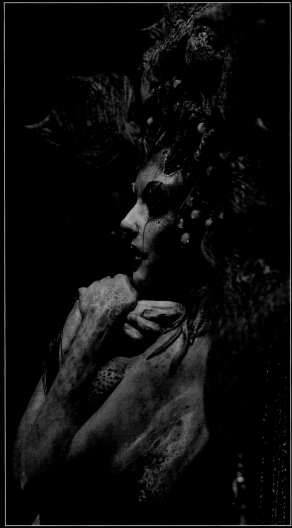
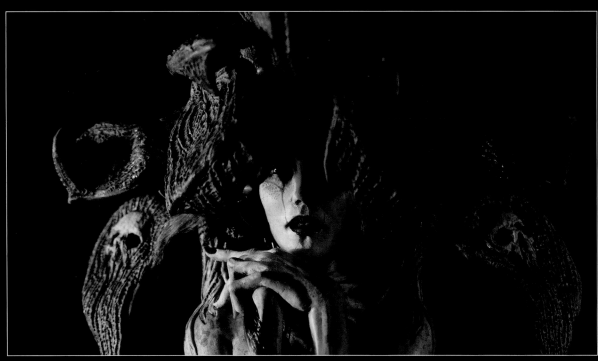

ACANTHOPHIS V

When making this doll, Virginie challenged herself to experiment with moving parts. She was not interested in making adjustable arms or legs like you see in most dolls, but instead wanted to fabricate something that was more like a moving decoration. She bought eyeglass hinges and came up with the idea of a shifting crown that could fold in to become a helmet. She decided to use pinkish red and light turquoise for its theme.

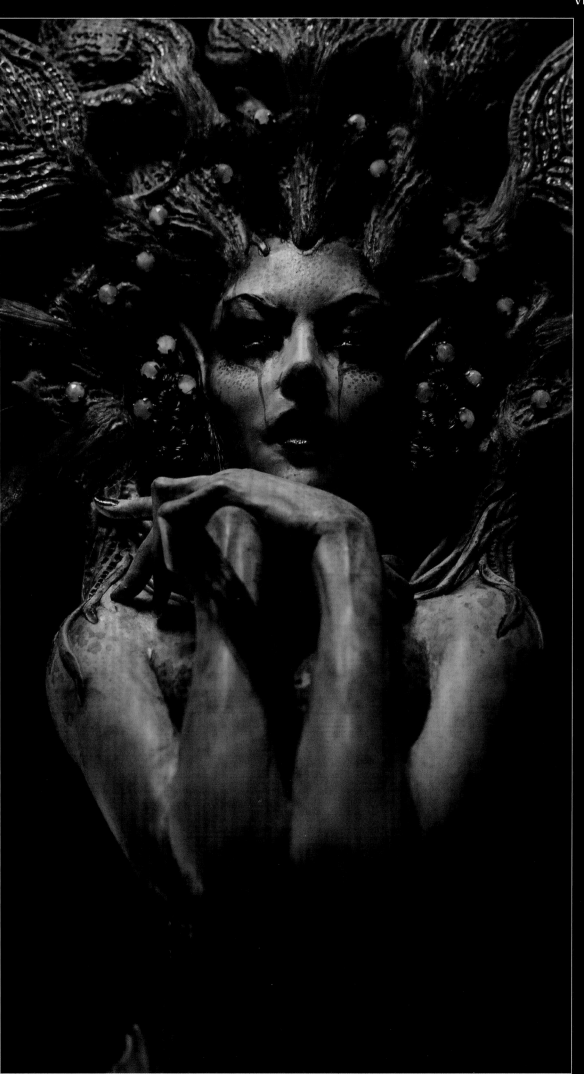

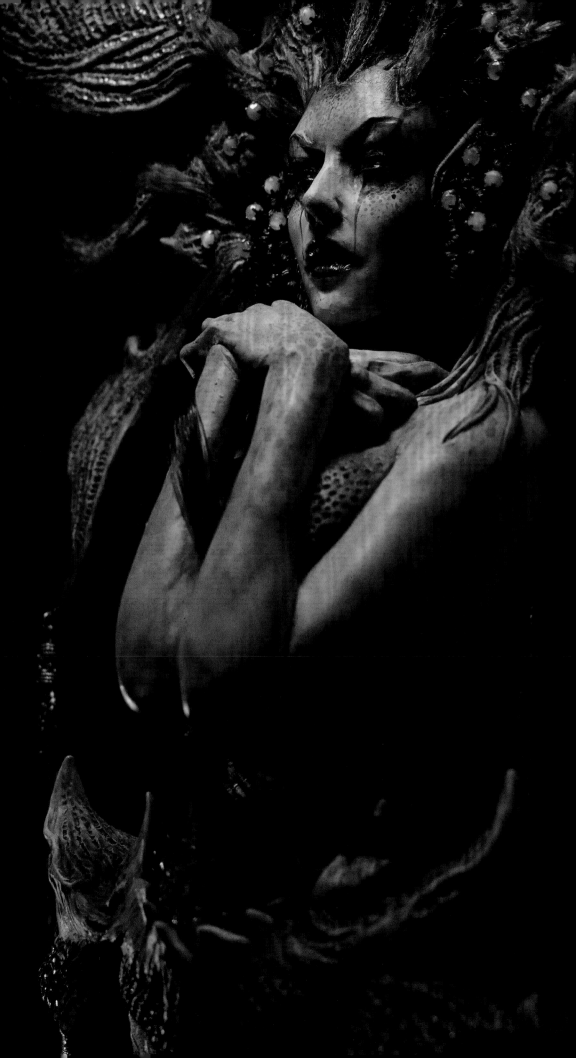

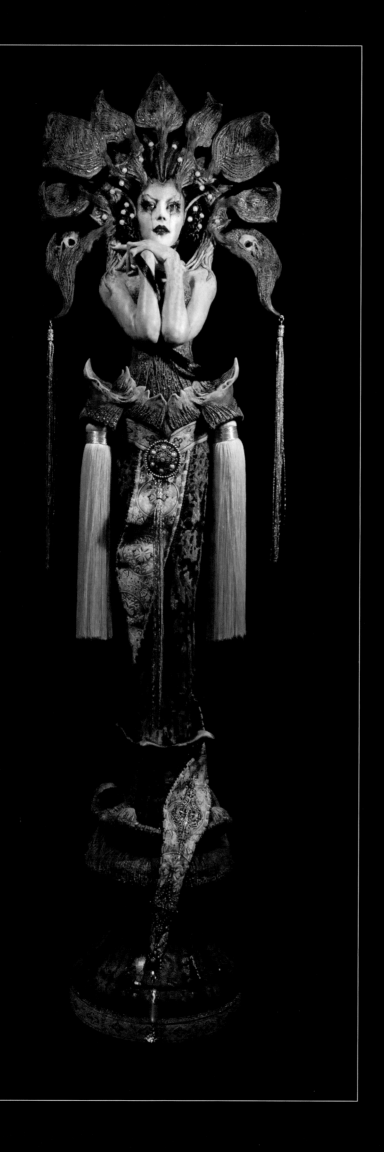

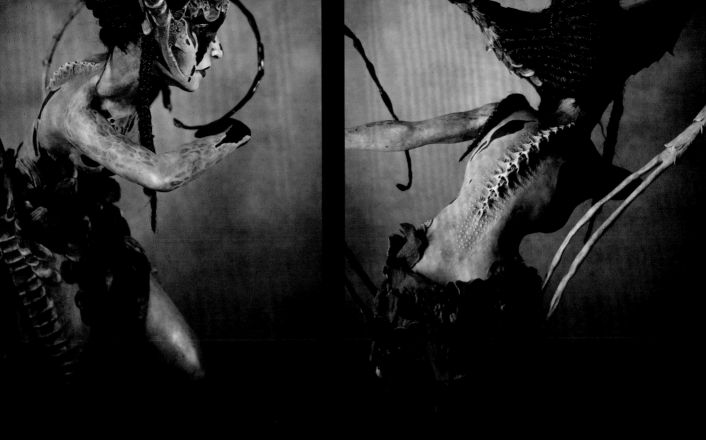

ACANTHOPHIS VI

This doll was originally inspired by the Goliathus beetle. "They have these white lines with a velvety texture and a cool design," says Virginie. "It's the first idea I wanted to work on for this piece, but after that my imagination took me to other places." Virginie channeled the insect theme when designing the head and big brown eyes. Though she may have started with this single theme, other inspirations began to expand her vision. She also was influenced by Rorschach-test inkblots and the fictional character Cheetara from *Thundercats*. Virginie does not draw directly from these inspirations but uses them as springboards for ideas. "I worked with the memory of the cartoon, which is very different from the real cartoon," she explains, "but it was an influence during this work."

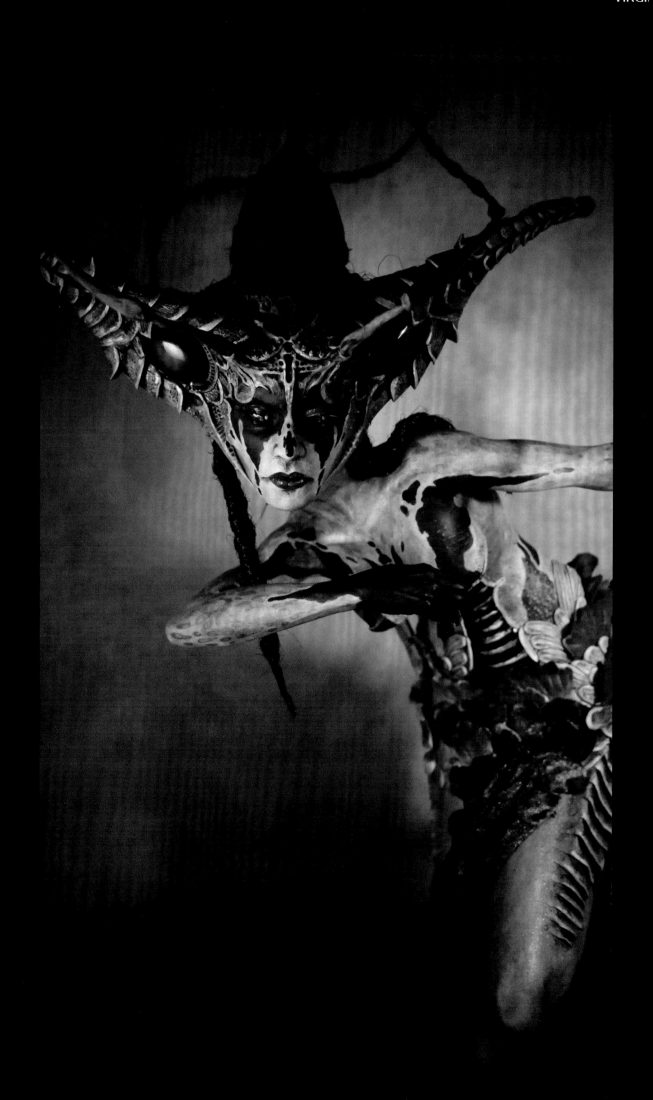

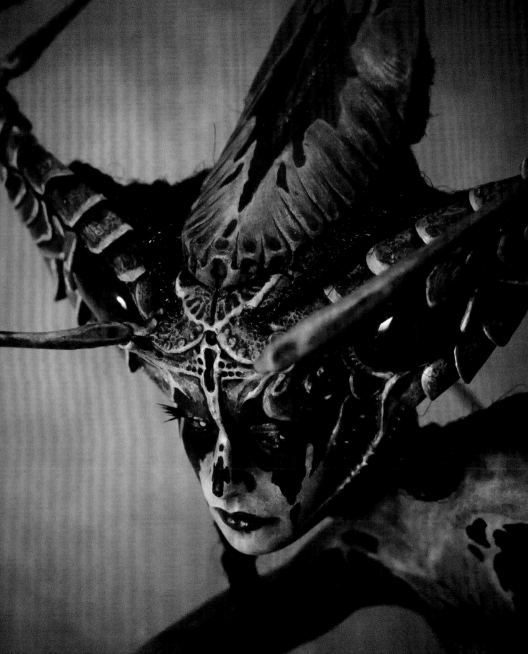

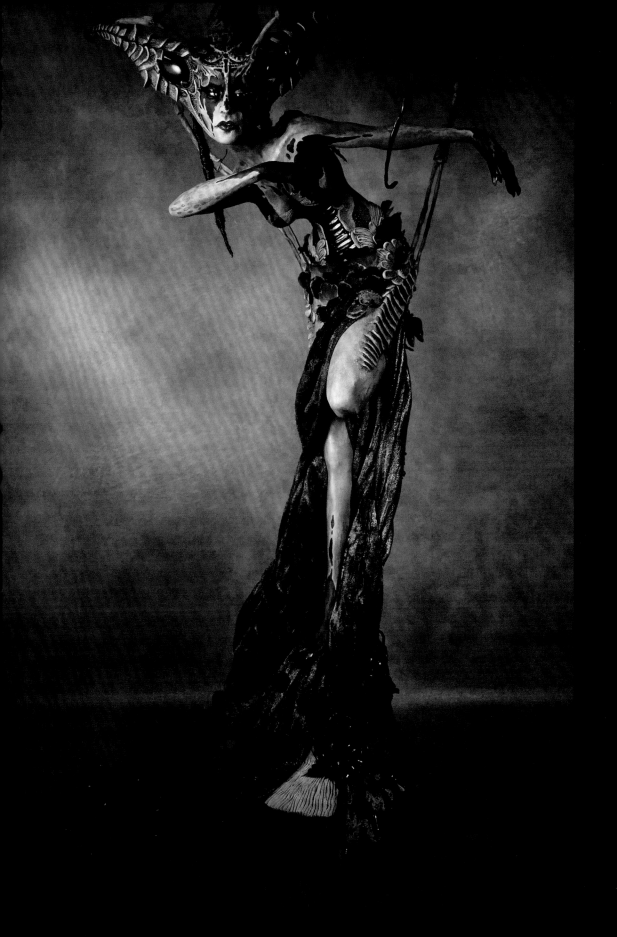

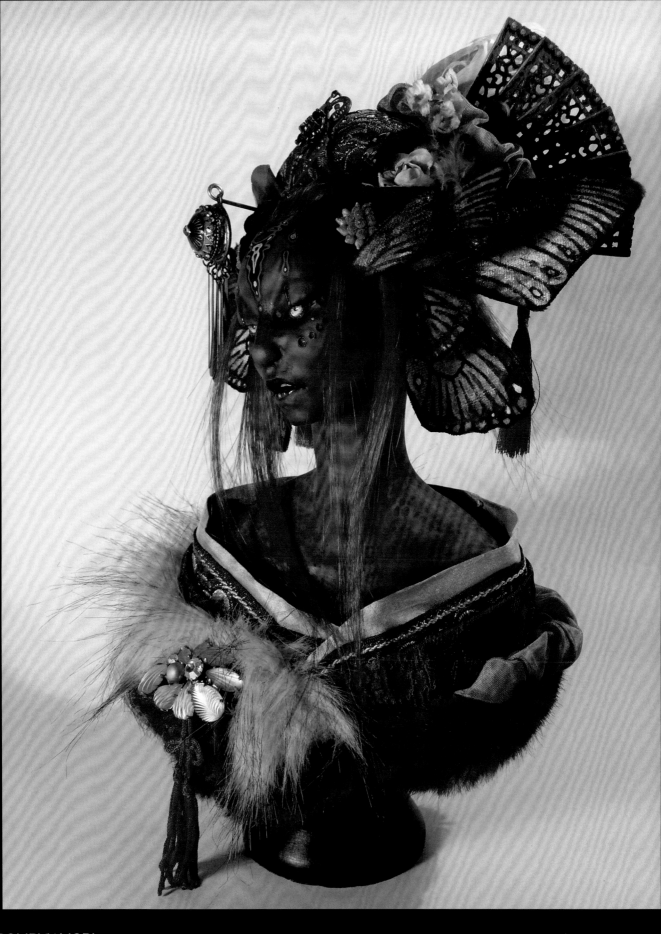

BOMBYX MORI

Virginie was influenced by two different subjects for this piece: the domestic silk moth—or *Bombyx mori*, for which this piece is named—and Japanese culture. She also was drawn to the idea of making the figure's skin red. Virginie chose turquoise as the complementary color, since its combination with red is very appealing to her.

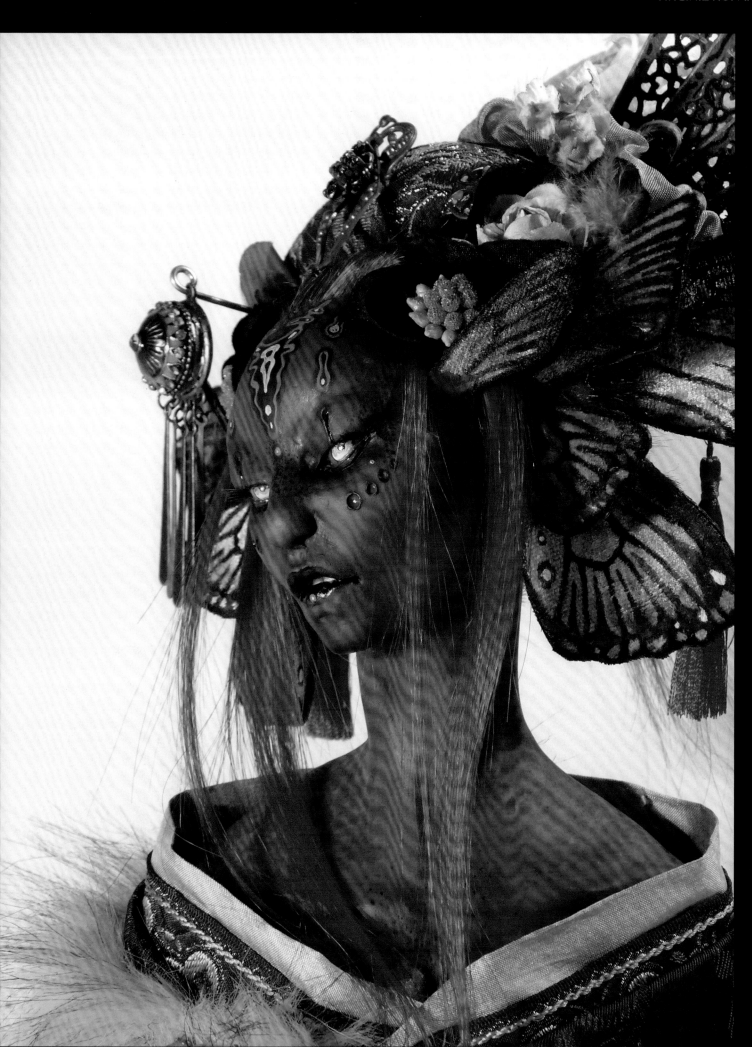

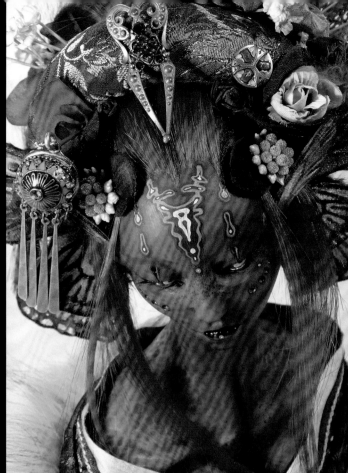
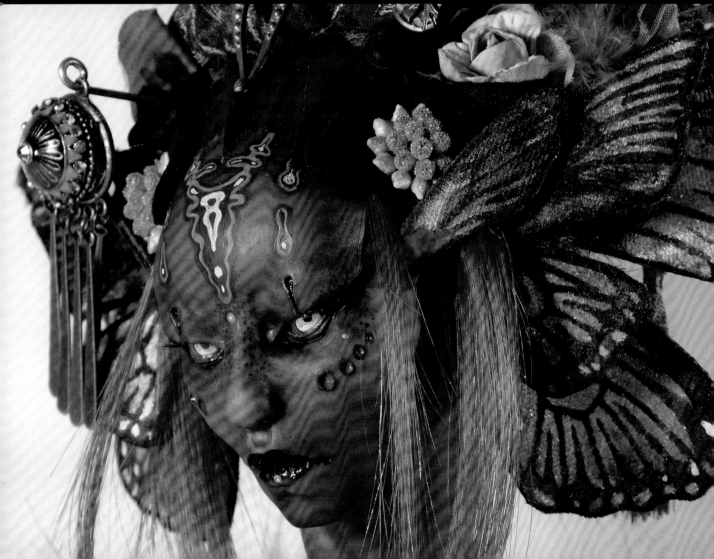

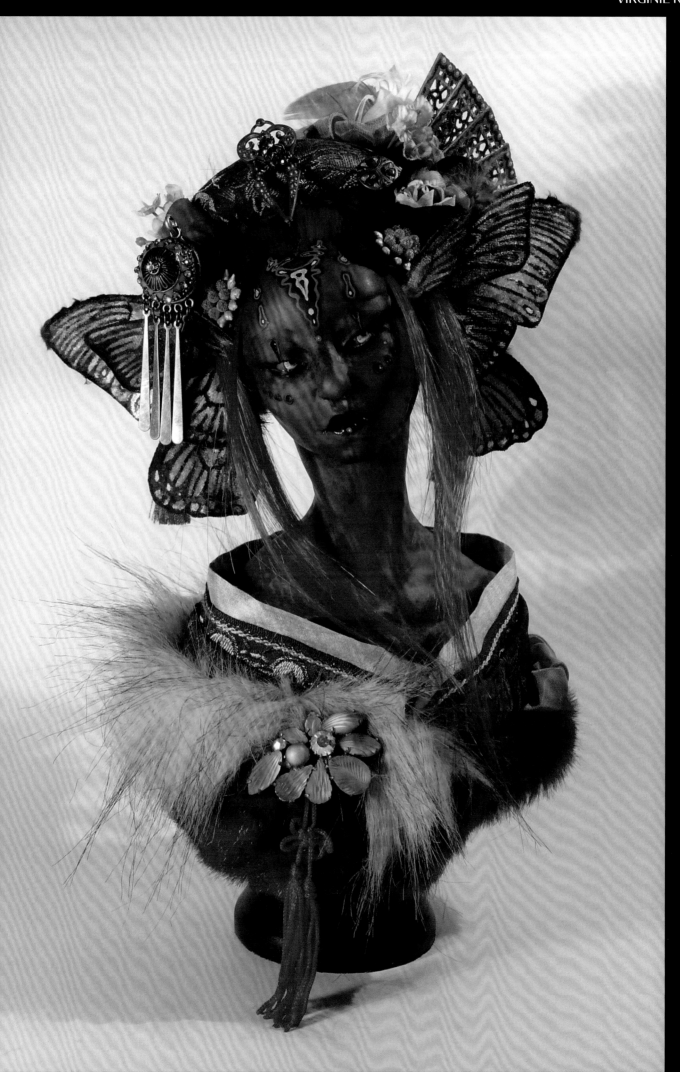

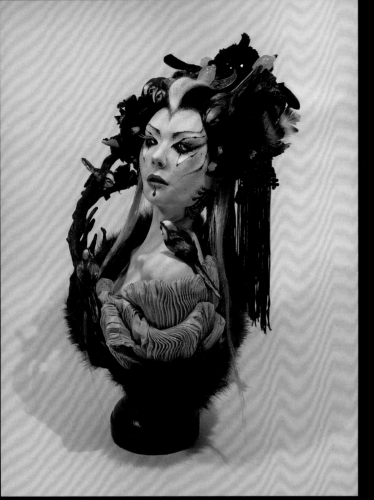
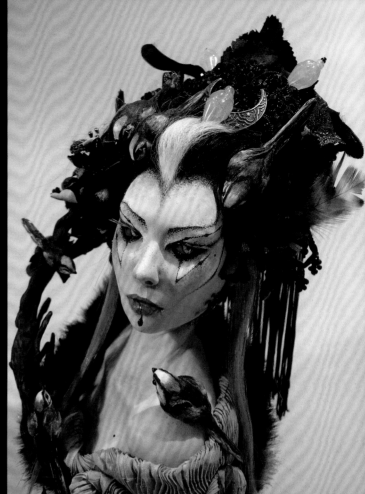

GATHERING

This doll was based on a tiny bird known as the *Mésange à longue queue*, or Long-tailed tit, which lives in flocks along waterways in Europe. Because Virginie's house is very close to a river, she sees them daily and loves the way they look and sound. She wanted to create a bust that featured a central figure surrounded by a gathering of these birds. When choosing the look for this piece, she wanted to stay true to the coloring of the species, so she used a mix of black, brown, pink and beige materials.

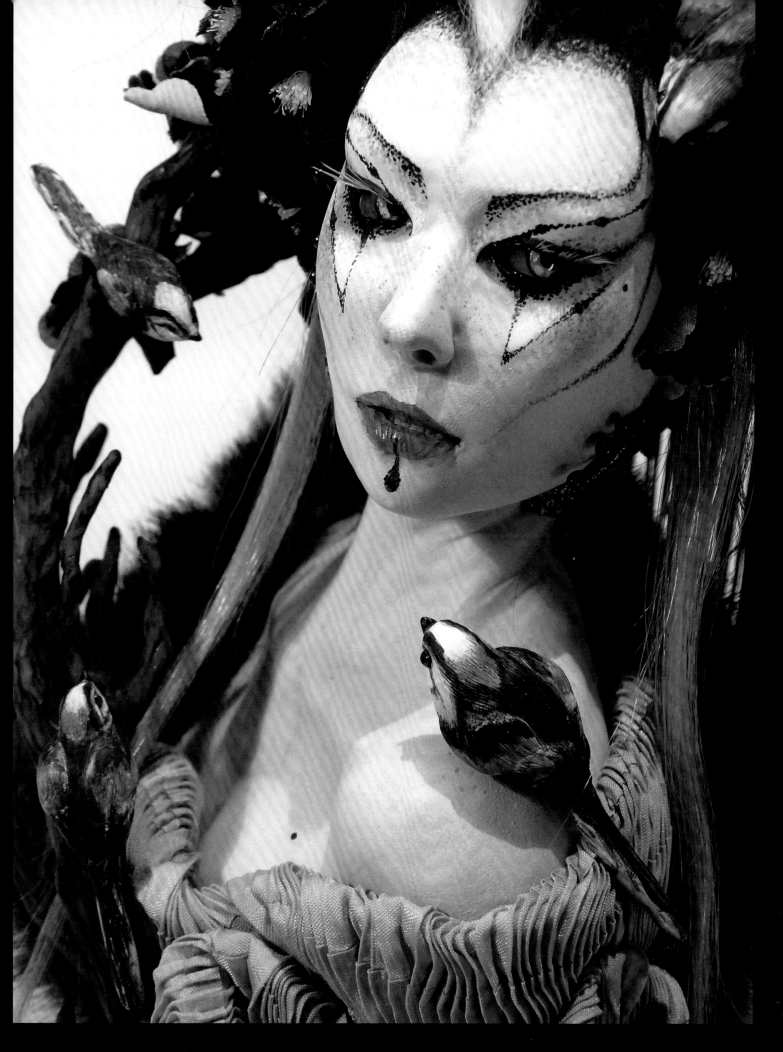

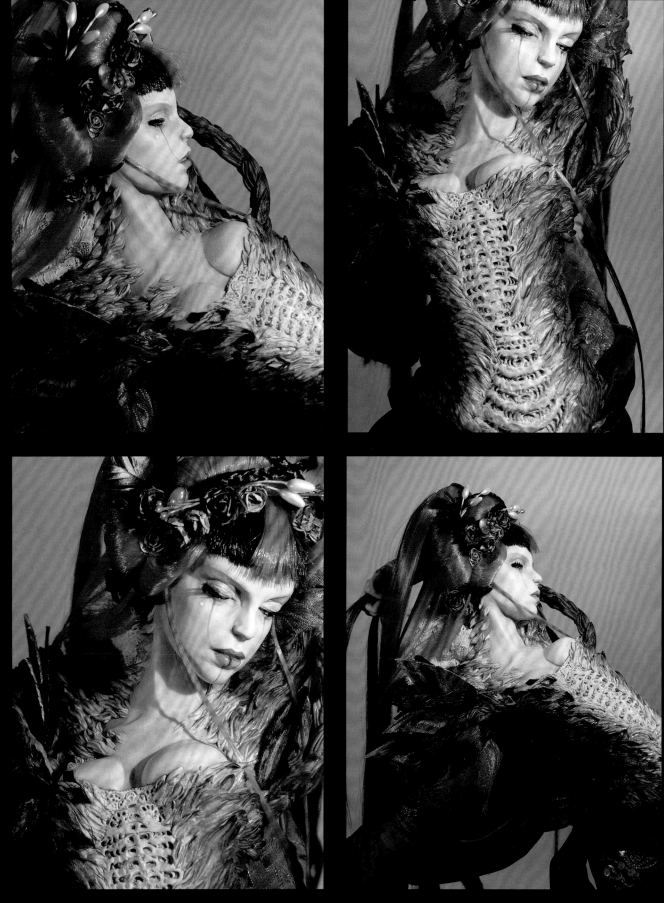

MOTHRA

The original spark for this doll came from Mothra, the fictional Japanese giant monster that appears in many *Godzilla* films. Though she may have started with Mothra in mind, the piece evolved dramatically as she worked. Virginie usually starts with an idea or a theme, but the piece often takes on a life of its own as she progresses and becomes something she cannot predict. "The spark is sometimes very clear, and at other times it's a complete mystery," she admits.

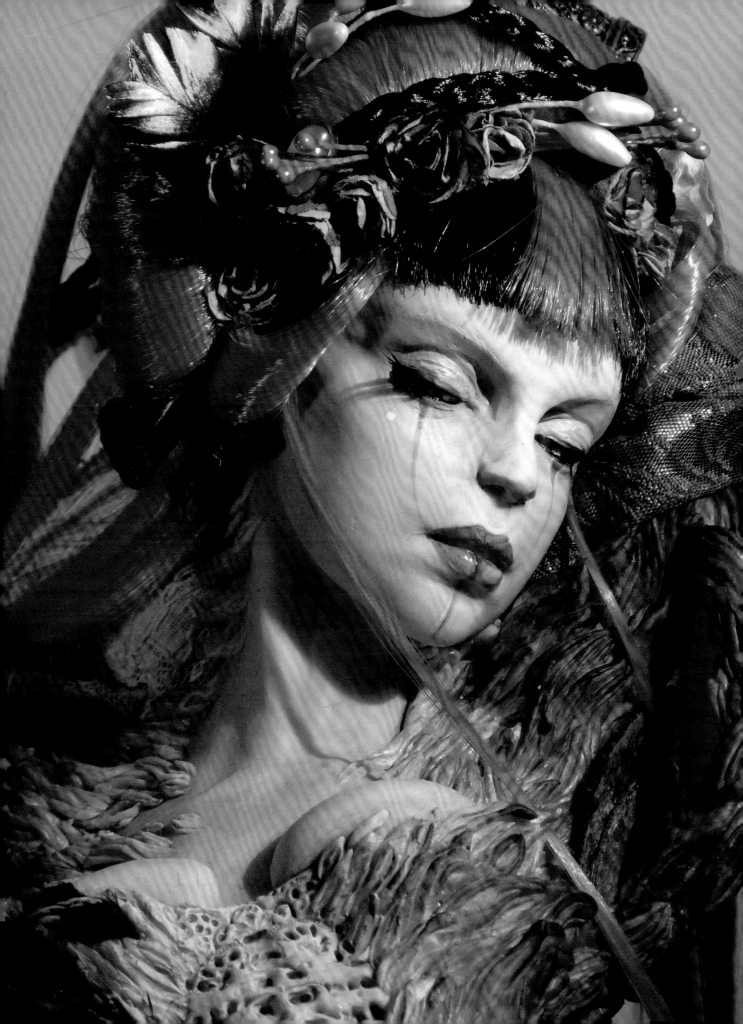

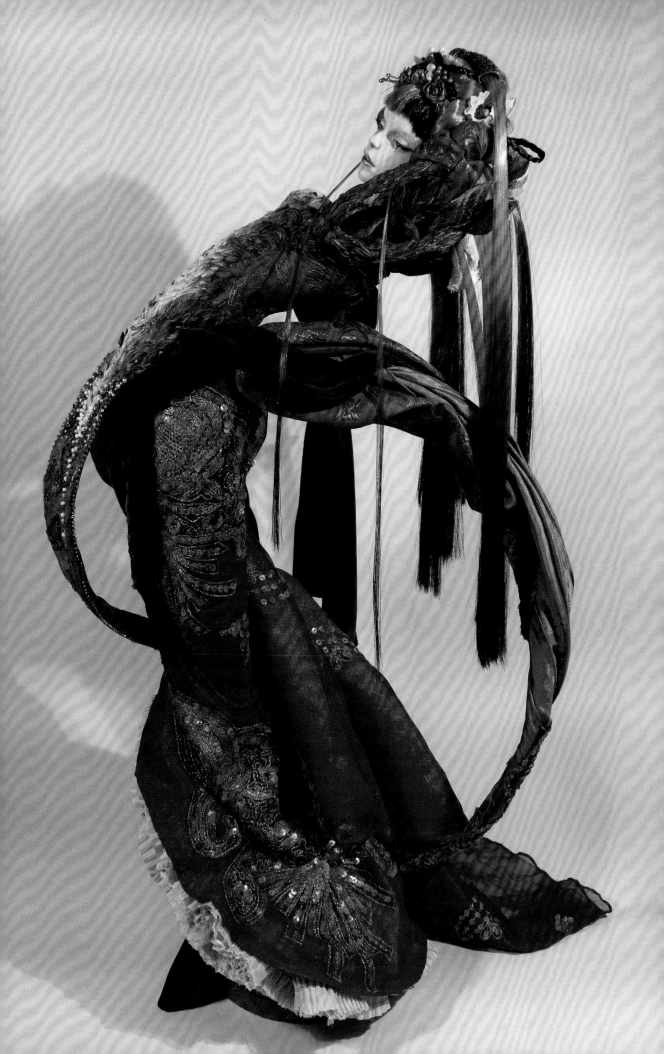

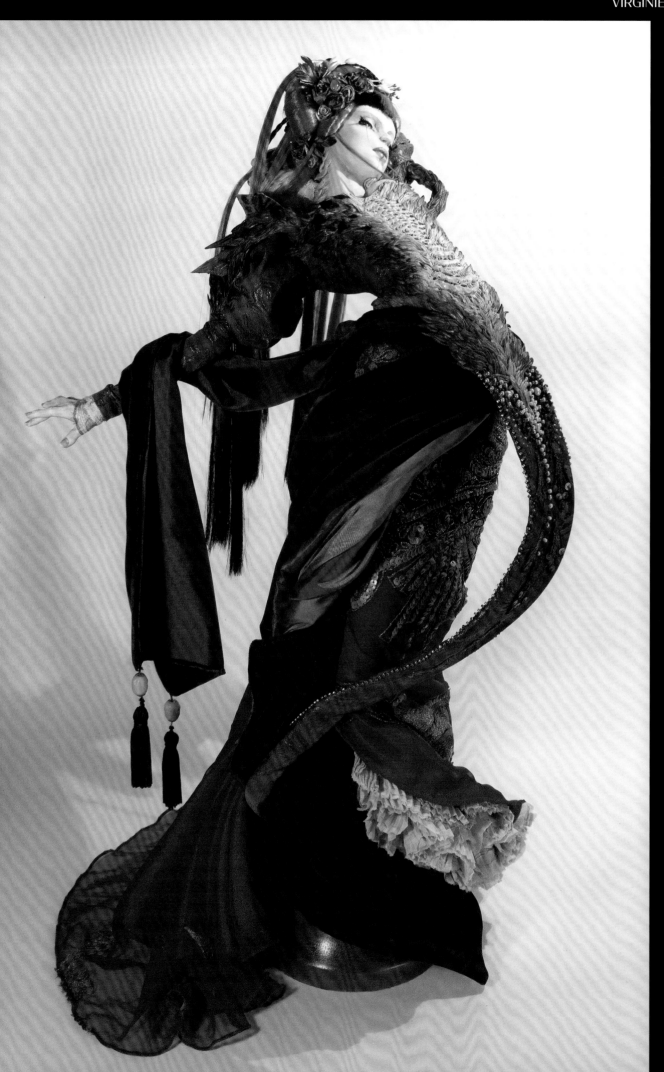

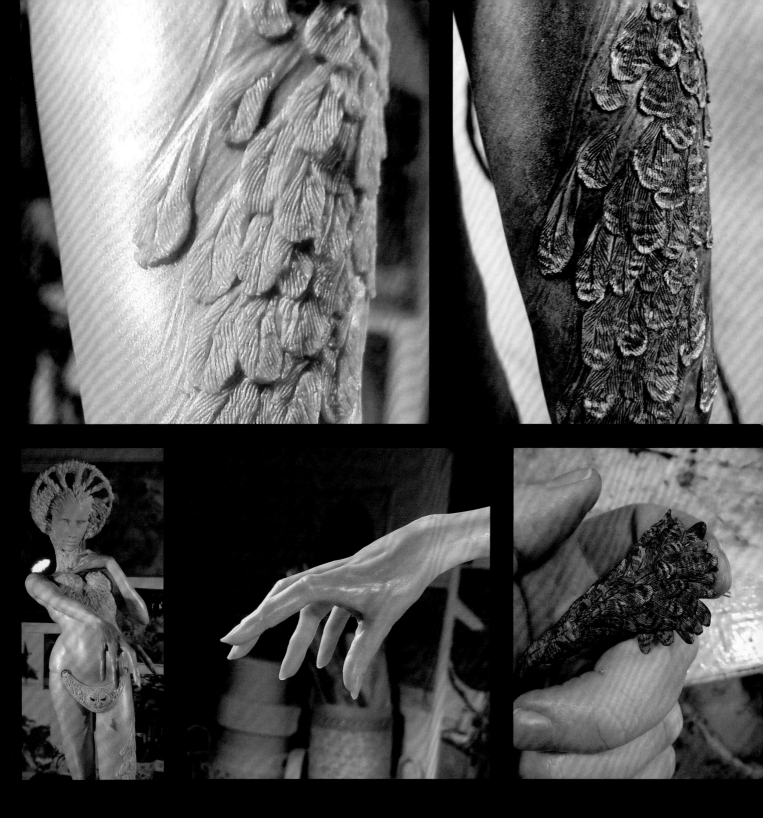

STRIX

The main theme for this doll stemmed from a Strix. According to Greek mythology, this night creature was considered malevolent and a bad omen. Virginie also wanted to include another creature that thrives in darkness, so she added some owls to the foundation. This is one of the few pieces where she had a friend pose for the figure's face. On rare occasions, Virginie finds that it improves her skills by working off a live model.

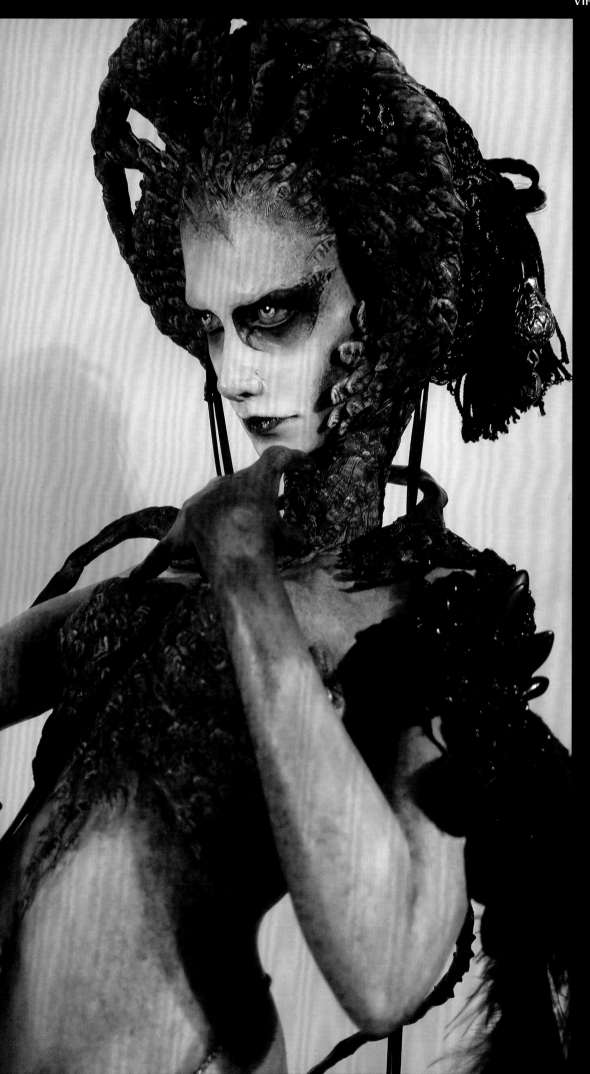

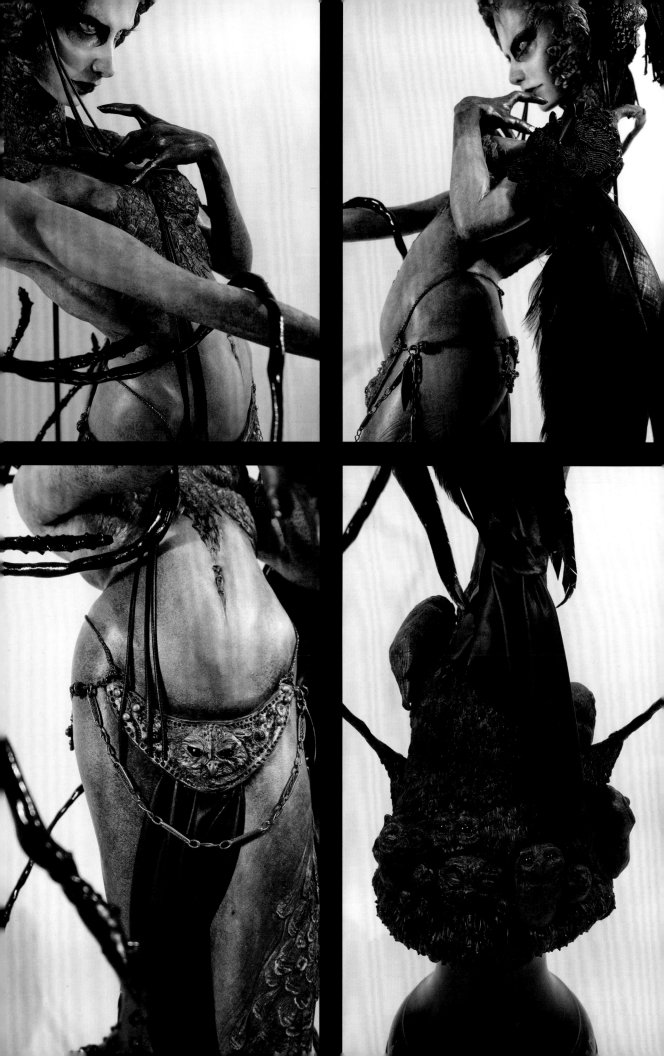

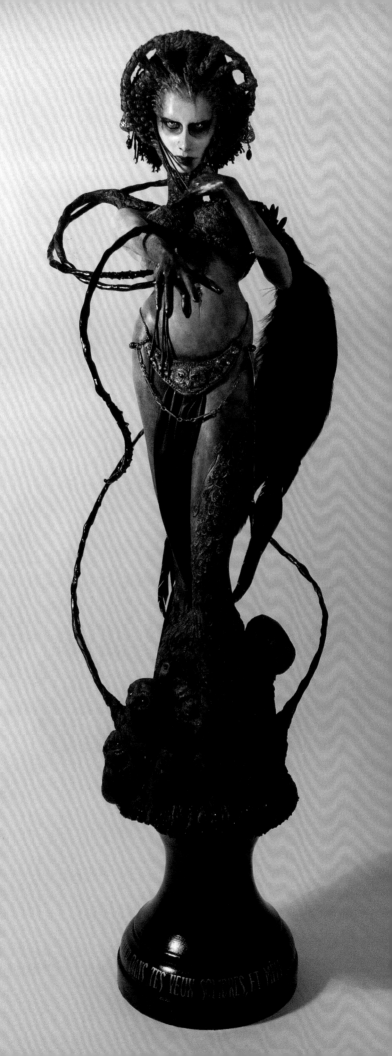

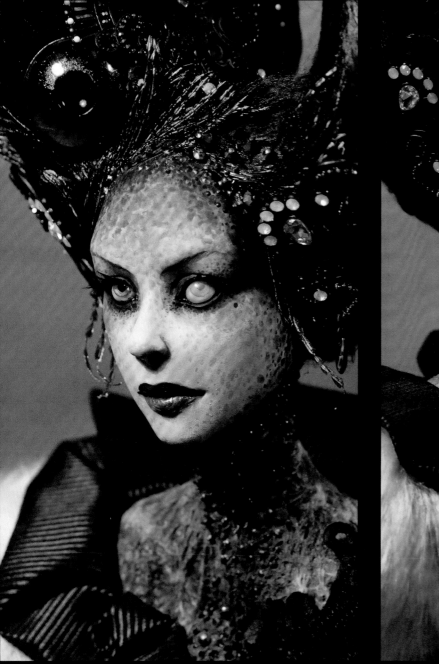
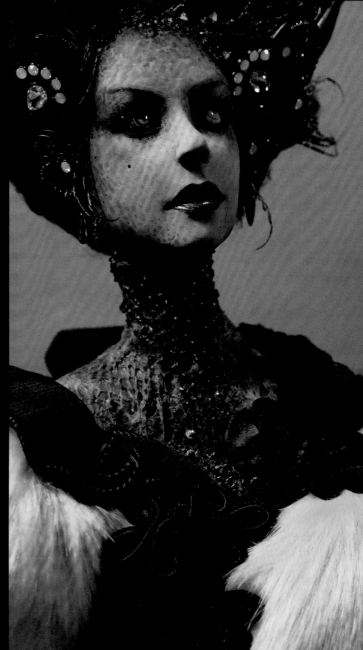

THE EVIL EYE

The main theme for this piece became the evil eye. Virginie chose to use green material because it represents witches and monsters. She also was inspired by a bright mint-colored faux fur that she had found. She combined it with other green and black materials to create this look. She then made the eyes two different colors and added a big eye in the figure's hair. When photographing this bust, she specifically chose a gray/violet background to help make the green pop.

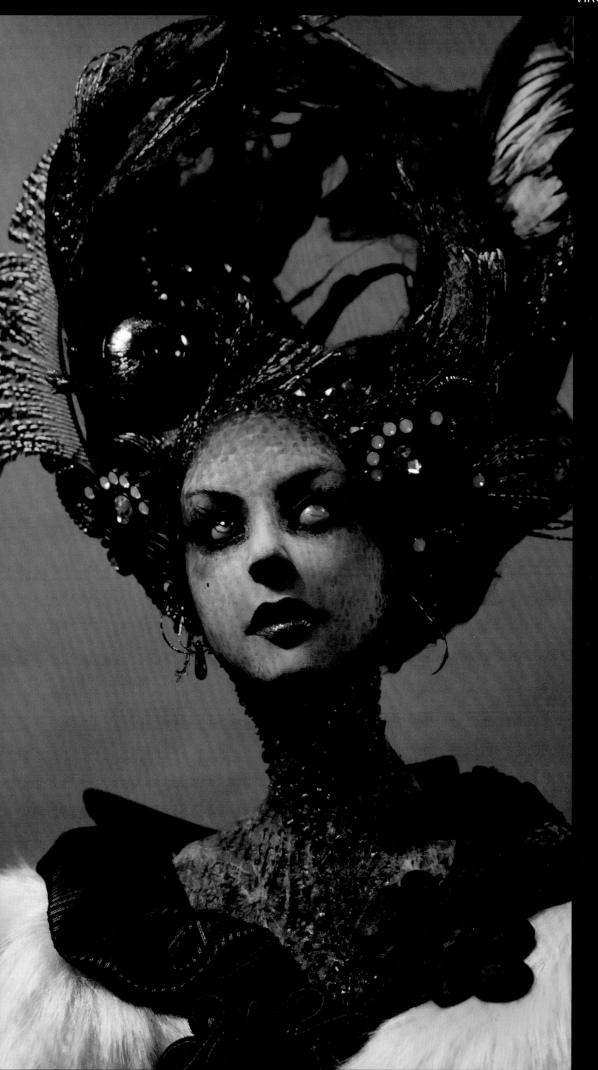

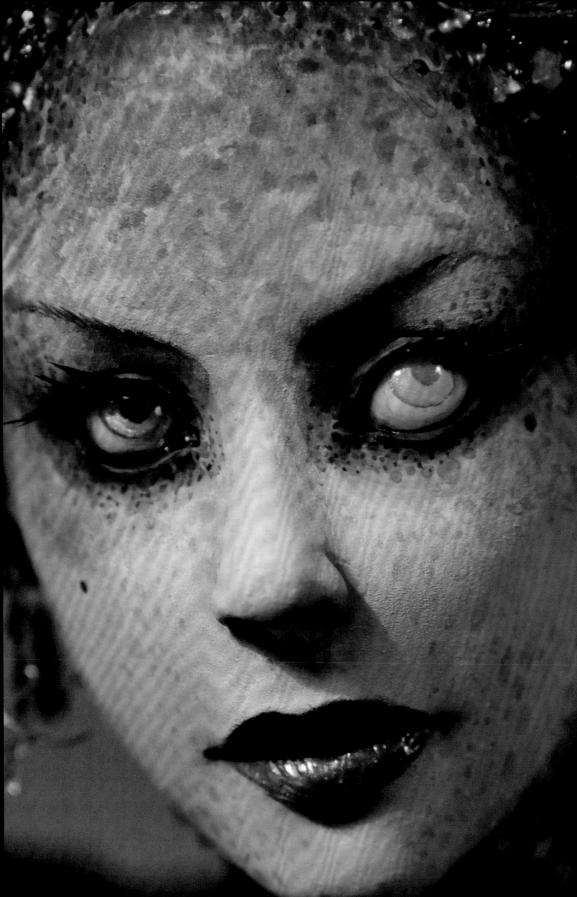

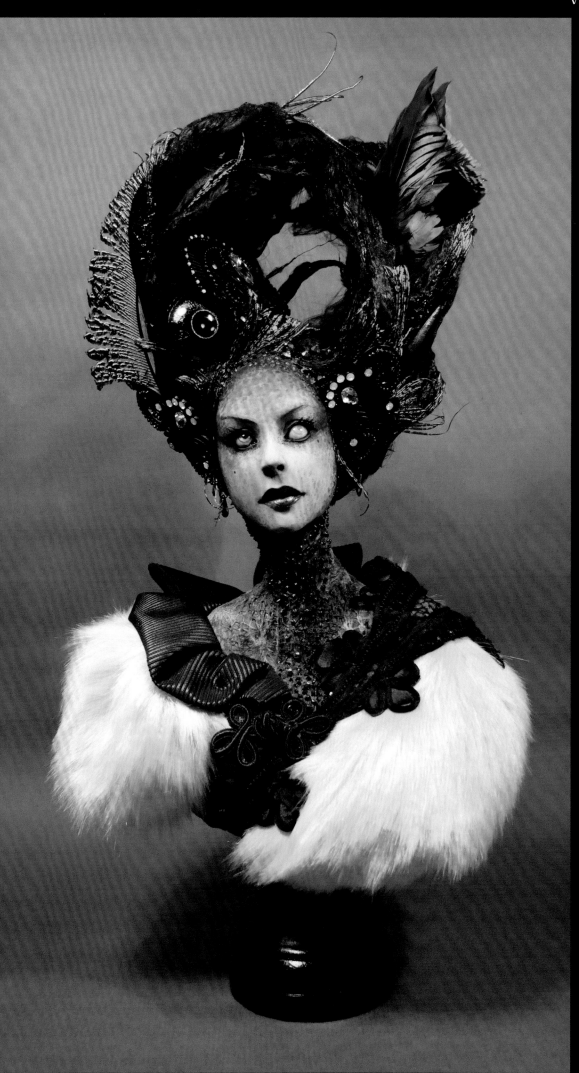

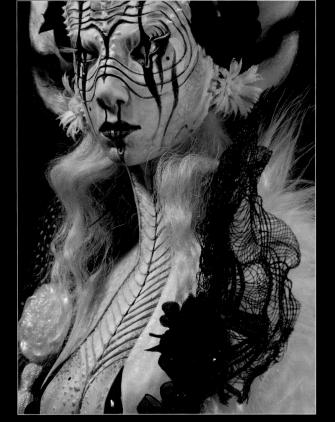
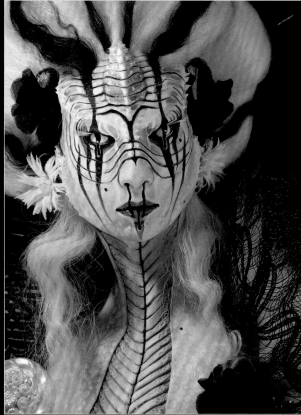
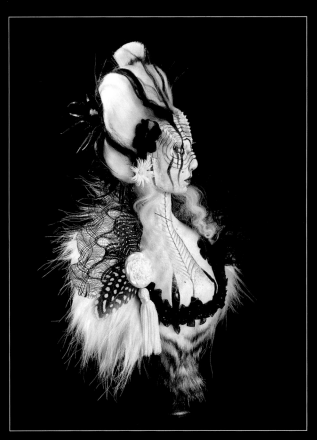
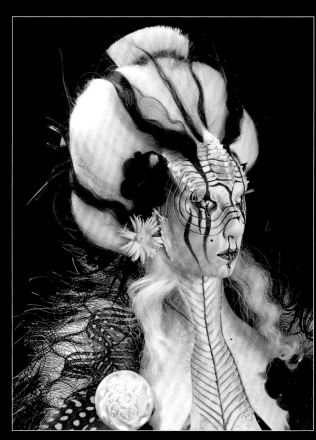

ZEBRA LOBSTER

The idea behind this piece was very simple. As with most of her work, Virginie really enjoys the challenge of imagining what two very contrasting things look like when mixed together. This piece is a fusion between a zebra and a lobster. Virginie chose the zebra because she likes the striped look and design of the mammal. She also thought that the contrast of black and white would work well with different fabrics and materials. She chose the lobster because it is a very organic creature with lots of textures and shapes and because it is related to insects. She enjoyed mixing the two animals together to create this doll.

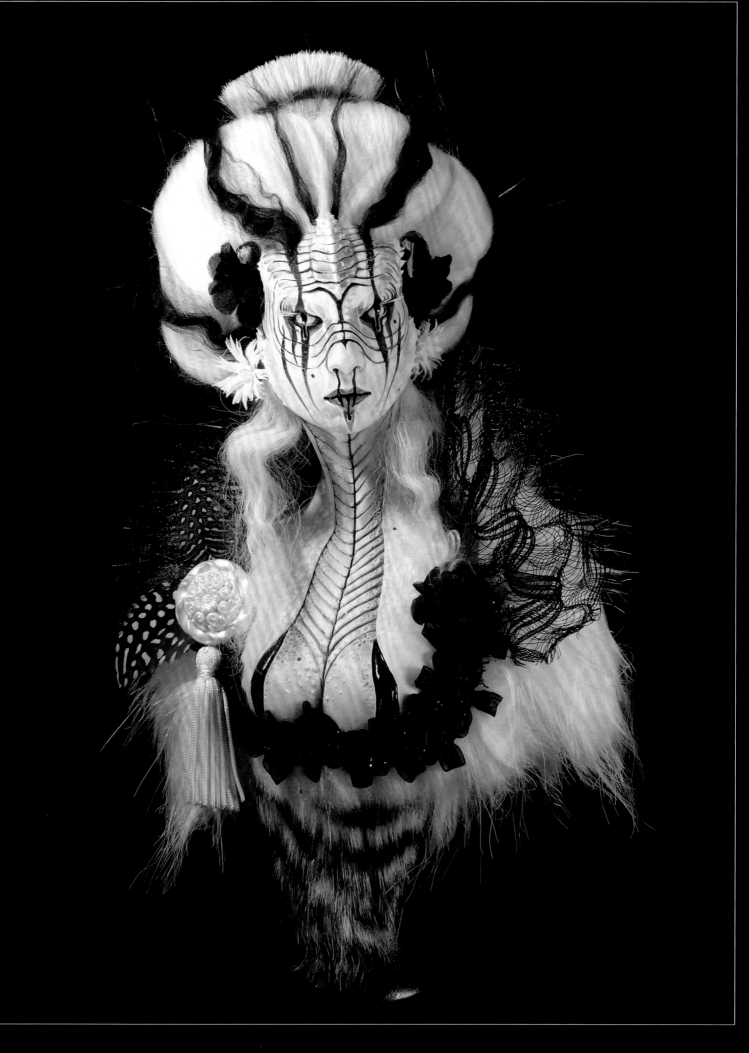

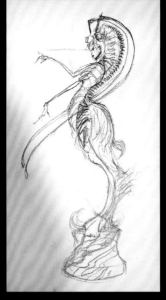
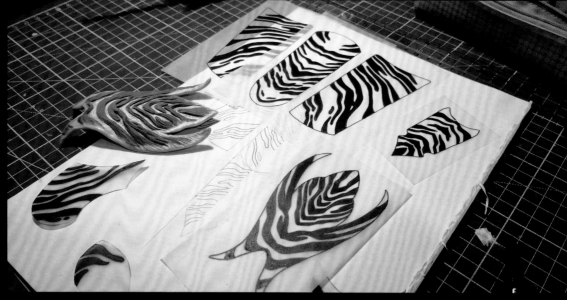
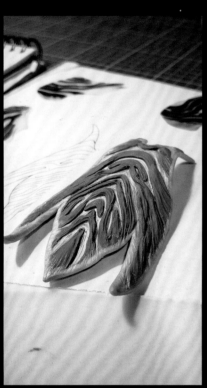

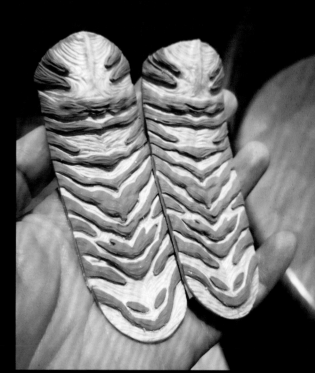

ZEBRA LOBSTER II

This doll is a revamping of the Zebra Lobster bust that Virginie previously had made. She wanted to make a bigger piece using the same theme and focus more on the inspirational patterns found on a zebra. "I wanted her to be fierce," she says. "It took a long time to make because I was adding and adding things. I also made a lot of oven sessions because of the stretched arm, which was really tricky to handle. I worked on her wild aspect, lines and contrast, keeping the zebra in mind. The lobster aspect became a thought as an armor."

top, left to right: Initial idea drawing; Designing the armor elements.
bottom row, left to right: Armor element finished; Sculpting a top skirt element; First oven session for top skirt elements.
opposite top, left to right: Sides of the skirt finished; Blending some faux fur details with the sculpted parts.
opposite middle, left to right: Hands sculpted separately; Sculpting the body and inserting crown elements; Sculpting finished and ready to paint.
opposite bottom, left to right: First coats of paint—many more to come; More painting.

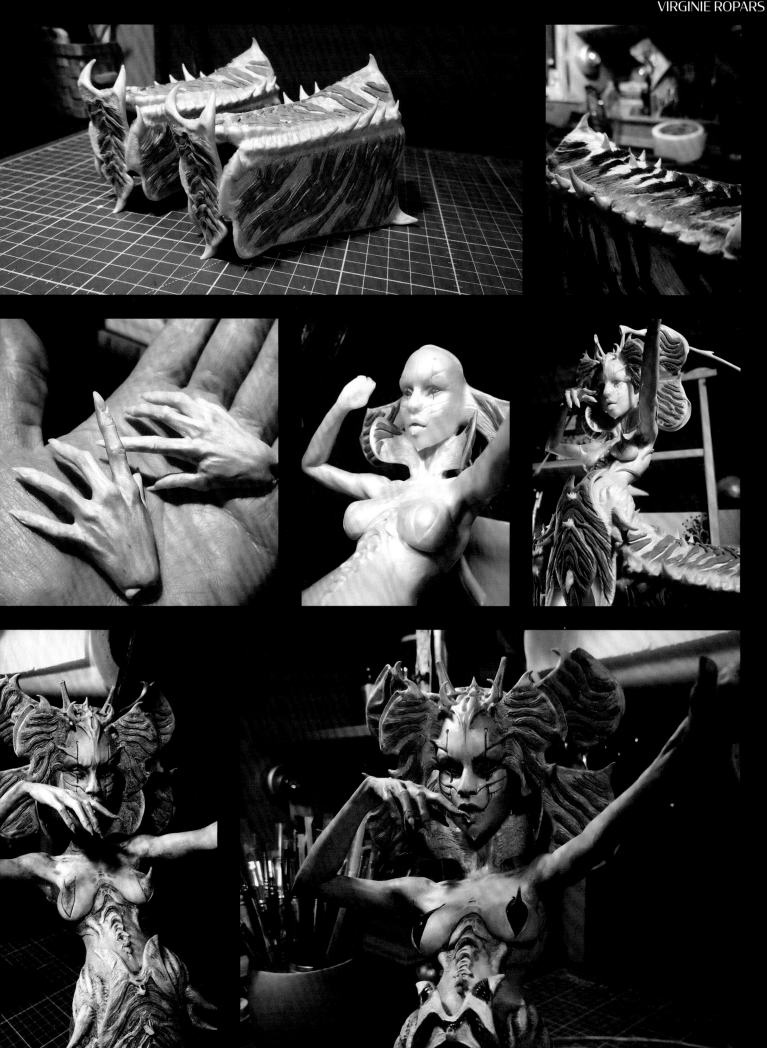

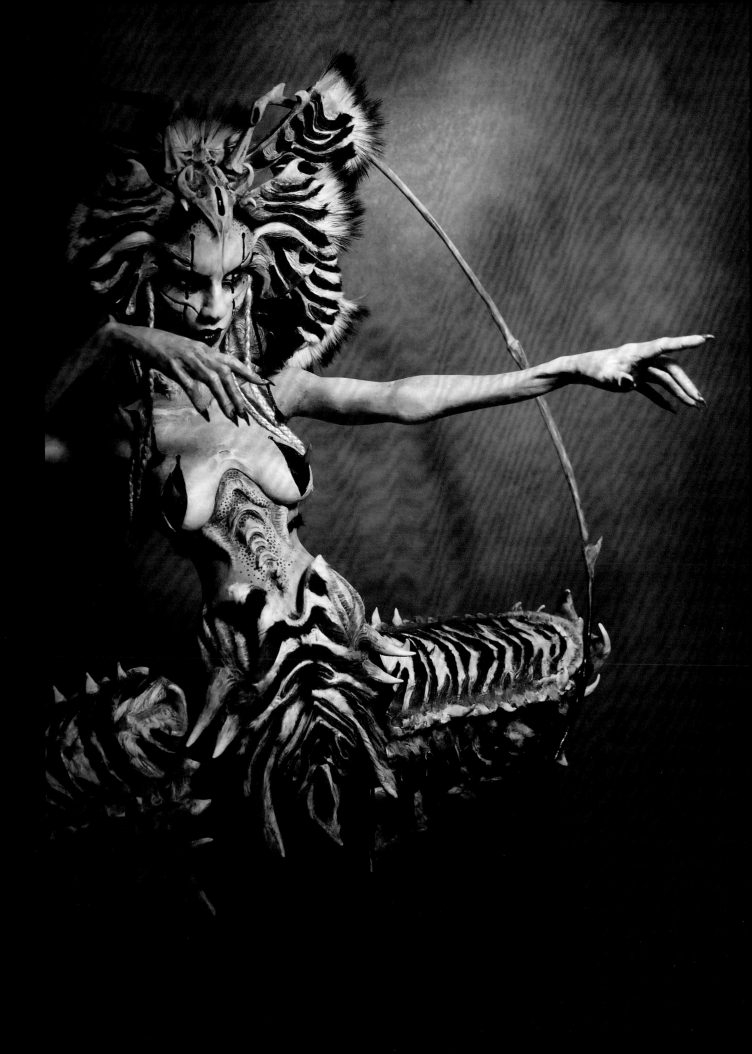

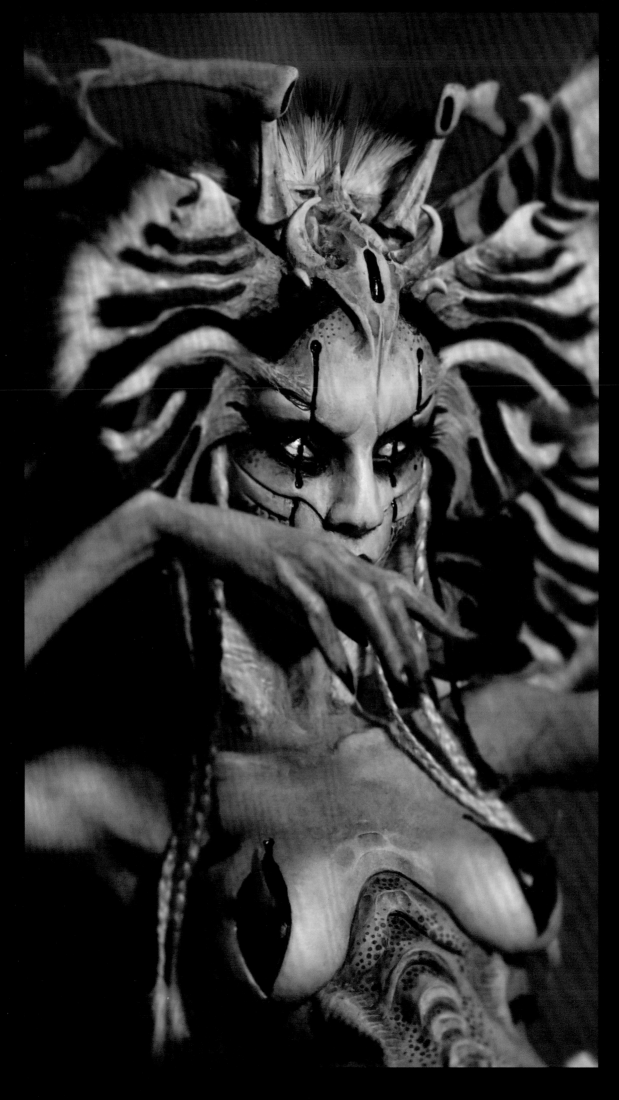

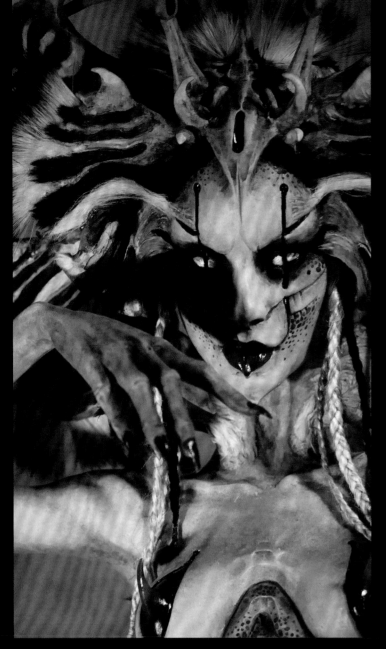
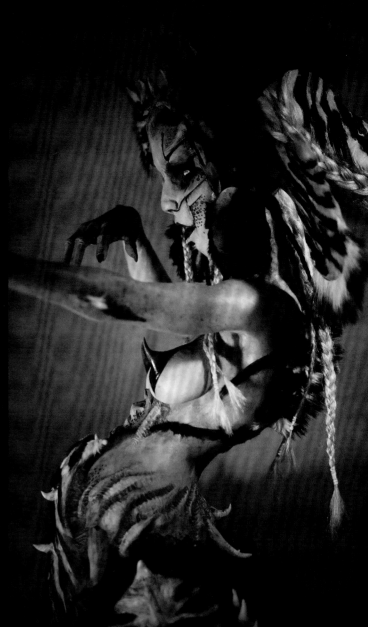
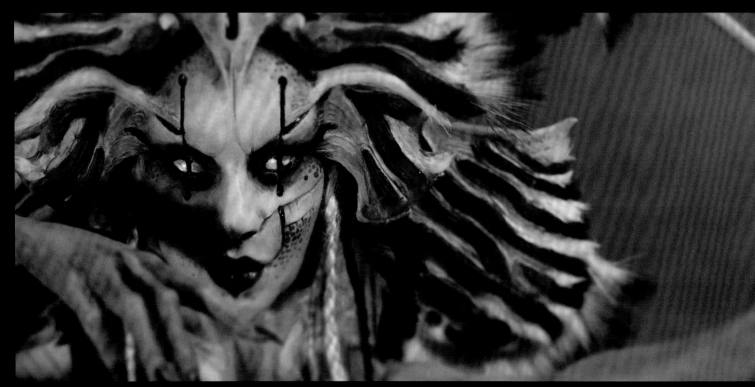

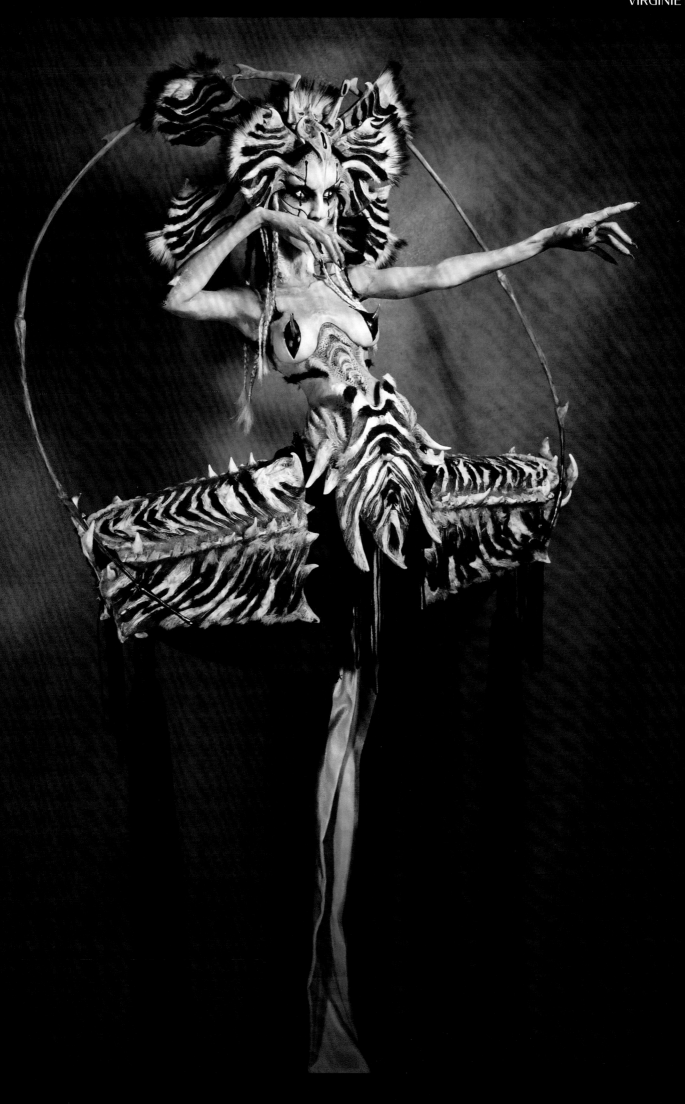

CRANE DANCE

This was my very first Dave Matthews Band poster for a show in California. Many music-poster clients really like you to touch on either the venue or something that has to do with the location of the venue. I was looking up the area in California where the venue was and just kept seeing all these beautiful pictures of California poppies all over the countryside. Hills and hills of rolling poppies, which are one of my favorite flowers. I thought, "Oh, well, this is great. I'll draw poppies." I also love cranes—what they symbolize and their elaborate mating dances. I decided to combine the California poppies with the cranes. That was it. That was the extent of the depth of this piece. However, it came out nice, and I thought it worked well.

ERICA WILLIAMS HOOKIEDUKE

Erica Williams, also known as "HookieDuke," has been a freelance illustrator since 2012—one whose unique works evoke intricate details from life and nature and are infused with fantastic and macabre tones. Erica creates elegant arrangements featuring complex elements and colors that make for graceful, poster-like designs. As we spoke, I was transfixed as I heard the details about the artist's journey. In the following interview, we talk about Erica's origins and early introduction to business, design and branding; that first concert poster assignment; the fears and obstacles that had to be overcome to reach personal goals; and so much more. The shear inspiration that Erica brings through perseverance will be motivational to others who are looking to chase down their dreams. The artist also provides fascinating commentary that accompanies each creation. I trust you will enjoy reading this interview as much as I did talking with Erica.

Flesk: You have a very individual style that is rooted in nature with a strong sense of design. Can you tell me about how you developed your approach?
Erica: I think it was something that developed slowly over time. When I first started drawing with any seriousness, I was drawn to anime. I wanted to be good at drawing Sailor Moon. I was drawn to the graphic styles and visual storytelling. I started working as a graphic designer at my mom's company when I was 14 or 15, so I've been doing graphic design for a long time. I studied it on my own when I was in high school because I wanted to be really good at it. I was already naturally building in design principles and having some more graphic stuff into my work. As I got older, I started building detail on top of the graphic work. There were a couple of years where it didn't necessarily mesh super-well, as I was trying to figure it out. Every once in a while, I still feel like it doesn't, but it's been building out over time as I spend time with the things I love and start incorporating them into the work. I prefer letting them take off on their own and see where they go, versus forcing them where I think they should. I used to force things more when I was still learning and trying to figure it out. Now I'm just kind of like, "Well, we're going to see what happens, and hopefully it goes okay."

Flesk: Looking back, was art always a part of you?

BLOOM LEPIS

This was one of my first music posters. I wanted to draw tiger moths, some beautiful peonies and hellebore. I focused a lot on the floral arrangement and figuring out how I wanted to work with posters and what I wanted that work to look like. It was definitely a poster that hit the mark and helped guide me a little bit toward where I was going, and it is still one of my favorites for that reason. Every once in a while, you have that piece that doesn't necessarily have to say a lot, but there's something that happened in the process of making it that clicked. For that reason, it becomes really special to you. This is one of those pieces for me, despite the simplicity.

Were there any points in your early life that proved instrumental in making an impact toward you becoming an artist?

Erica: Well, there are a couple of points. I always feel as though something happened, then there was an event, and then that kind of pushed me forward a little bit. You'll get comfortable with what you do for a little while, and then something else will happen to push you forward again. The very first one was when I was young and really into drawing. When you look at old home videos, I'm always holding a pen or whatever. If I was given something like a coloring book and other toys, it was the coloring book that was the thing I wanted. But I didn't really pursue it very often or very much.

Then, when I was in junior high, a girl that I had a huge crush on was great at drawing Sailor Moon. I decided, "I want to learn how to draw Sailor Moon too. I really want to impress this girl and be a good draftsman." So I started trying to learn how to draw, and at the same time I obviously was interested in other forms of visual art and information. I was working as a graphic designer for my mom and learning how to draw—deciding if I wanted to pursue this more as I progressed through school. There was a point where I had to decide: Do I want to go to art school or do I want to pursue some of the other things that might be more "financially viable"? Which they would *not* have been. Philosophy and literature degrees do not have any lucrative pay around them, so it would have been silly regardless. But I went to art school and was kind of focused on fiber art instead of drawing.

Flesk: What is fiber art?

Erica: Fiber art is a larger overarching umbrella that fits a few things under it. It can include some fashion design and fabrication, crocheting, knitting, looming, weaving and embroidery. Essentially it's anything that deals with natural or synthetic fibers and their form or construction. The school that I went to had an interdisciplinary studies program where I was going to focus on both fiber and sculpture. At the time I was interested in making elaborate fiber pieces and in combination with book arts—very concept-driven and not a lot of drawing involved. When I couldn't afford tuition anymore and had to leave, I didn't know what I was doing really.

Eventually, I met a guy who collected posters from the concerts he attended. He had one from the Japanese metal band Envy that I was immediately drawn to. I didn't really know anything about the band at the time,

but I remember looking at this poster for the first time and thinking, "This is so beautiful!" It combined this beautiful figure and a bird wrapping around her with these beautiful trees in the background. It was a two-color poster I believe, so it was very heavy on the line art and poetic. I knew, "I want to do that! I'm going to figure out how to do that!" And I switched. I stopped pursuing fiber art as heavily and was determined to teach myself how to draw well in ink. Previously I had made little comics and stuff like that on the side, but I really started trying to figure out how to draw with ink, since it lent itself to screen-printing quite well. At this time I was working as a production assistant at a screen-printing company that did apparel, so I was still working deeply with heavy graphics and production. I was weaving each of those things together, and it kind of took off after a while.

Flesk: From looking at your website and seeing how you run your booth at shows, it's obvious that you have a strong mind for business. You've developed a strong brand for yourself. That's something that a lot of artists don't know how to do or choose not to pursue. Is this influenced by your mom and her business or from someone or something else?

Erica: I think it comes from a couple of different places, and it is still evolving now. Earlier this year, I redesigned my logo again. As I changed my pronouns and bios online, I considered using the "HookieDuke" handle primarily instead of my actual name, since many people recognize that more now. It's a long process, though, that doesn't really stop. My mom definitely taught me a lot about business. I grew up being her assistant. She was an office manager for a long time, so the skills that she taught me in that role have served me well. I spent a couple of years working in offices with her, then moved into graphic design after proving myself and my abilities in the assistant role. I know how to work around the office and was allowed to kind of experiment with the graphic design for our company, which previously had none. While at KCAI [Kansas City Art Institute] I worked remotely as their designer while studying. I used the lessons that my mom taught me through being a business manager: "This is how you handle finances. This is how you keep things in track. This is how you're supposed to do this and you're supposed to be that." Those lessons helped build the foundation of being able to just know a little bit about how to operate financially and keep myself a little bit safe.

Branding wasn't something my mom helped with,

DETRITUS

"Detritus" is album art for the band Capstan. The pelican is one of their "mascots," so they asked for a piece with a deceased pelican. As one who never shies away from death imagery, I was happy to take it on. I really enjoy a project where the client's request allows me to play with something I'm already obsessed with.

Most of my animals—even the ones that don't look dead—are not actually alive, because they don't exist in a plane where they would have a heartbeat anyway. This one specifically. I went through a phase where I was drawing animals that were in the act of dying or already dead. I like celebrating them, honoring their life. It's going to happen. It's a part of everything. When you die, you become something else. You may not stay yourself—you may not keep that selfhood—but you still continue on. And it's the same thing where those particles don't stop existing. The universe does not delete things. It expands, and it grows and creates more, but it does not delete. Even if it changes, it's not gone.

though. Rather I knew it was vital as a graphic designer. I had studied it for years through books and working as a kid. It was another language I wanted to learn. I think the way that people present themselves through branding and how that changes across time is really interesting and important.

If I look at my own work, when I was first starting, I was thinking of logos that had a little nib from the pen in them. Or about how what I was doing could be presented in a visual format where you might not necessarily know what it was when you saw it, but it would make sense once you saw it next to my work. That logo kind of ended up transitioning into this wolf head thing, and now it's different again. For the past couple of years, it's kind of been a little planchette of sorts, and then this year I expanded on the planchette even more. I found out that I loved how much it mirrored my original logos, which were of that pendant or of a similar shape, but have a different break in the center of them. I thought it was really interesting, because it wasn't like a super-intentional transition to that, but it fit so well and told that story the same way it does for some other brands. But my own branding, as intentional as I was trying to make it, also just ended up becoming the extension of who I am and what I like.

For example, when I go out to conventions, I have my table and know what I want the table to look like to an extent. I want people to see my corner of the space and to be drawn out of where they are in the convention hall or that exhibitors' hall and to experience something a little bit different. That's why I have rugs, flowers and all of this stuff. I try to make it a little bit more like a boutique. Part of that is because my work is somewhat bespoke—not what you're going to see every day—and it's not really meant to be mass-produced necessarily so much. It's meant to be that very quiet expression of a very specific point of view. So the things I acquire to help with that are literally just things I enjoy. I would go to antique stores and I'd be like, "I love this. I think this would look really great next to this. These colors work well with my work. I love these colors."

I wanted to have fun with my signage. It was a fun excuse to play with fiber art again. So I hand-dyed fabric, and I embroidered everything. And all of those things are influences that have a huge effect from my past, and I try to bring them into what I'm doing now. Even though I'm not a fiber artist anymore, I'm still paying attention to how fiber looks in my drawings, and I bring fiber into the presentation that I have at

conventions or in public spaces. I'd like to revive it again a little. I'm paying attention to those things at the same time, so that when you see it here, you're like, "Oh, that looks really great." And then again, when you see it next, you're like, "Oh, this makes a little bit more sense," because you start to see those details getting pulled together a little bit. It is totally one hundred percent me just being like,

"I really like this, and I'm going to indulge in this." And that became the brand. It works really well as an artist when you're like, "Oh, well, everything that I'm doing is just stuff that I love anyway." And then it happens to be that I've gotten practice in presenting it in a way that looks good and helps to inform your experience with it. It has taken me years. I felt like I really had to earn that a little bit, but... I don't know. That's just kind of how it worked out.

Flesk: Basically, you're being one hundred percent yourself.

Erica: Yeah, it really is just me indulging myself all the time.

Flesk: That's got to feel pretty rewarding, right?

Erica: It does. It really, really does. I came from a place where I really didn't feel like I was allowed to express myself very well. My mom loved that I was good with business, but when I told her that I wanted to be an artist, she was disappointed. She wasn't very into the idea or practice.

Flesk: What were her fears?

Erica: There are so many when you're a parent. That I'm not going to make money, that I'm not going to be okay, not able to support myself. That I'm going to be a starving artist. All those kinds of things. Also, my mom comes from a strong religious background, so there are all of those things that come along with the perceived art lifestyle that she's not necessarily into and would prefer that I wasn't a part of. That's a whole thing, but there has always been this place where you don't necessarily feel totally great presenting yourself in those ways, especially as an artist. Well, not necessarily for everybody, because I can't speak to where everybody is or where it comes from. But my work is so deeply personal that it's really tough sometimes to put it online or to put it in the world at all and be like, "I hope that somebody likes this. I hope that I don't get hate for this." Or somebody just comes and trashes it, because it is still personal. Even though you have to get used to it at some point. But I really have gotten lucky in that there's something about what I'm doing that seems to

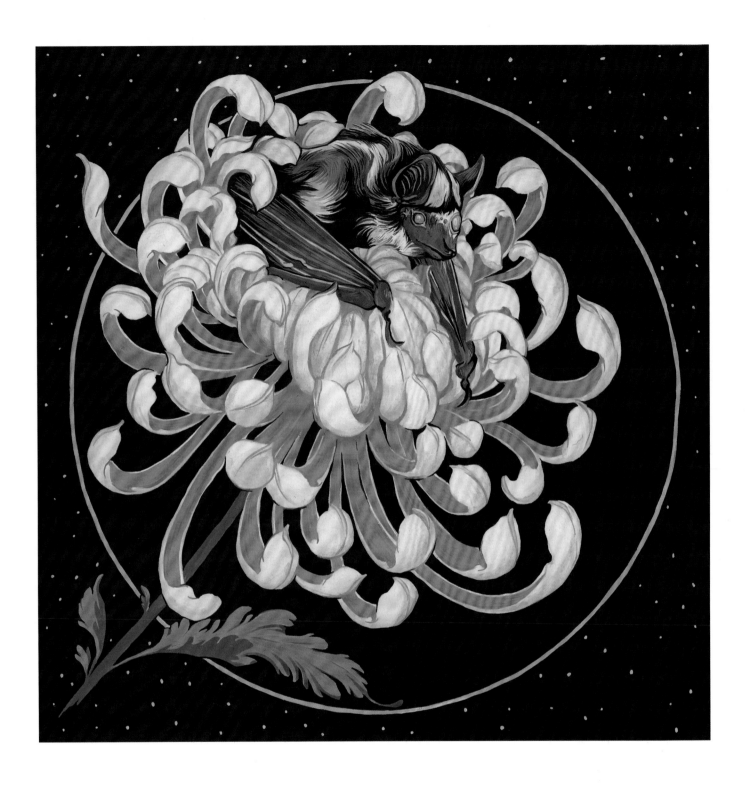

MICTECACIHUATL

This was made for a gouache course I took. They assigned a project based on your birth month, and for me that is November. In Islamic culture the bat is a symbol of the soul—sometimes considered to be a perfect creature—which I love, since I adore bats. In this drawing there is this tiny little bat that's crawling on top of a fluffy chrysanthemum. Chrysanthemums are a common funerary flower. The bat is sort of hugging it, which is a nod to softness and this gentleness about something that would otherwise be sad or potentially frightening to people. Also, bats are hella cute. I wanted to make death feel a little bit more like gently falling back into a field of flowers, versus fear that it would be painful somehow. Gently falling asleep and melting in, versus being afraid and anxious. This drawing is a bit self-indulgent, though, because it was all about November and things I enjoy.

resonate with a lot of people.

And I don't know exactly where that started or exactly where that comes from, but it continues to happen. I mean, I just got back from the New York Comic-Con, which is why my voice is very tired. But you get to see people. They walk by, and they have that physical reaction sometimes—a point of discovery. Then they zoom to your spot, or they stop and talk to you about it. You realize that you're touching on something. I'm just so grateful and thankful all the time that whatever it is that I'm doing, and whatever it is that I feel super-powerful about, is also powerful to other people. It makes them interested in figuring out more and seeing more about it. I'm so thankful that it's a real thing and that it happens, because I don't always know where it comes from, it's just there. I'm very thankful.

Flesk: I'll touch on a couple of these things, though. As someone who's also a business owner, it's not easy. It's a very lonely path. Because whenever you want to do something that's purely for yourself, there are people all around who want to stop you. And the people who want to stop you the most are the people who are the closest to you—your family and your closest friends—because they're projecting their fears on you. The greatest way that you can turn that around is to be successful. That's the greatest way to earn your value. Not only for yourself but also for them. So, when people come to your booth, it's this unexplained energy that they feel, where they're being pulled into your booth. They may not be mentally aware of it, but they feel it. And so, if you have people coming to your booth, you have people supporting you—and this is getting really deep here—but they're seeing it even if they can't verbalize it. So your success has got to be very validating for you. Does it create a lot of value for you?

Erica: It does, especially in the last couple of years. In 2020, COVID was initially spreading, and everything shut down just when my first Kickstarter was launched. It was really a point where I realized I had accomplished something, and I felt incredibly validated and empowered by my work. I felt empowered this entire time because I was able to do things, and I kept getting jobs, and my audience grew. I wasn't failing or homeless, so I was like, "Yay, this is cool!" But when the Kickstarter happened, it just took off in a way I wasn't super-prepared for and wasn't expecting at all. The last stretch goal I had set for the Kickstarter was done thinking that it would never be reached and I wouldn't have to do it: "I'm setting this goal because it's the pipe

dream." That kind of a thing. Then, when that last stretch goal was reached, I was amazed. My partner at the time came and woke me up because I had spent all night being anxious and then just passed out. He came and he woke me up. He was like, "It happened! You're funded!" I couldn't believe it and cried.

And then it kept going further and further. Then I think there was still a week and a half or two weeks left. I had met the last stretch goal, and I knew I really did do something here. I worked my butt off, and I knew that I had earned it because every single part of that book, every single part of the Kickstarter, every single part was completed by me. I did it alone. I did it by myself. I worked really, really hard for *Ritual*. The fact that it did so well, and then again, the response that I received from the Kickstarter—from when the book started shipping, from when things were going wrong and people were just being really patient, and they were just like, "You know, we just want to see it. We're just waiting. We're so excited. Take care of stuff." And I was like, "Wow, what the heck?" I felt so validated, truly, for the first time. I realized that I could potentially keep doing this for as long as I wanted. If I was smart about it, if I kept the drive going, if I kept myself humble and kept myself at a place where I really believed in what I was doing, and I believed in the people around me and the people that love my work, because they haven't let me down. They've been amazing before that and ever since.

So, as long as I kept faith in those things, and as long as I kept faith in myself and didn't lose that, then I would probably be all right. And I have been thus far, which is really cool and hopefully will continue. It's beyond validating, because I've always struggled with feeling out of place and like I didn't know what I was doing and I was kind of wandering around. And then that happened. I feel way less alone since that happened, because I'm not alone. I know I also have an amazing fan base and even more amazing friends. So it's incredibly validating. I feel so much more at home and so much more able to be myself in a really genuine and unfiltered way than I used to. You've already mentioned that I'm not online all that often, and there isn't much information about me out there. I don't even post my face in photos very often. I still filter my presence greatly, but I feel so much more comfortable about it and much better compared to where I was even a little bit ago.

Flesk: There are two key things I really like about

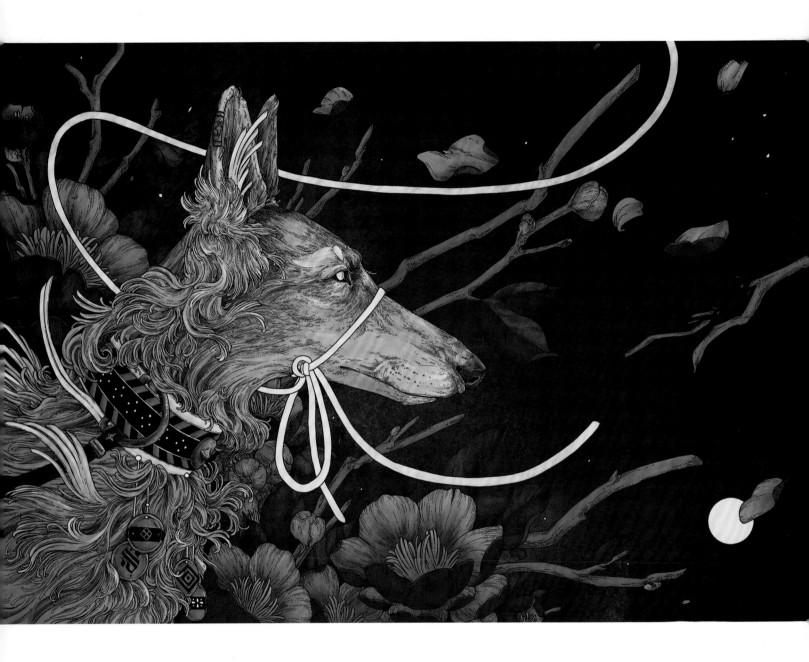

VEIL

This piece features borzoi, one of my spirit familiars. I was really thinking about liminal spaces. The background is mostly texture except for a sphere in the lower right corner that's a bit of a mystery— maybe a light somewhere in the darkness. You don't know what it is or what's coming, although you know there's *something* here. This isn't an empty space. The hound is coming out of this bushel of flowers—it's kind of exploding with flowers. You know that there are things happening and there's space being taken up, because there are petals and there are branches pushing forward in this dark space. The hound has a tether, but if you look right under the chin, it's coming undone. It really is that theme of coming undone. Fortitude in the face of uncertainty and transformation.

you, which are that you're humble and you're grateful. When you have those two components and you don't get greedy, it's really hard to fail. But it's really about believing in yourself and loving yourself. So if you can do those two things, it's really hard to stop your momentum.

Erica: I have to agree, like, one hundred percent. These past few months, I've been thinking about all the things that I really want to do. If you compare it to two years ago, it's just a total night-and-day difference between what I feel I am capable of doing and what I'm actively pursuing. Versus before, when I was like: "That's for real artists, for people who are good." Now I'm like: "I'm just going to go for it." So I definitely feel that—just keep believing in yourself.

Flesk: If you're lucky, that feeling never goes away. The more you embrace it, the better off you are.

Erica: I'm trying my best. I hope I'm doing okay. I honestly think that I feel way more capable as a person now than I did a couple of years ago, and I definitely feel more capable as an artist than I did a couple of years ago. That's partly because of the amount of support that I received in the last couple of years. But, yeah, I definitely feel it, and I hope I can continue it. I don't intend to let it go. I'm a very optimistic person.

Flesk: Yeah, that's great. You're doing great work, and it's coming from a nice place. To switch topics, I have another question for you: What is the meaning or origin behind your handle name, "HookieDuke"?

Erica: It's actually just a nickname. It was the name that somebody gave me, and it doesn't really mean anything. They had created it out of a couple of other things. There was a mascot that they thought was funny, and then there was the *Duke Nukem* game, which I literally never played. But they had enjoyed that, and they just started calling me HookieDuke. I was like, "okay, whatever." I thought it was silly but kind of liked it. I liked that it had "Duke" in it. But really I love nonsense names, because I think a lot of names can be nonsense. I feel like my own name is nonsense. The name that my mom gave me means "ever-powerful leader of the people." So I was always like, "Are you sure about that? That's kind of a bit much, Mom." But when I actually went to start building my business online, *ericawilliams. com* was a porn site. I couldn't get the handle. So I went with Erica Williams Illustration, which is incredibly long, but it has maintained ever since. Later on that got bought out by another Erica Williams, a politician from D.C. There's also a baker, there's another artist,

there's a photographer. Erica Williams is an incredibly common name. I realized really early on that there was no way that I could necessarily use that online and know that people are going to get filtered to me. I decided that I was going to have one handle that I could use across everything. Out of all of the nicknames that I had, HookieDuke was the most unique and original. It meant nothing. It was nonsense. And I kind of like that because I feel like art is not nonsense, but art also is nonsense. It's me drawing the nonsense in my head and into the world, so it kind of works. It's silly. It's a story that doesn't make sense. It's kind of like one of my favorite bands, Archers of Loaf. They chose their name by opening up a dictionary to a random page. They did it a couple of times, and they built their name off of that. I really love this sort of conceptual, nonsense way of deciding who you are to the people, because that's all it is anyways. I just kind of went with HookieDuke. Now I've kind of been bringing it down to just be Duke, which I really love because it's sort of like Dukes, the Dukedom or whatever. It's also a play on gender a little bit. But it's been really flexible for me this entire time. Nobody has HookieDuke. It doesn't exist except for me, which is perfect. What better do you need from a name?

Flesk: It sounds good. It flows really easily. It's really easy to say, and it's fun to say, And I like nonsense. It's good.

Erica: A little levity, a little silliness. Can't go wrong with that. And that's why, even in the back of my business cards, I think some people are like, "Where's your name?" And I'm like, "Well, my name doesn't really matter as much anymore because it's so popular." It's fine for talking to me in person, but HookieDuke just makes so much more sense in today's world and how things operate that I just was like, "This is perfect. Why mess with perfection?" It seems like it's nothing, but it works really well.

Flesk: Yeah, you've given it meaning.

Erica: Thank you. I appreciate that.

Flesk: Something I really like about your artwork is that, to me, there's a strong tie to nature. Is that intentional? Can we talk about that a little bit?

Erica: It definitely is. I grew up in Colorado in a very natural city. You're at the foothills of Pikes Peak, which is a super-famous mountain because of how beautiful it is and because it's got these very picturesque views all around it. I've always been kind of an introvert. Well, not "kind of." I've always been an introvert. So, rather

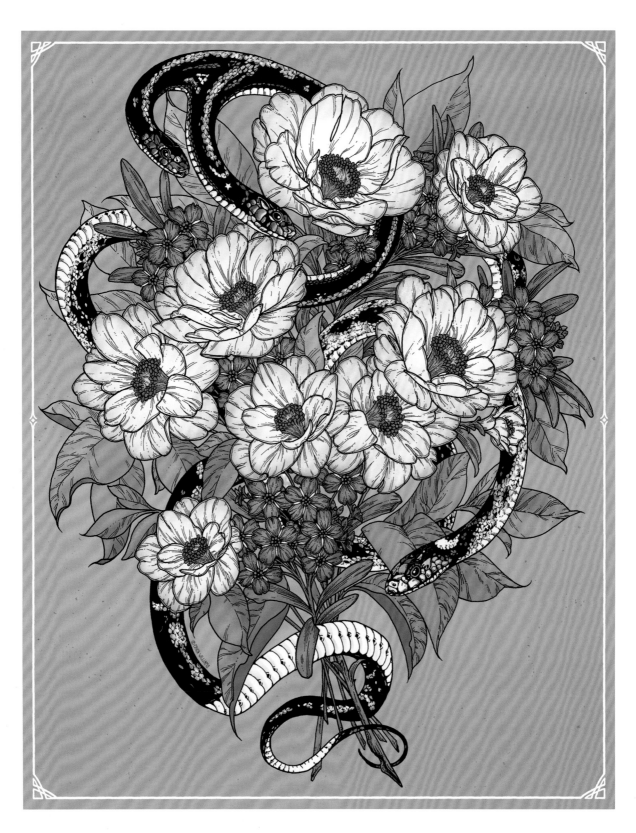

above
CHARNEL LODGER

This is part of a set of three pieces for the group Murder by Death. Originally there were to be four posters, but it was pared down to three. I created bouquets based on flowers that I thought would work well with snakes. The snakes are all mutants, as depicted with a couple of them having two heads. They're slightly unusual things, where it takes you looking at the image a little bit longer to realize that there's something odd about it. This isn't just any snake. This is like, "Oh, there's something else happening here." I like instilling that feeling in general for all of my artwork. I always want you to spend a little bit of time on it to really pick up what's there.

right
TOGETHER WE WILL LIVE FOREVER

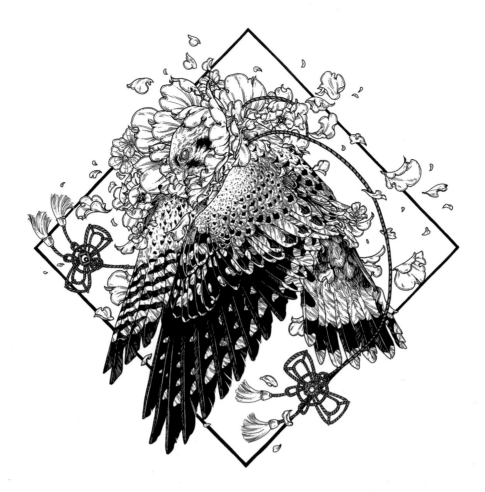

than going out and hanging out with large groups of friends or going to football games and stuff like that, I would actually just go and explore the parks around my house. I would literally get off from school, go to a park, take a nap in the park, wander around, draw a little bit, read a book, listen to music in the park and then, when it's dinnertime, go home.

Also, when I was really little, my mom would send me to Georgia for the summers to stay with my grandmother. My grandmother lived on a farm in rural Georgia that was surrounded by woods and had a little pond and all kinds of stuff and animals. I would just spend a lot of my time outside. The farm had this old, decrepit barn that was filled with random stuff. I would just go exploring and spook myself out by making my own ghost stories about what was happening or whatever. But the times that were the happiest for me growing up were probably the ones where I was outside in nature. My mom also liked nature, in that we always had animals around. I've had so many pets, there's never been a day in my life where I have not had a pet, if not two. We've had all kinds. We've had dogs, cats, skunks, ducks, other various farm animals. We had hamsters and ferrets, all kinds of stuff. I've always had a really deep appreciation for animals and plants, and I could not live without these things. I could not live without my pets. I could not live without the natural world around me.

The year 2020 taught me exactly how much I needed immediate access to green spaces in a way that I was not expecting. And I feel like those things should be exalted. And also the stories that I've grown up on. Natural spaces and animals were always exalted in those stories. The need to protect them. The need to offer them. The need to respect them. Those kinds of things. So it's just been instilled in me since I was tiny. I really believe it, and I really feel it. I even started doing some meditative exercises where I would go into these guided meditations. It would guide you through this world-building thing and the world that I'm building in my head and that I live in and that I'm pulling all of my drawings from. It's deeply natural. If there's a building, it's like one building completely surrounded by nature. There are animals and stuff like that all over the place. But the man-made structures are so secondary to everything else that's a part of the world and everything else that is super-meaningful to me. That's just how my head has built itself around it. So it's just kind of where it is now, but nature is just... How do you live without it? We wouldn't be here without these things. If we were here without these things, would we love the world? How different would this world be? Would we feel the same way? There's just so many things to think about. Nature is very exalted.

Flesk: Thanks so much for sharing these details about who you are and what makes your art so wonderful.

above
RIMBA FLYING FOX

This piece was commissioned by the Rimba Conservatory in Malaysia. They're a not-for-profit sanctuary and conservatory research center. I really appreciate this piece because I love bats, as I've already mentioned. I love being able to help the people who are researching and protecting our wildlife to continue to do that. So, whenever conservatories come to me, I usually try to carve out the time to participate in what they're looking for and to help give them beautiful artwork with the hope that it will catch the attention of more people and be able to further their mission. It's so hard sometimes for these establishments and these resources to be able to attract people, simply because they don't have the visuals that go with it. You can tell a story to somebody, and they might get on board with it, but if there's not a visual attachment, you don't have as much to get attached to. I mix the causes I care about with my work as much as I can.

right
CEREMENTS

"Cerements" is a companion piece to "Veil." They share colors, with an addition of pink in "Cerements." Falcons and borzoi are both a spiritual familiar for me. At about this time I was beginning to play with the idea of pulling on the ends of something, like a loose thread on a sweater. You have an object that seems typical, but before you know it, it's unraveling. Maybe slowly at the edges first, but no longer the same as it was and impossible to return to what it was. You can see this in the feathers at the bottom of "Cerements"—how they get pulled and stretched, coming apart around the edges. The falcon also has a hood that renders the bird blind. On its back, however, is one large open eye: a new way of seeing and a new perspective. When something ends, something new takes its place.

 "Veil" and "Cerements" are tied together in name as well. The hood kind of serves as this veil, where you cover up what you used to be. In doing so, however, you open yourself up to another reality. Both of the animals are supposed to be spirits or ghosts encountering a veil between worlds.

above

ESTE PEQUEÑO TEMBLOR

There was a period when I was naming my pieces after the music that I was listening to at the time. I really enjoyed *Rime* after a friend recommended it. The soundtrack by David Garcia Diaz is gorgeous! I wanted to draw borzoi again and play into the storyline of *Rime* a little. You're running around and going through changing landscapes, following spirits. You're running and chasing something, and you don't really know what you're chasing, but there are all these forces that kind of come after you a little bit. The dogs in this piece kept running, and at the same time there are branches that continue to grow after piercing the hounds. The branches have leaves coming off of them, which ties into tarot and symbols of growth. These strong, powerful hounds have been shot with lances but still keep going. You can be pierced by a blade, and your body will heal around it. In this piece, there is a lot of growth and injury and yet the need to endlessly carry on. Accepting and moving forward.

right

RESTLESS

Another Patreon print, this one was inspired by *The Golden Bough*, by Sir James George Frazer. There's a section in the book that goes into this Sacrificial King and proxy kings or sacrifices. Kings are often represented as stags, so I drew a stag that is being pierced. The piece is about flourishing, however, because the entire purpose of the myth laid out in this book is to be able to bring that energy back into the world: to re-establish it and distribute it among people, so that plants and crops still grow and people are still happy having babies and all these things. This necessary thing has to happen in order for the continuation of our culture and people. It's death, myth, magic, and it became religion. All of those things are really tied together. So it was kind of my fan art to this book and the story that I really like.

above
OUROBORUS

right
PARADISE

This was a drawing for a Metallica poster. In 2018 I went to Japan for the first time, for a few weeks. I spent the first half with a group of other artists on a retreat trip. We did this travel thing all through southern Japan. Then I spent the second half by myself in Tokyo, but I really wanted to go climb in the Shiratani Unsuikyo forest in Yakashima, which is on an island south of mainland Japan. The Shiratani Unsuikyo is also known as the "Mononoke forest," because it's the forest that the art director for Studio Ghibli went to when they were working on *Princess Mononoke*. I am a huge Ghibli fan. I grew up on Ghibli movies. I went to the Ghibli Museum as well, but this was my pilgrimage.

When I returned to Tokyo, I had to work on the poster. I sat down at a café and created the sketch, which was the only piece I really got time to work on while I was there. That itself is really special to me, and I had just come from the Mononoke forest! So you've got the two wolves from Mononoke, and it also played into this idea of a deep transition space, because I was at the point of transition myself. You've got these two things that you don't really know where they begin or where they end: Was it one wolf or two? Are they joining together or pulling apart? What's happening with these flowers? Is this painful? Are they upset? Are they sad? There are all of these questions that I think the piece can ask, based on where and how you're looking at it. Maybe focusing on it not reading as a traditional space, but instead it still exists within those places and where you just are not really sure. It's potentially unsettling a little bit. I wanted to celebrate how I felt at the moment—getting to have done this thing that I wanted to do forever and how that was affecting me—having come out of the Ghibli Museum, crying. Experiencing a ton of emotions.

PIZZA LA MORT (MUSHROOM PIZZA)

The client's version actually has glasses and a little mustache on the skull. Every year, this client hires a handful of artists to do a T-shirt design. This design was a part of that. I only did one concept sketch and one rough sketch, with very limited options, because I felt very strongly about the design. I channeled exactly what I wanted to and had a lot of fun. I was getting to play with their logo, but a heavily illustrated version. I also got to play with the idea of light occultism and tripping mushrooms. Since that was the other part of the client's request, it had to be their creator and then pizza: psychedelic mushrooms, the skull, a third eye...with some pizza in it. I had a lot of fun playing with the combination, and I think it shows.

right

LILLITH

This is kind of a fun piece because it unintentionally became something more than was intended. When I started, I was kind of going with it and seeing what happened. As I was drawing it, I just kept on thinking that this looks like Lady Amalthea from *The Last Unicorn*, an animated film from the 1980s. Then I started adding in the other things, like these horns and big red flowers. There is a point in the film where the unicorn becomes human. The way that they animated the hair definitely was the beginning of an obsession for me. There's also another character, the Red Bull, that is controlled by King Haggard. Basically, King Haggard hunted down all of the unicorns in the world and forced them into the sea so that he could stand in his tower and watch the unicorns roll in and out with the waves. I was drawing and reminiscing about the movie when it hit me: This is *The Last Unicorn* fan art by accident but also tied in with a bit of Lilith lore and some of the different ways that she's been interpreted. There are all these stories where women are seen as a corrupting influence, but Lilith actually never felt that way for me. So I depicted her there healing a branch. Which is another way the drawing resembles Lady Amalthea healing the world by returning the unicorns. There's just a bunch of influences that kind of collide in this drawing—a hodgepodge of characters and stories that resonate with me.

above
VISITANT

right
SANSIN

In Korean lore there are old mountain spirits called the Sansin that live atop mountains and have tiger familiars. They protect the mountain, keep the peace and make sure that everything's okay. I love the idea of these old men on the mountain just living among tigers. Also having a tiger familiar would be so cool. I was also spending time with gore and horror comics and similar things. You can see a bit of those elements getting carried through with all the extra eyes. Even the flowers have eyes in this one, and the tiger has a third eye. That third eye represents the tiger being able to channel the Sansin and the connection between the spirit and the gods who protect things. I adore mountain spirits and protective guides. So many of my creatures are protection spirits, and Sansin is the same. He is my interpretation of what these familiars would look like in a way that I felt would work well with the aesthetic of the band that commissioned the piece. They're kind of like that punk grunge vibe but a little bit darker, lots of aggressive energy. So it was trying to merge this idea that I had, and this thing that I really love, with this kind of aggressive version of how it was going to be presented in the end.

above
AGEHA

right
SOMMAR

This piece has a lot happening. One of the inspirations was the song "Curlew's Call," by the client. The birds in that piece, curlews, are very similar to sandpipers. I had to do a bunch of research on them because I don't know a lot about this bird. I was looking at where they lived, and the song has lyrics that incorporate nature and the changing of seasons and the passing of time.

I knew that I wanted to draw the foreground with curlews hanging out on the beach and a prominent sun. I wanted it to be a beach scene because all year I had been stuck inside due to COVID-19. Then, when I went out, I kept going to Michigan. I don't know why. Everybody wanted to go to Michigan that year. I spent a lot of time on Lake Michigan, watching the sunrise and sunset on the water. So I wanted it to be a beach scene and to be a sunrise or sunset or read as both. The central emblem shows duplicates of the theme. It has all four seasons, and it contains four different kinds of earth and water plant life that the curlews live around. I believe it has thistles, marsh marigold, seaweed and some marsh grass. It also has twelve stars for the zodiac and several tiny curlews in the emblem itself. So it's got astrology, the seasons and the planet.

Then, when you pull back from the emblem, you also have those curlews in the foreground. There are more curlews flying in the sky, as well as a full moon and partial moon for the lunar cycles. The emblem has three levels of time change and the progression of the Earth, and then you've got the same duplicate in just the presentation of the birds and how they're depicted in there as well. I had a ton of fun making that little border with the little flowers, which I wanted to feel like that expression of energy as the seasons are always changing. The piece is named "Sommar" because that's when everything is at its peak of blossom. It's exciting, and it feels very magical, a little bit fantastic. Yet it's just a snapshot in time.

above

SPARROW

"Sparrow" is a companion piece with "Nightingale." They were commissioned by a restaurant in Temecula, California. This is inspired by an Aesop's fable and was a lot of fun to work on. I really enjoyed getting to create these graphic, sort of mirrored illustrations based on this nightingale character and this sparrow character. I think they turned out really lovely. I made an approximately five-foot by six-foot print of each one of them and then gold-foiled the prints by hand. Those are now framed and hanging in the restaurant.

right

HAZE

Another music poster, this one for the folk duo Mandolin Orange. In this piece I wanted to draw a lynx, because I think they are stunning. I focused on finding a good composition for a poster and being able to display the necessary information on it. I also had a grand time drawing another cat, and I really love to draw flowers. There is a version of this poster where there are gold lines that move throughout the drawing. That was one of the first pieces where I started incorporating such elements. If you look at the things that I've done in a sequential order since then, you'll see way more graphic lines that come through the pieces. I also utilize more space where I put blocks of color or lines and switch between spaces. I was experimenting with what it would look like to have a really lush area of something on what would potentially become a really minimal space without it feeling threatening. Thus the really bright colors—very soft and gentle—but you're not sure what's happening. You feel that you're in between something.

above
WAYFARER

This one is for Dabin, actually probably one of my favorite pieces that I've done for him to date. I had never drawn so many wolves in a piece before. It was a lot of wolves! I wanted to create something a bit in between in the sunset or sunrise colors and water that moves in all directions without any solid end. I wanted everything to emerge or melt into the water so that there wasn't a separation between the foreground and the background or between what was happening as much. I drew Hana dragging her hair through the water and thinking about that as well. I was thinking about the spirits in the films *Fern Gully* and *Princess Mononoke*. When the characters stepped down on the ground, plants grew up after them. In *Princess Mononoke*, they grow and then they die immediately. It kind of felt like she's leading them along and all of this stuff is coming out after them. You know what was going to happen, but it's the power of the magic within you.

right
STAY IN BLOOM

This is another piece for Dabin. His original character Hana is featured in a lot of his media. She's very often seen with other animals. In this one Hana is with some cranes. He draws inspiration from *Princess Mononoke* and that type of world-building space. Dabin asked me to break into a different color scheme than I was used to. I had used mostly autumnal colors up until that point. Before, I had been really afraid of having something that read as "feminine" and with a soft color palette. These pieces really helped me to break away from that and get back into a space where I felt comfortable using some of my favorite softer colors. I'm grateful to him, because I don't know if that would have happened if he hadn't been like, "No, these are the colors. Use them." It was just really fun. I love drawing Hana. I love getting to work with that world, because it's all about exalting nature and space, but a lot of fun.

VINEYARD

Another Aesop's fables piece for a restaurant in Temecula, California. The fable used as inspiration for this piece is about abundance and learning to take care and sow seeds mindfully. I drew the goat with these insane horns. At that time, I could draw horns for days and days at a time. Very high-fantasy but also weird and pretty. I remember struggling with the background a lot. I was told that this was going to be a mural, so I knew it was going to be giant. You would be able to walk up to part of it, and you wouldn't necessarily be able to tell what was happening at the other end of it. I wanted you to be able to walk along the entirety of the mural and feel like you were progressing through the story a little bit, even though it's presented in such an abstract way that you can't. However you still kind of have to go from one end to the other and then pull back and look at the whole thing in order to get it.

above

TRANSARCTIINAE

That was a piece for the Dave Matthews Band. I love drawing moths, but none of these actually exist. I enjoy combining fantasy with things that resemble reality, though. One of the moths is similar to a luna moth, another to a tiger moth, and one is kind of a mix with multiple wings. That's all it was—me drawing weird new moths. They are often considered to hold the soul when it leaves the body, so of course I also adore them.

right

SOMETHING FISHY THIS WAY COMES

This one is all about joy. I have a Patreon and every year I try to do an exclusive print. I try to make sure that it's also one of my favorite prints of the year. Originally I had a different concept that was more serious and a bit darker. I was on Twitter one day and saw this photo set that somebody posted: It was just cats carrying fish in their mouths. It hit me that I had to draw them. It was a rough year for everyone with the pandemic, and having a bit of fun sounded like a breath of fresh air. Even the title is a joke: "Something Witchy This Way Comes," but make it "Fishy." I really just wanted to inject a little bit of joy in the year and have a little bit of fun.

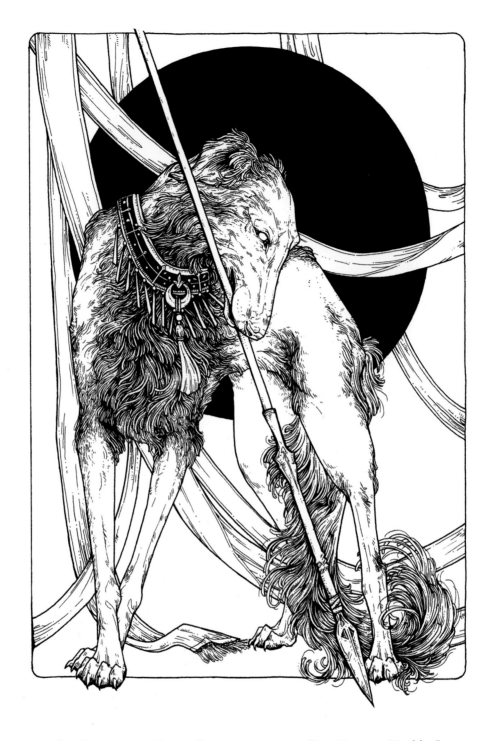

above
SENTINEL

"Sentinel" is another one of my borzoi pieces. It actually is a companion to "Este Pequeño Temblor."
Again, this one is a little bit more of a guardian spirit. This is one that is a sentinel. It's standing with a
lance and waiting for what comes next, eager and ready to go. I started drawing a lot of weapons because
there's so much that we do with weapons. We exalt weapons even though they're these very destructive
objects, but we've made them so beautiful. An interesting combination of beauty, craft and violence.

right
SAGITTARIUS SERPENTUS

Another music poster! I love secretary birds. They are stunning and so interesting with their insanely long
eyelashes—the model of the bird world. I feel like I did this one at the beginning of when Trump was in
office. He's having all this hateful speech about other countries being "shit holes." I was like, "You could
say this about these other countries, but there's all these beautiful things that happen in each country/
continent." I couldn't do one for all of them, so I focused on some of the wildlife in Africa, to celebrate a
little bit of the beauty from the region.

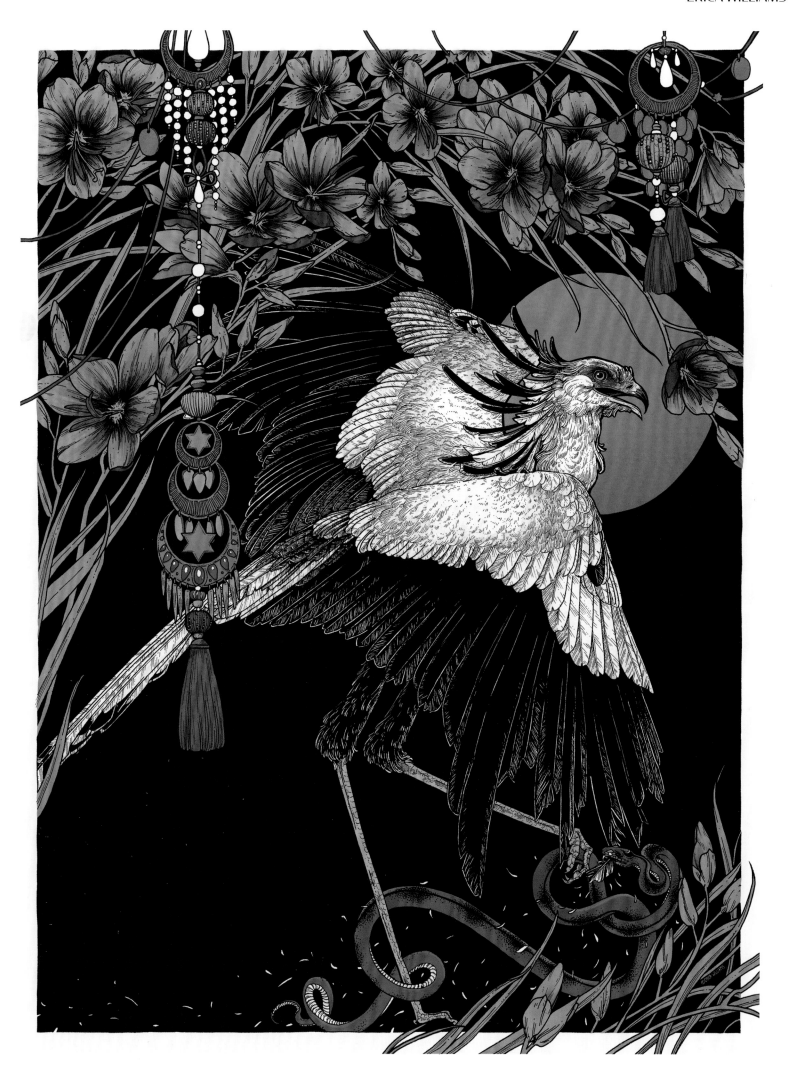

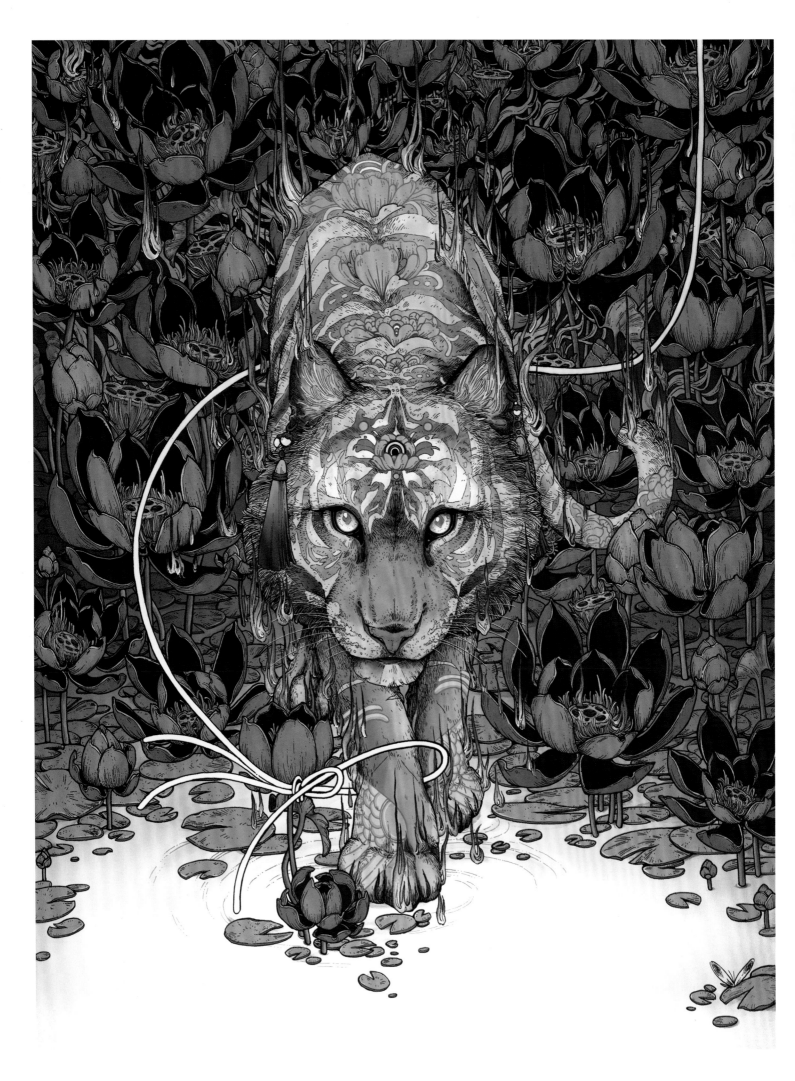

cover and left
LUPENTE TIGER
by Erica Williams

page 1
STEALING EMBERS
by Stephanie Law
Sometimes Stephanie draws inspiration from a single mythology. With pieces like this one, however, she draws from the collected mental concepts of many cultures. There are various stories and mythologies about how humans attained fire, which often symbolizes Knowledge. Among those stories are several in which this happens when a bird steals an ember from the gods and bestows it to humans. Stephanie decided to create this piece using the general concept of Knowledge as a burning ember being gifted to humans by a magnificent bird.

page 2
DESPIERTA
by Karla Ortiz
Digital, People's Print Shop, Berkeley, California, 2018.
This was a painting for the People's Print Shop. They had asked me to do a painting for them. I had done this image before in a drawing. I always thought it would make for a cool painting, and so I turned it into a painting.

page 4
GATHERING (DETAIL)
by Virginie Ropars

page 176
SNACK TRUCK IN KYOTO
by Julia Blattman

Thank you to Mark Schultz and Denise Prowell for their cover design assistance; to Alice Carter and Courtney Granner for their encouragement with this book; to Ocean Fleskes for his help in coming up with the title for this book; and to Erica Williams for making the new cover art for *Lupente*.

Edited and interior design by John Fleskes
Cover Design and interior assistance by Vicky Lien
Copyedited by Martin Timins
Production assistance by Katherine Chu
First Printing, August 2022
Paperback Edition ISBN: 978-1-64041-059-6
Hardcover Edition ISBN: 978-1-64041-060-2
Library of Congress Control Number: 2022931822
Printed in China
Asia One Printing Limited, Hong Kong
Flesk Publications™
fleskpublications.com